JAN 22

D0286092

THE LOST MUSEUM

THE NAZI CONSPIRACY TO STEAL
THE WORLD'S GREATEST WORKS OF ART

HECTOR FELICIANO

BASIC
BOOKS

A Member of the Perseus Books Group

On the cover: *The Astronomer* by Jan Vermeer (1668), that was taken from the home of Édouard de Rothschild in 1940 by the ERR (Einsatzstab Reichsleiter Rosenberg), was stamped with a swastika, declared as "Property of the Third Reich," and was put in a crate stamped H13. H here stands for Hitler.

Originally published in 1995 © Éditions Austral, Paris. English translation and updated edition copyright © 1997 by Hector Feliciano.

Translation by Tim Bent and the author.

Published by Basic Books,
A Member of the Perseus Books Group

All rights reserved. No part of this book may be used or reproduced in any manner whatsoever without written permission except in the case of brief quotations embodied in critical articles and reviews. For information address HarperCollins Publishers, Inc., 10 East 53rd Street, New York, NY 10022.

Designed by Elliott Beard

Library of Congress Cataloging-in-Publication Data
Feliciano, Hector.
 [Musée disparu. English]
 The lost museum : the Nazi conspiracy to steal the world's greatest works of art / by Hector Feliciano. — 1st ed.
 p. cm.
 Includes bibliographical references and index.
 ISBN 0-465-04194-9 (cloth)
 ISBN-10: 0-465-04191-4 (paper) ISBN-13: 978-0-465-04191-6 (paper)
 1. Art thefts—France—History—20th century. 2. Germany—cultural policy. 3. World War,—1939–1945—Art and the war. 4. Pillage—France. I. Title.
N8795.3.F8F4613 1997
709'.44'09044—dc21 97-7195

CONTENTS

ACKNOWLEDGMENTS

Writing this book would have been inconceivable without the help and encouragement of many different people: Anne Heilbronn, who was so quick to grasp what I was after and whose support was there from the beginning; Elie and Liliane de Rothschild, for their ideas, insights, encouragement, and hospitality; Hubert Heilbronn, for his patience; Alain and Denise Vernay, who encouraged me all along the way and nearly adopted me; Elaine Rosenberg, for her friendship, ideas, hospitality, and for the unlimited access to the Paul Rosenberg archives she offered me; Elisabeth Rosenberg-Clark for her ideas and encouragement; Michel Dauberville, for being so accessible and helpful; Jean de Martini for always making himself available; John Richardson, for his encouragement, superb memory, insight, and enthusiastic support; Georges Halphen, for a magical day spent together and for his reminiscences; Gérard Stern, for his kindness and help; Nick Goodman, for his quick complicity and help; Lili Gutmann, for her helpfulness; Jeanne Bouniort and Bernard Piens, for sharing with me not only their library and their

knowledge of art history, but also their reflections on the French and English languages, with patience, daily.

My thanks also extend to those who generously gave me access to their archives: Mr. and Ms. Michel David-Weill; the Paul Rosenberg family; Francis Warin; Mrs. Simone Durosoy, Mrs. Jacques Schumann, Mrs. Katiana Ossorguine; Mrs. Kaplan; Mrs. Sol Chaneles; Wanda de Guébriant and Lydia Delectorskaïa; Jorge Helft; Alfred Daber; Henri Bénézit; François Rognon; Philippe Morbach; S. Lane Faison; Craig Hugh Smyth; Bernard Taper; Robert Saunal; Pierre Daix; Baron Guy de Rothschild; Mrs. Misrahi; Ms. Cellier; Mrs. Muraz; Colonel Paillole; Mrs. Kolesnikoff; Mrs. Masson.

For the help of my colleagues and friends: Marlena Hiller; Werner Spiess; Wolfgang Form; Alexei Rastorgouev; William Honan; Klaus Goldmann; Konstantin Akinsha; Grigori Koslov; Eric Conan; Yves Stavridès; Jean-François Fogel and Jocy Drémeaux; René Huyghe; the staff at the Centre de Documentation Juive Contemporaine de Paris; the staff at the Watson Library of the Metropolitan Museum of Art; Lynn Nicholas; Peter Harclerod; Willi Korte; Giela Belkova; Philippe Sprang; François-Xavier Jaujard; the staff at The Giraud-Badin Bookshop; Murielle Ballestrazzi; the Direction des Musées de France; Mrs. Marie Hamon; Laurence Bertrand-Dorléac; Henry Rousso; Ilda François, for her enthusiasm and constant assistance; Christian Derouet, for having generously shared his knowledge of Léonce and Paul Rosenberg; Jim Cohen; Maurice Jardot; Mrs. Binda; Tamar Shiloh; Professor Steve Ross at Columbia University; Michel Besson; Patrick Franc and Isabel de Pommereau; Jack Flam; Amy Barasch; Serge Jacquemard; Françoise Bonnefoy of the Jeu de Paume Museum; Caroline Roueche at the Drouot Archives; Jean Astruc of the BDHC; Marie-Hélène du Pasquier of the Archives Department at *Le Monde*; Daniel Cattan; Sonia Combe; Marianne Vidon; Pierre Oster; Herbert Lottman; Laure Murat, for her enthusiasm; Connie Lowenthal; Montserrat Domínguez; Jim Hoagland; Jacques Lust; Mini

and Regis Protière; Peggy Frankston; Maya Vidon; Irus Hansma; Quentin Laurens; and Alain Tarica.

And also for this updated and enlarged U.S. edition, many thanks to my editors Juliana Nocker, Linda Carbone, and Richard Fumosa, who all three made the impossible possible; to Rose Carrano, who diplomatically worked so many things out; to Stephanie Lehrer, to Kristen Green, to Tim Duggan, Elliott Beard, Randy Pink, Gay Salisbury, Ann Sass, and to Tim Bent for his work on the English manuscript; to Linda Kahn for believing in this book, to Nathalie Gimon for fighting for it, and Lucinda Karter for her "eye." Thanks also to Weronika Zarachowicz and Dijana Sulic–colleagues eternal. And thanks also to my agent Heather Schroder at ICM–who extinguishes all types of fires–and to her assistants N. G. and Philippe Ing.

And, last but not least, to those closest to me, for being there all along: Oticroma, a miracle of ideas and patience; Gustavo Guerrero and Anne-Joëlle Stéphane; Hector and Nereïda Feliciano, for their proud support.

THE LOST MUSEUM

art dealers, and experts of this century worked, traded, and lived.

Occupying and plundering this high place of culture after the unexpected defeat of the French army in June 1940 presented a unique historical opportunity for Hitler and the Nazis, and gave them access to a nearly inexhaustible war booty.

If Hitler and Goering had not been interested in the arts, Nazi art looting would certainly not have been a war priority; it would not have happened in the methodical manner and on the overwhelming scale it did in Occupied Europe. Nazi confiscators in France had at their disposal a staff of sixty persons and the ability to commandeer trucks, transport trains, and valuable allocations of fuel.

By the Liberation of Paris, in August 1944, France was the most looted country in Western Europe. One-third of all the art in private hands had been pillaged by the Nazis. Many of the tens of thousands of works stolen then are missing to this day.

This story will not be a straightforward one. Despite the high degree of organization and order that characterized Germany's authoritarian bureaucracy under Hitler, each branch of government (as in any other state bureaucracy) was in continual competition with other branches. To that normal bureaucratic confusion we must add Hitler's own particular governing style, which was to assign two or even three rivals to the same task, and by so doing retain mastery over them and over the divisions within his government generally. Hitler's approach extended even to acquiring works of art. Albert Speer, a Reich minister and friend, recalled that on more than one occasion Hitler had given two different art agents identical instructions: to purchase a certain work of art at an auction, at whatever the price. What naturally happened was that each unknowing agent attempted to outbid the other, forcing the price to spiral out of sight.[1]

So, too, three separate governmental branches were charged with supervising the confiscation of art in Occupied France: the Kunstschutz, which took its orders from the Wehrmacht; the German embassy in Paris, which took its orders from the Ministry of Foreign Affairs; and the Einsatzstab Reichsleiter Rosenberg für die

Besetzten Gebiete, known as the ERR, which took orders directly from Nazi ideologue and Party leader Alfred Rosenberg. In the end it was the ERR that dominated the other two branches, though to complicate matters still further, Reichsmarschall Hermann Goering, head of the Luftwaffe and an avid art collector, surreptitiously but effectively controlled the ERR. It was under Goering's control that the ERR undertook its largest confiscations of works of art from the most renowned Jewish collections. Among all the Nazi leaders, Hitler included, Goering most directly profited from the plundering of France.

This is not a neutral story. It is the compact and forceful personal story of a few individuals and the art they owned and of the schemes, ploys, and tricks the Nazis devised to dispossess them. When the Nazis arrived in Paris, works by Van Eyck, Vermeer, Rembrandt, Velázquez, Goya, Degas, Monet, Cézanne, Van Gogh, Picasso, Matisse, and Braque were swiftly taken off the walls, rolled up and crated by their distraught owners, and ferreted away in temporary safety, only to be discovered—rather sooner than later—by the Nazis, or by an intricate network of collaborators, moving companies, neighbors, and house servants who informed them. When the sought-after paintings were found, they were quickly sent to the Jeu de Paume, to be cataloged, photographed, and shipped by train to Germany.

This story may seem at times like an adventure novel or a spy thriller—with the line between the good and the bad, the confiscators and their victims—firmly delineated.

It also deeply concerns art and culture, symbols of the soul and breath of a country. By looting French art collectors and dealers the Nazis stole much more than mere assets. These wily and tenacious confiscators were also stealing the soul, meaning, and cultural standards of these collectors. Not only do conquerors try to physically obliterate their enemies, but they also try to take over the precious art objects they own and patiently collected. This plundering gives us a fair insight into the reason the power of all victors—even recent

ones, like in the former Yugoslavia—rests in part on the looting and destruction of the cultural possessions of the enemy.

Of course, behind this tightly organized confiscation of art stands the Holocaust, as a backdrop and context.[2]

The looting of cultural property by the Nazis was a serious priority. So serious, it became one of the indictments against Nazi dignitaries at the Nuremberg War Crimes Tribunal.

But when I started this investigation, in 1989, there were only scarce threads and loose ends to be picked up on this intricate subject. I wanted to know what exactly had happened in the past, but I also wanted to know, if possible, the whereabouts of thousands of paintings still missing today. I realized that painfully little had been done to reconstitute the history of the looting itself or to track down the lost paintings. Much of the information available was still classified in France or inaccessible in the government archives of several countries. It was also scattered among a few books and private archives, and in the memories of people—mostly members of looted families—who had never told what they knew or remembered.

No one, to my knowledge, had tried putting side by side and meticulously analyzing these long-compartmentalized and heterogeneous elements: wartime books and memoirs; classified and declassified documents and interrogation reports coming from France, Germany, Switzerland, the U.K., the former Soviet Union, and the United States; period photographs; art history and museum documents; exhibition catalogs; and art gallery archives. I combed these sources, adding to them hundreds of my own journalistic interviews. Obtaining some of this information was almost as difficult as knowing what had certainly happened during the war.

I wanted to solve the numerous mysteries surrounding these artworks, and follow and tell the full details of the persons and collections involved. But this was possible then only in a matter of speaking. What I quickly discovered was that to reconstruct these events, you had to find out, step by step, exactly what had happened to these collections. Putting them back together again has been like

finding long-lost pieces to a puzzle. Not only was the paper trail—who had what piece when—of the utmost importance to this kind of research, but also the constant shuttling back and forth between people, paintings, and papers was central to it. A piece of the puzzle would suddenly materialize while I was conducting an interview in Paris, but only in fragmented form, and the missing element—or confirmation of the piece's authenticity—would not appear until months or even years later, while I was leafing through documents in an archive or an art catalogue in a different part of the world. I soon realized that many of the obsessively precise Nazi looting inventories and art files are still the best and most reliable sources to be used to reconstruct the history of these looted missing paintings.

But consulting wartime documents in French archives and libraries is extraordinarily difficult. Procedural delays, confidentiality laws, and the administration's bad faith slow things down to such an extent that it is often easier and more efficient to seek the same evidence from other sources and other countries.

In order to acquire some solid elementary facts, I was forced to consult many still-classified intelligence documents from the French DGER (Direction Générale des Etudes et Recherches, or General Services for Study and Intelligence)—the French Secret Service created by de Gaulle in 1944 after the liberation of France. This government office performed a series of fundamental inquiries right after the Nazis left, and gathered much essential intelligence on confiscation and the Paris art market.

In large part thanks to the duplicates of these French (but also British) reports, sent to U.S. army investigators by their European colleagues, plus those the U.S. army itself conserved in the National Archives and Records in Washington, D.C., it was possible for me to begin, at long last, a thoroughgoing investigation into the art market in Paris during the German Occupation, without which one cannot understand the looting itself. This book, I believe, contains heretofore unpublished information about that market and some of its most active buyers and sellers.

Once I was able to locate the right documents I soon found the Allies had performed many interrogations. What intrigued me most, as I read the interrogation transcripts, was how frequently those being questioned—mostly art connoisseurs—were stricken by timely bouts of amnesia, becoming unable to remember little or nothing about a piece in question—a lost Matisse drawing, say. The closer the interrogators' questions were associated with them, the less they could remember about the period. Once the questions moved further away, their memories improved suddenly and remarkably.

Fortunately, many of the missing paintings had been photographed by their owners. These cautious collectors and dealers unknowingly have bequeathed to us the only visual testimony of the lost artwork we may ever see. Collecting some of these heretofore unpublished photos you will find in this book was a complicated task that took me to several countries. Sometimes their quality leaves much to be desired. These photos were shot in the 1930s, before the Nazis marched into Paris, and before color photos were widely used.

Each looted individual, each confiscated collection, each and every seized painting, has a unique history. They all merit their own separate accounts and investigation. When I approached them, many of the family members, members of the Resistance, art dealers, and army officers, had never been thoroughly interviewed or listened to, nor had their private family archives been examined. Slowly, many of these eyewitnesses would allow me to talk to them and to look over their personal documents. At the same time, with documents gathered elsewhere, I was able to provide them with new, unsuspected information about their own lives, families, or collections—information that questioned even longstanding family legends. Over many years of contact, some of these exceptional people and I became personal friends, to my delight.

This project soon became an investigator's joy: going from an anecdote to a confirming piece of paper, with much deduction, trial and error, patience, and stubbornness in between. Since organized information was scarce, what was already available had to be neces-

sarily questioned and events reconstructed from scratch; it might take years for me to know whether an idea, a hunch, or an intuition was right or wrong. Any new bit of information could suddenly turn into a new development. A recently declassified wartime document, for example, would bring up information that would question the reliability of the source I happened to be interviewing. This soon made me extremely cautious, and I sometimes checked out facts four times before giving them credit. But finally the whole picture, with all its nuances, surged into view.

As my knowledge of the general story became clearer, direct leads to missing paintings started turning up. Some led, surprisingly, to the Louvre and other French museums, where some two thousand unclaimed artworks (looted or sold voluntarily) are still "waiting" to find their owners. Many other tracks led to other countries in Europe and to the United States.

The role played by Switzerland in the Nazi art-confiscation in France also started acquiring a clearer shape. The French–Swiss art connection was a well-established one. Many have talked of Nazi gold and the forgotten accounts in Swiss banks, but few have specifically looked into the art found in that country. I have, and what I found out is intriguing and disquieting.

It has been a personal pleasure to have solved some of this puzzle. I wrote this book out of a sense of justice, and it is an unexpected satisfaction to know that it has helped increase interest in the Nazis' confiscation of art while helping some families in Europe and the United States to reclaim their looted paintings.

Since this U.S. edition appears one year after this book was published in France, I have been able to augment and update my research. But the story of the Nazi confiscation of artwork is both endless and complex.

The years I spent working on this investigation can be com-

pared to the discovery of an archipelago. At first, the islands in this archipelago seemed unconnected. But the more I could bring to the surface about the Nazi confiscations in France, the closer these islands grew together. Eventually, the islands became terra firma, then turned into a large unknown continent, and this continent transformed itself, in turn, into new historical labyrinths to be followed.

Although I have made some discoveries about this stolen art, I must acknowledge those fellow discoverers who went before or with me. Before, and just after, the end of the war, art historians and journalists—whether in uniform or civilian clothes—had already begun to explore this lost museum of art, sharing with others what they learned. Others have approached it recently; they include: in France, Eric Conan and Yves Stavridès of *L'Express*, and Philippe Sprang of *L'Evénement du Jeudi*; in Belgium, Jacques Lust; in the United States, Andrew Decker, William Honan of the *New York Times*, Willi Korte and Lynn Nicholas; and in Russia, Konstantin Akinsha and Grigori Kozlov. They all have shared what they found.

Many of the basic facts about the confiscation, transport, and sale of works of art in Nazi-occupied Europe are already known. Investigative journalism doesn't so much discover as contribute, connect, establish links, and, finally, disclose. Such has been my intent from the start.[3]

PART I

A Certain Love of Art

1

Vermeer's *Astronomer*, or Hitler's Blind Spot

To begin this intricate story we must first go to the Louvre Museum in Paris. There, in the Richelieu wing containing Dutch and Flemish masters, and surrounded by much larger paintings, we find *The Astronomer* by the seventeenth-century Dutch painter Jan Vermeer (*see* insert A1). This painting portrays a man wearing a blue robe, sitting comfortably at a desk in the serene privacy and quiet of his study. He faces a window; his right hand reaches for a celestial globe. In front of him, on the desk partly covered in drapery, sit a compass, an astrolabe, and an open book. Careful inspection of the book reveals that it is a manual of astronomy and geography, one whose fame had spread throughout Europe at the time. The book was inspired by the Old

Testament, and is open to chapter 3, which discusses stars, constellations, and star-watching and establishes connections between astronomical observations and biblical sources. The globe dates from 1600.

A cupboard positioned against the rear wall bears Vermeer's signature and the approximate date the painting was done—1668. On the righthand side of the same wall, is a small anonymous painting depicting the central biblical scene of the *Finding of Moses* (Exodus 2:1-10). That painting appears, at a much larger scale, in another Vermeer work, *Lady Writing a Letter with Her Maid*.

As in many of Vermeer's works, subdued indoor light plays a central role in setting the scene's intimate, domestic ambiance. Here, a soft and filtered light enters the room from the leaded windows on the left side of the canvas. The light envelopes first the globe, then the draped desk and the open book. Finally, following its natural spreading course, the light illuminates the man's face and the rest of the study.

But, at this point, two important elements of *The Astronomer*—unnoticeable at first sight—must be pointed out. They are essential for the story that follows: The first escapes notice; the second was consciously removed, and can be reconstituted only in our imagination.

The plaque that Louvre curators have placed next to the painting informs visitors that this particular Vermeer was donated to the museum in 1982. In fact, *The Astronomer* had been the property of the French branch of the Rothschild family for nearly a century. Since 1886, the year Baron Alphonse de Rothschild bought the painting in London for his private collection, it had been part of the Rothschild family fortune, a prized possession passed carefully from father to son.

The painting had arrived from the Netherlands into England around 1800. Until that date, it had always accompanied another Vermeer painting, *The Geographer*. They have almost always been considered to be pendants, since their subject matter and dates of composition are closely related. By 1939, *The Geographer* was in Nazi Germany.

What the Louvre's plaque does not say is that there is a gap in the painting's history. There is a time in very recent memory when *The Astronomer* was neither hanging in the Rothschild home, nor on display at the Louvre. No trace seems to remain of this abrupt and mysterious eclipse in the life of a world-renowned masterpiece. You might have a clue about that gap if you were able to take the painting off the wall and examine the back of it. There you would see the spot where Nazi art historians had stamped a swastika on it.

Indeed, *The Astronomer* was once part of Adolf Hitler's private collection, if only for a short time. Soon after the German invasion of France in 1940, the painting was seized at Édouard de Rothschild's home by the Einsatzstab Reichsleiter Rosenberg (ERR), the government branch responsible for most art confiscation in France, and taken to the Jeu de Paume museum, which the ERR used as a warehouse. There, a team of German art historians and officials declared the work the "Property of the Third Reich," estimated its value, and stamped the back of it with a small swastika in black ink.

The full title of the ERR's director, Alfred Rosenberg, was "The Führer's Representative for the Supervision of the Intellectual and Ideological Instruction of the National Socialist Party." He also supervised Nazi plundering. On November 13, 1940, Rosenberg sent Martin Bormann, Hitler's closest collaborator in charge of his personal finances, a note in which he expressed his satisfaction at the seizure of *The Astronomer* in Paris: "In great haste, the report to the Führer, included herein, will I believe bring him great joy—I am pleased moreover to inform the Führer that the painting by Jan Ver Meer of Delft [sic], to which he made mention, has been found among the works confiscated from the Rothschilds."[1] Not long afterward, along with hundreds of other works of art, the painting was sent by special train from Paris to Germany.

The Astronomer figures among a Nazi inventory of "European works of the highest historical and artistic value." Some of these works, which came from every country the Germans had conquered, were selected for the museum of European art that Hitler

planned to establish in the Austrian city of Linz. The rest went into the private collections of Hitler, Goering, Foreign Minister Joachim von Ribbentrop, other Nazi dignitaries, used to decorate Nazi Party offices, or else sold or exchanged on the European art market.

Between 1939 and 1944, the Nazis systematically confiscated, stole, or bought works from a number of European collections, or from private collections belonging to wealthy Jewish families, Freemasons, and political opponents. In the end, hundreds of thousands of paintings, priceless sculptures, and drawings by the great masters—as well as millions of books, manuscripts, and other cultural artifacts—were taken from across Europe. These were the spoils of war. Holland and Belgium were heavily hit by this plundering, but of all the Western European countries it was France that suffered the most. Eastern Europe, of course, presented a different case; it was the victim of the Nazis' iron will to shamelessly annihilate its cultural heritage. There, the Nazis undertook to destroy its identity, folklore, architecture, and even its language through mass murder and forced Germanization.

On the other hand, French culture was for some Nazi officials not only admirable but desirable; the idea was, then, not to annihilate it but to capture it. Despite its profound chauvinism about all aspects of Germanic culture, the Nazi aesthetic could appreciate, whether openly or secretly, the architectural and cultural creativity of France's autocratic and aristocratic past, from Louis XIV to Napoleon.

Hitler confided to his friend and favorite artist, the sculptor Arno Breker, that he had always felt a fascination for Paris, a city he had never visited. About Hitler's first and only trip there on June 28, 1940, a few days after signing the Armistice with France, Albert Speer, the Führer's personal architect and friend, wrote in his memoirs that, in spite of the military and political context of the trip, it was also a kind of "art tour" of the city which had fascinated Hitler from his earliest years.

The tour began one Sunday at 5:30 in the morning. Paris's streets were deserted. Hitler and his party, driving in three Mercedes sedans, went directly from the Le Bourget airport, north of Paris, to the Opera, Hitler's favorite building. Inside, all the lights were glowing. Hitler had carefully studied the architectural plans of the building and acted as the group's tour guide. He inspected the great stairway, the foyer, the elegant parterre. "He seemed fascinated, went into ecstasies, about its beauty, his eyes glittering with excitement." Near the stage, Hitler found out that a salon he had studied in the plans was missing. He asked the attendant and he turned out to be right. "There, you see how well I know my way about," he commented complacently. From there the party continued on to the Madeleine, the Place de la Concorde, down the Champs-Élysées, to the Arc de Triomphe, Trocadero and the Eiffel Tower, arriving finally at Napoleon's Tomb in the Invalides. There Hitler "stood for a long moment" and posed for a propaganda photograph. The tour then continued on to the Pantheon, where Hitler examined the vault, "whose proportions greatly impressed him." During his visit Hitler "showed no special interest in some of the most beautiful architectural works of Paris: the Place des Vosges, the Louvre, the Palace of Justice, the Sainte Chapelle." Then, Speer recalls, "the goal of our tour was Sacré Coeur, that insipid and romantic imitation of early medieval domed churches." There, Hitler paused for some time, surrounded by several of his bodyguards.

That evening Hitler confided to Speer: "It was the dream of my life to see Paris. . . . You cannot imagine how happy I am that today my dream came true." He ordered Speer to draw up a decree ordering full-scale architectural renovation projects in Berlin. "Wasn't Paris beautiful?" he confided to Speer. "Berlin must be made far more beautiful. . . . In the past I often considered whether we would not have to destroy Paris. But when we are finished in Berlin, Paris will be but a shadow."[2]

Since his teenage years, Hitler was drawn to the arts. With his typical self-conceit and vainness Hitler in *Mein Kampf,* his autobi-

ography, spoke of his talent as a painter, "which was overcome only by my talent as a draughtsman, especially in all the fields of architecture."[3] But his real talent was soulless and lacked personality. He had twice tried, without success, to pass the admission examination to the Academy of Fine Arts in Vienna. He was also rejected at the School of Architecture. Idle, he then started to paint and to sell his paintings of Vienna in the form of postcards. He also drew advertising posters. After becoming a professional politician, Hitler continued to draw and design, while developing extremely conservative and antimodern ideas about art with rigid notions of what can and cannot be done.

It was during Hitler's rise to power that his admiration for the great painters and his anti-Semitism were bonded together. We know that one of the books that had influenced him was entitled *Rembrandt as Teacher*, by the German writer Julius Langbehn. The author found heroic qualities in the Dutch master, whom he pronounced to be a model for the Germanic culture and Aryan race. Langbehn also predicted that a Greater Germany would one day govern Europe and the world.

The figure of Rembrandt, as both hero and painter, comes up again and again in Hitler's conversation. The issue of his racial purity therefore became central. Disquieted probably by the proximity that the painter had had all of his life to the world of Dutch Jews, Hitler tried to convince himself of his idol's Aryanness. One of Hitler's closest friends at the beginning of his political career was Ernst Hanfstaengl, a sophisticated German bourgeois and a Harvard graduate. Hanfstaengl, who was the heir to an art publishing house in Munich, believed then, he could transform Hitler into a cultivated and reasonable German nationalist politician by bringing him closer to his own milieu. He recalls at the very beginning of the 1920s, one visit with Hitler to Berlin's National Gallery after an unsuccessful political fundraising stint: "We spent quite some time standing in front of Rembrandt's *Man in the Golden Helmet*. Hitler began to pontificate: 'There you have something unique. Look at

that heroic, soldier-like expression. It proves that Rembrandt, in spite of the many pictures he painted in Amsterdam's Jewish quarter, was at heart a true Aryan and a German.'. . . Then, barely glancing at the Berlin Vermeers, we galloped in search of Hitler's other artistic hero, Michelangelo."

But the National Museum, unfortunately, possessed no original Michelangelos, apart from a statue of the young John the Baptist that was attributed to him. "Hitler came to halt in front of this lightly poised, almost feminine figure and proclaimed: 'Michelangelo. That is the most monumental, the most eternal figure in the history of human art.'" Hitler then went off in search of other works by Michelangelo, convinced that the museum must have them. When Hanfstaengl caught up with him, he found Hitler "lost in meditation in front of Correggio's *Leda and the Swan*. He pulled himself together. . . . And although it was the sensuous portrayal of the two central figures that fascinated him," Hitler hurriedly started in on a lecture about the 'wonderful play of light on the bathing nymphs in the painting's background.'"

Hanfstaengl was to learn in the years to come that the subject of Leda and the swan was nearly "an obsession" with Hitler. When he came to power, any painter employing the subject at a Nazi exhibition was sure to be awarded the gold medal.

A little later, during that same visit to the museum, Hitler came to a sudden halt before Caravaggio's *Saint Matthew and the Angel* and exclaimed, "There was no end to his genius! There is no time now but we shall have to come back and look at it again." Hitler was convinced the painting was by Michelangelo, but he was wrong. The plaque next to the painting read, "Michelangelo Merisi–Caravaggio."[4]

In that one afternoon at the Berlin museum Hitler revealed some of his essential aesthetic preoccupations: Rembrandt's Germanness and racial purity, Michelangelo's powerful use of classical forms, and his own attempt to deny Correggio's sensual appeal.

For the purpose of this book, it is Hitler's thoughts about Rembrandt that are of greatest interest to us. He was doubtless aware that

the Dutch masterpieces so dear to him were rich with references to the Jewish world. If Rembrandt embodied the Aryan ideal, his contact with the Jewish world was incompatible. Hitler knew that Rembrandt frequented the Amsterdam ghetto, and surely that he had painted the well-known Dutch Jews of his day. It was, for example, the publisher Manasseh ben Israel—whose portrait by Rembrandt can be found today at the Israel Museum—who supposedly introduced Rembrandt to Dr. Ephraïm Bueno—whose portrait and etching by Rembrandt are hanging, respectively, in Amsterdam's Rijksmuseum and at the Pierpont Morgan Library in New York.

Biblical subjects also abound in Rembrandt's paintings. Some of them, of course, stem from the Protestant Reformation, when direct reading of the Bible was being rediscovered. Rembrandt added allusions to Dutch history to these biblical subjects. Holland had just gained its independence from Spain and it identified with an Israel that had conquered the land of Canaan. Generally speaking, the Dutch of the seventeenth century felt an affinity for Jews, and had openly welcomed exiled Portuguese Jewish merchants and intellectuals.[5] The anecdote about the *Man in the Golden Helmet* that Hanfstaengl recounts reveals to what point Jewish references in painting had become a matter of concern to Hitler.

As for Vermeer's *Astronomer,* a painting Hitler coveted for his own collection, it too contains an obvious reference to the Hebraic world, as we've seen, though one filtered through the prism of Protestant culture: that small painting showing the "Finding of Moses," when the Pharaoh's daughter and her servants discover the newborn on the Nile. Hitler may not have understood the reference. And this small painting inside *The Astronomer* was a sort of blind spot for the Führer.

A dozen years after his visit to the Berlin museum, when he had come to power, Hitler's interest in art and the state's control over it would constantly increase.

In *Mein Kampf,* he had already violently attacked modern art—Cubism, Futurism, Dadaism. These were, he wrote, "products of de-

generate minds." He went on to argue that it is the "duty of the State, and of its leaders, to prevent a people from falling under the influence of spiritual madness."[6] He would be the only one of the dictators of the period (the others being Stalin and Mussolini) to involve himself as much in the aesthetic details of his empire—the art, architecture, political parades, the choice of uniforms, and insignias—as in political or military matters.

Hitler had begun creating his own art collection in the 1920s and 1930s, using his portrait photographer Heinrich Hoffmann as a broker. Revealing his provincial tastes, Hitler acquired numerous paintings by nineteenth-century realists, many of them products of the Munich School. In June 1939, he appointed Dr. Hans Posse, then director of the Dresden Museum, in sole charge of acquiring works for the Linz museum. According to Hitler's grand scheme, Linz, a provincial capital in Alpine Austria, where Hitler had spent part of his childhood and his adolescence, was to be, along with Munich, Nuremberg, and Berlin, one of the Reich's crowning glories, a showpiece of Nazism. The monumental museum was to be made up of a series of colossal buildings housing the most important European works from prehistoric times to the present day. Every European master of painting and sculpture (recognized as such by Nazi ideology, of course) would be represented. The core of the museum's collections would consist of Northern European art, starting with the collection of nineteenth-century mediocrities Hitler himself had collected. The Dutch Masters would of course be accorded a significant place. The museum's collections would be constituted through massive acquisitions but also through the seizure or exchange of paintings from public and private collections in the occupied countries.

Speer recalls how Hans Posse, an art historian of some repute, took matters in hand. When he named Posse, Hitler showed him his earlier acquisitions, including his collection of works by Éduard Grützner, one of the realist painters Hitler most admired. The viewing took place in Hitler's bunker, where his paintings hung on the

walls. Objective and incorruptible, Posse rejected outright many of these costly acquisitions, calling them "barely acceptable" or even "not up to the level of the Linz museum, not as I imagine it." Immediately afterward, Posse, whose budget was 10 million marks—the equivalent today of $85 million—began acquiring works. He kept Bormann, Hitler's collaborator, constantly informed of his activities. Most of the pieces he acquired were stockpiled in the basement of the Führerbau in Munich, the massive building that served as Hitler's headquarters there. Posse could also choose what he wanted from art coming from the confiscated collections of Jews and other "undesirable persons" in Austria and Czechoslovakia.

In June 1940, in his first annual report, written at the very moment of the invasion of France, Posse informed Hitler of the status of the Linz collections, and that he had acquired 465 paintings in one year alone.[7] He respectfully reminded the Führer that it would still be necessary to obtain works by Rubens, Rembrandt, and Vermeer, so as to have a complete collection. We might now understand the significance of the seizure of Vermeer's *Astronomer* in November of that year, and the joy the news would bring Hitler.

As the Nazi military victories increased, Posse regularly visited every occupied country so that he could buy, often using force, paintings, sculptures, and drawings destined for the Linz museum. Posse was not alone. Maria Dietrich, one of Hitler's confidantes and a friend of Eva Braun, also made purchases for the Führer. France was one of the foci of Hitler's ambitions in this line. He eagerly anticipated the signing of an official peace treaty with France so that he could take some of the Louvre's best works as war reparations. The treaty, however, never took shape. Only an armistice was signed.

In any case, the ERR confiscated thousands of paintings from throughout occupied Europe. Each was inventoried, cataloged, and photographed. The ERR art historians put together for their Führer a photo album of some these works, to which he could refer and from which he could choose at all times.

The Reich's military fortunes may have declined, and the country become embroiled in economic crisis as defeat loomed, but the acquisition budget for the Linz museum actually rose during the war. By the end of 1944 it approached 70 million marks. The storehouse containing works that were to go into the Linz museum contained more than eight thousand items.[8]

Hitler's extreme interest in art continued until the final hours of his life. From his bunker, on the eve of his suicide on April 30, 1945, with Berlin under siege by the Soviet Army, he dictated his last will and testament. Goebbels, Bormann, and Colonel von Below witnessed while he dictated the terms to his secretary. He wished to bequeath, he said, all his assets to the Party. The only possessions he mentions in any detail are the paintings intended for his museum project: "The paintings in my collections, which I purchased over the course of years, were not assembled for any personal gain, but for the creation of a museum in my native city of Linz on the Danube. It is my most sincere wish that this legacy be duly executed."[9]

With Hitler's death and the end of the war came the end of the Third Reich. In twelve years—not the thousand that the Führer had predicted—as many works of art were displaced, transported, and stolen as during the entire Thirty Years War or all the Napoleonic Wars.

2

The Kümmel Report, or
The Nazis' Reply to Napoleon

In 1940 an inordinate and disproportionate project, conceived at the highest levels of the Nazi hierarchy, began taking shape. It had its origins in the same conception of Germanic aesthetics that had given rise to the Linz museum project, but its focus was somewhat different. Already sketched out in Hitler's writings and in those of other Nazi ideologists was a plan to repatriate works of art taken from Germany and dispersed throughout the world. Martin Bormann and Goebbels, Minister of Propaganda, transmitted a written order from Hitler to the eminent art historian Otto Kümmel, director of the Reich's museums. Kümmel was to compile an exhaustive list of German art held in foreign countries since the beginning of the sixteenth century.

Kümmel's research culminated in three volumes, combining the work of three specialists: Dr. Franz Rademacher, director of the Upper Rhine museums; Dr. Otto Apffelstaedt; and Dr. Hans Baumann.[1] All three would also play significant roles in the Parisian art market during the Occupation. Their vast work remained a secret for the entirety of the war. Point by point, it outlined the historical circumstances surrounding the transfer of Germanic works of art to countries outside Germany; it also provided a basis for future reclamation. Using the Nazis' systematic method of art research, Kümmel established the work's place of origin in Germany, the date of its disappearance, its current location, and an estimate of its current value. The art fell into three categories: "works of special historical significance," "works of lesser importance," and "works of local interest."

At the time, Hitler's strategy of world conquest was on the point of being realized. The recuperation of German art seemed not only possible but imminent. Hitler had just overwhelmed France, Holland, and Belgium. He had already carved up Poland and annexed Austria and the Sudetenland.

Like Hitler's territorial ambitions, the scope of the Kümmel Report was global. Included in it were demands for the return of art being held in countries from the Soviet Union to the United States, art taken from Germany from the 1500s to the 1930s. By "art" was meant everything from banners taken from the Imperial Army by the Swedes during the Thirty Years War, to paintings bought on the market during the twentieth century and hanging on the walls of the Louvre or the Metropolitan Museum in New York. The report even included six paintings from the private collection of the King of England, one of which was Rembrandt's *Christ and the Magdalene.*

Paintings, sculptures, medieval armor, porcelain, silver, military flags, glassware, medals, and coins—the Kümmel Report overlooked nothing. It mattered little whether the terms under which these objects had left the country were legal or illegal, friendly or

hostile. What was essential was that the German people had been *geraubt*, despoiled, of their heritage and that these works were to be found outside the Reich. But the report's demands also had an historical significance that went deep into German nationalism: They were to erase the humiliation of the Treaty of Versailles in 1919, which ended World War I, and to restore to German culture the central place that Nazis thought was its birthright.

It was therefore natural that the first reclamations were made against France, Germany's traditional enemy. Some 1,800 works were demanded of it, of which 359 could be found in museums or in public places. No French museum, whether in Paris or in the provinces, escaped scrutiny, whether publicly funded or privately owned. Nor did individual collections. And as regards works whose location in France could not be identified, the Kümmel Report called for compensation, taking French art that was of equivalent value.

Kümmel's introduction to his inventory is a veritable indictment of France. Napoleon's armies are excoriated as the guiltiest perpetrators of pillaging, an accusation that confirmed the symbolic importance of Napoleon for the Reich's leaders. Napoleon's actions are cited with such frequency that it seemed as if the Third Reich, in an act of symmetrical reparations, intended to undo them, one by one.

There was basis in fact for this. Apart from seized works from Italy and Egypt, Napoleon had in large part filled the Louvre with looted German art. Even today, the official catalog of works in the Louvre makes distinctions among the different sources. The catalog notes the origins of paintings taken during the Munich campaign of 1806, the Kassel campaign of 1807, and Vienna's in 1809, when parts of the Austrian Imperial Gallery were transported wholesale to Paris. From the city of Kassel alone Napoleon looted as many as 299 paintings, including sixteen by Rembrandt, four by Rubens, and one by Titian. The Kümmel Report also demanded the restitution of 584 gold medals and 4,428 silver medals that had

also belonged to the city of Kassel, though without providing any indication where they might be found; the Nazis knew only that they had been "taken to France." The art collections of Frederick the Great had been transported from Potsdam and Berlin to Paris. Among the works were two very beautiful paintings by Watteau, and Hitler's favorite: Correggio's *Leda and the Swan*, which was returned to Berlin after the downfall of Napoleon.

Certain works considered "German" had first passed through Italy, such as Pieter Bruegel the Elder's *Earthly Paradise*, which had been taken from Milan's Ambrosiana Gallery in 1796.

The Congress of Vienna in 1815 attempted to establish order and restore works displaced by the Napoleonic Wars. Raphael's *Transfiguration* and *Madonna of Foligno*, Poussin's *Saint Erasmus*, Caravaggio's *Entombment*, Titian's *Martyrdom of Saint Peter*, the Hellenistic sculpture of the *Laocoön*, the horses and the lion of Venice, as well as several works by Rubens—all were returned in due course to their former Austrian or Italian owners. Others, however, never made it back to their countries of origin. Events, or the clever evasions of Vivant Denon, who was then director of the Louvre, interceded. Hence, Veronese's *Marriage of Saint Catherine* remained in France (today it can be found in the museum in Rouen), and Rubens's *Adoration of the Magi*, which had been in Munich, stayed in Lyon.

The Louvre also kept two of the most important of the confiscated paintings: Tintoretto's *Paradise*, which was plundered from Verona, and Veronese's *Marriage of Cana*, which Napoleon's army had lifted from the church of San Giorgio Maggiore in Venice. Vivant Denon employed several stratagems to retain possession of this latter painting. First he had it sent off to a workshop in the provinces for restoration, hence delaying compliance with Austria's restitution order. Eventually he offered to trade it for Charles Le Brun's *The Feast of Simon*. The Austrians agreed to the swap; today it would appear Denon got the far better deal.[2]

Kümmel could therefore prove, without difficulty, that France's

museums had profited by the Napoleonic Wars. A similar conclusion had been reached by others having nothing to do with the Nazis, such as French art historian Marie-Louise Blumer, who in the 1930s had traced some 500 paintings taken from Italy by Napoleon's army, and located 248 that were never returned.[3]

Hence, the Nazis demanded of the Louvre an impressive number of paintings, among them Rembrandt's *Self-Portrait*, taken in 1806, and seven works by Dürer taken from the Albertina Museum in Vienna in 1809, including the *Portrait of Erasmus* and the *Portrait of a Young Man*. Even France's provincial museums were called upon to return works, such as a Rubens from the museum in Rouen and Tintoretto's *Danaë* from the museum in Lyons.

Nor did the Kümmel Report ignore art confiscated by French authorities from German and Austrian nationals living on French soil at the outbreak of the First World War. That list included the art collections of Wilhelm Uhde, Daniel-Henry Kahnweiler, Baroness Betty von Goldschmidt-Rothschild, and the dealer Hans Wendland, as well as those of other collectors of lesser importance who frequented Parisian art circles. Ironically, the report also included "degenerate art" collected by German Jews—who were just then being persecuted in Germany. Along with the Cézannes from the Wendland collection, the Nazis demanded works by Braque, Léger, and Picasso, and Fauve works by Vlaminck. One wonders what they had intended to do with these, apart from putting them up for sale. The fate of Cézanne's *Village of L'Estaque*—which had belonged to Wendland and was therefore deemed the inalienable property of the German people—had been followed step by step by the report's writers, from its initial sequestration and the three auctions of Wendland's property in Paris to its purchase by the Brooklyn Museum during the 1920s. Dozens of avant-garde paintings from the Kahnweiler collection were also declared part of the German national heritage.[4]

Those German collections seized after the outbreak of war in 1914 had also included Old Masters, such as Dürer's *Portrait of the*

Artist, which the Louvre bought at auction for 300,000 francs. It had belonged to Nicolas de Villeroy, who had had the misfortune of choosing German nationality when the war started.

While France was the main target of Kümmel's demands, it was by no means the only one. The Germans also demanded that the Metropolitan Museum of Art in New York return *Hay Harvest* by Pieter Bruegel the Elder that Napoleon's army had taken from Vienna in 1809, as well as Van Dyck's *Portrait of a Man*, taken from the city of Kassel's gallery in 1806, a painting by Pieter de Hooch, and finally Remb randt's *Portrait of a Man*, which had come from Frankfurt. From the Hermitage Museum in the Soviet Union, a painting by Claude Lorrain and one by Andrea del Sarto, both seized by Napoleon's army, were demanded.

The Kümmel Report focused sharply on the *Ghent Altarpiece* by Hubert and Jan Van Eyck, an early Flemish masterpiece also known as the alterpiece of the *Mystic Lamb*. Article 247 of the 1919 Treaty of Versailles had required Germany to give to Belgium twelve panels of this altarpiece as war reparation. Even though the Kaiser Wilhelm Museum in Berlin had legally bought these twelve panels in the nineteenth century, but in 1919 they were returned to the Church of Saint Bavo in Ghent. Kümmel was well aware that at the beginning of the war Belgium had sent the altarpiece to France for safekeeping, and that it had been stored in the château at Pau, in southwestern France, far from the front. With France under occupation, it would be possible to recover not only the twelve panels but the whole altarpiece.

The Kümmel Report was officially presented to the Reich's Chancellery in January of 1941. Taking advantage of the break in hostilities between the autumn of 1940 and the first months of 1941, the Germans intensified their art-purchasing and looting efforts. But the Kümmel Report was not acted upon. It could not serve as a guide to Nazi pillaging; monumental and exhaustive, it was fairly useless from a piecemeal perspective. Moreover, it was kept secret and never made available. Quite reasonably, the German authorities

worried that if it were made public the report would provoke widespread resistance in the conquered countries. The decision was made to keep the report in reserve, in the event a peace treaty with France and other countries was drawn up and official reparations called for.

Had Dr. Otto Kümmel wasted his time composing his long list? Not really. Despite the efforts of the Belgians, the *Ghent Altarpiece* was surrendered to the Germans by Vichy France. Goering eventually succeeded in having it transported to Germany, and in June 1943 it was put on display in Berlin. Then, artworks belonging to churches and museums in Alsace (which the Kümmel Report considered German territory), most of which had been housed in the château of Hautefort, in southwest France, were also given over to the Germans.

The Kümmel Report was a sort of chimerical projection of Nazi ideology and its obsession with "German heritage." It stands as the cultural and aesthetic aspect of Hitler's project of conquest, next to its political, racial, economic, and military components.

It was in Eastern Europe that the Nazis most succeeded in total cultural reappropriation. This was very different than what happened in Western Europe, where the brunt of art confiscation fell on certain sectors of the population, such as Jews, Freemasons, and political opponents. In other words, there German looting focused on individuals, rather than on recovering every single artifact of the German cultural heritage, regardless of its ownership.

3

Hermann Goering,
"Friend of the Arts"

Unlike Hitler, Rudolf Hess, or Alfred Rosenberg, Hermann Wilhelm Goering was born in Germany proper—in Rosenheim, Upper Bavaria, to be precise. Son of the ex-colonial governor of German Namibia, he was also one of the first of Hitler's confederates to come from the bourgeoisie. Also notable is that he was a true hero of the First World War, during which he had distinguished himself as a pilot, shooting down more than thirty enemy planes and getting wounded several times in the process. After the war, Goering worked in commercial aviation. During a forced landing on a Swedish estate, he met the wealthy Baroness Carin von Fock, who later divorced her husband to marry him. In 1922, his new

wife, who was well connected in the world of German ultra-nation-alists, introduced Goering to Adolf Hitler, who was thrilled at meeting a German fighter ace awarded the prestigious "Pour le Mérite" medal, and who was, moreover, rich. After the failed Mu-nich beer-hall putsch, Goering fled Germany and spent several years living in Italy and Sweden, a period of exile during which he became a morphine addict and developed his taste for unlimited power, money, and luxury. Carin died of tuberculosis in 1931. Go-ering had her buried at his large hunting lodge and estate situated south of Berlin; he renamed it "Carinhall." His ambition was to fill it with a world-class collection of paintings and artworks, which would expand largely from the spoils of war.

After Hitler seized power on January 30, 1933, Goering moved into the Nazi Party's number-two spot. He was appointed minister-president of Prussia and Minister of the Interior, both posts that permitted him to place members of the Nazi Party in positions of power within the government. Having organized the Prussian polit-ical police, he created the Reich's first concentration camp, at Oranienburg. But it was in 1936, when he was made plenipoten-tiary minister of Germany's economic and industrial "Four Year Plan" and took charge of armament production, that he began to amass the enormous personal fortune that would fatten his art col-lection. He became a highly valued client of dealers not only in Ger-many but throughout Europe. The growth of Goering's collection mirrored his political and military success. Principal architect of Austria's Anschluss, commander of the Luftwaffe during the blitzkrieg in Poland and France, named Reichsmarschall in June 1940, Goering was at the height of his prestige at the beginning of the war. The German occupation of France increased both his ap-petite and his opportunity to collect art.

Following the rapid successes of the blitzkrieg, Hitler's governing style took over again. In somewhat feudal style, each branch of gov-ernment was placed in competition with the other branches. This was most certainly the case with art confiscation. Several months

after the invasion of France, Goering, who was keenly interested in French art and in any opportunities to acquire examples of it, was soon in conflict not only with the Wehrmacht, but with the German embassy in Paris.

Beginning with the French defeat in June 1940, the Reichs-marschall tried to extend his influence to Rosenberg's ERR. He was aware that doing so would greatly increase his chances of getting at the artistic treasures waiting to be plundered in the occupied countries.

The ERR, with offices at the Hotel Commodore at 12, boulevard Haussmann, had been created on July 1940 and was charged with organizing seizures of libraries and archives within the occupied countries as part of its mission to "battle Judaism and Freemasonry." As such, it could not at first pretend that its powers included the confiscation of works of art. That mandate did not come until October 1940, at which point it found itself in direct competition with the embassy's diplomatic services.[1]

In fact, on June 30, 1940, before the creation of the ERR, a note signed by General Wilhelm Keitel, German army chief of staff in Berlin, to General von Boeckelberg, German military commander of the city of Paris, specifies that "the Führer, in response to a report from the Ministry of Foreign Affairs, gave an order that, excluding those belonging to the French State, all art objects and historic documents belonging to individuals, and Jews in particular, are to be put into safekeeping." Rather than appropriating them, German forces were to place these objects under the supervision of the German embassy, in anticipation of peace treaty negotiations, at which point their fate would be finally determined.[2]

Between July and September, Ambassador Otto Abetz and his staff organized a rapid series of confiscations: In July 1940, the contents of a number of galleries belonging to Jews, such as the one owned by antiques dealer Jacques Seligmann, on the Place Vendôme, were seized; on August 11, the original copies of the Treaty of Versailles and Saint-Germain-en-Laye were seized at

Langeais, and the following day a number of works at the library of the Ministry of Foreign Affairs met the same fate; on September 6, Maurice de Rothschild's mansion was searched and a number of his works of art seized.

Like many other Nazis who frequented cultural circles, Ambassador Abetz had lived in France before the war and was well acquainted with the country, its right-wing circles, and its literary and artistic centers. He had even married a Frenchwoman, the daughter of the well-known journalist Jean Luchaire. A journalist and the organizer of the French-German Committee before the war, Abetz was accused of espionage and expelled from the country in July 1939. According to Colonel Paillole, who worked in the French counterespionage division during the 1930s, Abetz provided financial subsidies to pro-German magazines and newspapers.

After he had returned to France as a victor in June 1940, his contacts and his familiarity with the French system made Abetz's duties as a diplomat, propagandist, and "chief confiscator" of artwork that much easier. Still, it wasn't long before his branch ran up against the office of the German army assigned to protect works of art. This branch was known as the Kunstschutz, and led by Count Franz Wolff-Metternich, a former art history professor at the University of Cologne. Formed on May 11, 1940, during the military offensive in France, the Kunstschutz's duties included compiling a list of artworks located in the war zone and protecting them in the name of the army of occupation and in conformity with international agreements. The Kunstschutz's methods were therefore less crude than those of the other agencies. Metternich did not confiscate; he contented himself with verifying the inventories and collections. He would occasionally even stand up against looting; he even warned curators at French museums of impromptu raids by the German embassy and the ERR.

Beginning in mid-August 1940, Ambassador Abetz conceived of the idea of official pillaging. He suggested to Foreign Affairs Minister von Ribbentrop that he take several works into the possession of the

Reich as "prepayment and advance for war reparations." Abetz chose a number of paintings, some of which he hung in the German embassy on the Rue de Lille. Others were sent to von Ribbentrop's home in Berlin and to the ministy's offices. And still others, deemed examples of "savage expressionism," would be kept at the embassy before being sold or used as exchange pieces on the Paris art market. These "prepayments" had very little to do with any "supervision" or safekeeping.

But the art-plundering schemes of the ambassador and the diplomatic corps in Paris suffered a setback. On September 17, 1940, the same General Keitel transmitted an order from the Führer to General Walter von Brauchitsch, the German military commander of Occupied France, declaring that all release of goods or assets to the French State, or to individuals, following the declaration of war on September 1, 1939, was henceforth to be considered null and void. The order gave the ERR, for the first time, instructions and powers involving "the right to confiscate precious objects and to transport them to Germany."[3] The order had direct bearing on most of the art owned by Jews who had temporarily "donated" their art collections to the French government to protect them. The nature of the ERR's mission had therefore changed in a matter of months. As we have seen, in the beginning the ERR limited itself to confiscating libraries belonging to political opponents, such as the Turgenev Library and the Polish Library, or to Freemasons, such as those of the Grand Lodge of France and the Grand Orient of France. Financed by the Nazi Party, the ERR's early confiscations benefited the Hochschule, the training school for the Party's administrators. But beginning that September, the ERR's new responsibilities soon gave it a monopoly over the confiscation of art and other cultural properties within occupied France.

The first rival ousted from the field of confiscation was the Wehrmacht. Metternich was little more than a non-Nazi art historian with a specialty in Gothic art, and the Kunstschutz, a branch of the army with as-yet-undefined powers, was soon accorded only conservation tasks.

Tensions between the ERR and the embassy, on the other hand, began to escalate. They exploded in October 1940, when personnel from the ERR raided the warehouse of the Schenker Transport company and impounded two hundred crates of confiscated art the embassy had put there for transport to Germany. Ambassador Abetz was faced with a fait accompli; from that point on, the ERR dominated art confiscation in France.

Goering started to use the ERR for his own ends early in the fall of 1940. His power and prestige were such that he could impose his will on any number of government branches, even those that didn't fall under his direct command. Moreover, he had private trains, Luftwaffe personnel, and valuable logistical advantages that he could place at the ERR's disposal.

The final administrative coup was delivered by Reichsmarschall Goering himself. In an order dated November 5, he extended the duties of the ERR to include the confiscation of art collections owned by Jews in the Occupied Zone, and therefore deemed "without owner."

Goering didn't bother with the ERR's governing body, which was in Berlin; he dealt only with its operatives in Paris, and in particular with its first director, Baron Kurt von Behr, who served as adjunct and then was named to oversee ERR operations in France. Von Behr very soon established close contact with the Reichsmarschall. Goering was also able to enlist the art historian Dr. Bruno Lohse as an adviser and agent for his private collection by offering him commissions. The art dealer Walter Andreas Hofer, curator of Goering's collection at Carinhall before the war, had become his agent in France and throughout Europe, while Gisela Limberger, his librarian and personal secretary, coordinated his purchases.

Goering had access to the rooms at the Jeu de Paume that became the main repository for confiscated art in Paris. Between November 3, 1940, and November 27, 1942, he visited the museum no fewer than twenty times. Further proof of the central role art

played in the life of the extremely busy Reichsmarschall was that one of these visits took place on July 9, 1941, a mere three weeks before he signed the order given to Reinhard Heydrich, chief of the Reich's security police, to find a "final solution" to the Jewish question. And one week after signing the order, Goering took advantage of a little spare time to visit the Jeu de Paume and select some more paintings for Carinhall.

Generally the Reichsmarschall gave only a few hours' warning before one of his visits, barely enough time for the staff to arrange a display of the most recently impounded works, so that he could choose the pieces he wanted to bring back with him. Von Behr, and most especially Hofer, would pass along the Reichsmarschall's list to the ERR, after which Jacques Beltrand, a French engraver well known in Paris art circles, who served as Goering's official art expert, examined each work on the list. Beltrand always went to great pains to provide favorable evaluations, since many of the works Goering had chosen would be used in exchanges for other works. For example, five tapestries depicting scenes from the life of Scipio were evaluated at 2.8 million francs, an amount that significantly enhanced Goering's purchasing or bartering power. On the other hand, Beltrand's evaluations of modern pieces, though they were then very much in demand on the Parisian market, follows Nazi aesthetics guidelines and places them below their market value. Two paintings by Matisse, one by Modigliani, and one by Renoir, for example, were valued at a mere 100,000 francs. Still better: seven paintings, including one by Léger, two by Braque, two Matisses, one Picasso, and one by de Chirico were valued at 80,000 francs.[4] The ever-agreeable Hofer always questioned Beltrand's estimates, sometimes reducing them by 50 percent in order to obtain more modern paintings to exchange.

The paintings Goering chose were then loaded onto trucks and taken to one of his four private trains. The official arrangement called for Goering to purchase the works from the ERR and to place the money in an account in the name of the French government. In

reality, however, Goering never paid a single cent, and it is esti-
mated that he acquired as many as one thousand paintings and
other art objects in this manner.

Another link in the chain of contradictory commands that char-
acterized Nazi bureaucracy came in the form of an order directly
from Hitler, dated November 18, 1940, in which he demanded that
all confiscated art be transported to Germany and placed at his per-
sonal disposal. The entire inventory of impounded art was from
then on to be given to Hans Posse, the director of the Dresden Mu-
seum and of the museum planned for Linz. But this order was never
executed since Goering had a certain interest in seeing it remanded.

So passionate was the Reichsmarschall about art that he always
found time and resources, in the middle of war, to devote to embell-
ishing his collection at Carinhall. In a letter addressed to his "dear
party comrade" Alfred Rosenberg, dated November 21, 1940, Go-
ering, who wanted to manipulate Rosenberg's special task force for
his own purposes, rejoices in the decision to concentrate all confis-
cated art under the ERR command. He notes, though, that the For-
eign Ministry claims that mission for itself. He also notes that
Goebbels has been put in charge of preparing the Kümmel Report,
which provided the justification for recuperating cultural artifacts
"stolen" from Germany. But Goering promises Rosenberg he will
support the work of his staff to the full extent of his powers and
place the Luftwaffe at the ERR's disposal. He also notes the impor-
tant role he himself had played in uncovering "well-camouflaged
caches" of art, and in paying informants. "At the current moment,"
Goering adds," thanks to acquisitions and exchanges, I possess per-
haps the most important private collection in Germany, if not all of
Europe. . . . To complete my collection, I had also planned to buy a
small number of works taken from confiscated Jewish collections."
He ends by reassuring his party comrade Rosenberg that, in spite of
all the artwork he has taken from the ERR's Paris depot, "there still
remains a very large number of objects than can be used to decorate
party buildings, the State, and to fill our museums."[5]

The Vichy government had naturally tried to oppose these confiscations—while at the same time taking part in them. Starting in summer 1940, laws governing fleeing nationals were passed that justified seizing some Jewish property as well as property belonging to French Resistance fighters who had left the country. In October 1940 the Service de Contrôle des Administrateurs Provisoires (SCAP, or Provisional Administrators Supervisory Board) was created by Vichy to confiscate and oversee the Aryanization of Jewish businesses. SCAP was to limit itself to sequestering buildings belonging to Jewish art dealers and collectors. When it tried to extend its powers to include gallery stocks and collections, it bumped up against the German looting organizations. On March 29, 1941, at the insistence of the Germans, the GCJA, or General Commissariat on Jewish Affairs, was created, headed first by Xavier Vallat and then by Louis Darquier de Pellepoix. One of the GCJA's first acts was an attempt to recuperate the paintings and art collections already confiscated from French Jews by the Germans. The GCJA met with no success in the Occupied Zone, where the best it could hope for was collaborating with the ERR and taking its cut. In any case, the largest and most significant collections had already been impounded and dispatched by the Germans even before the GCJA had been created, and the ERR's French collaborators profited very little from this type of partnership. Other branches of the Vichy government, from the Direction des Domaines (State Property Department) to the very active Direction des Musées de France (French Museums Administration)—which had often in fact actually and actively protected the private objects placed under its protection—were also keenly interested in what happened to Jewish collections. But again, confronted by German confiscation, all they could do was to make feeble protests to the Vichy government or to the Wehrmacht.[6]

Launched by the ideologue Alfred Rosenberg, protected by Reichsmarschall Goering himself, the ERR's powers—like other cogs in the great combine of the Final Solution—grew beyond the control of ordinary institutions. The ERR's response to the French

government's protests and the justification behind its systematic looting of collections owned by Jews and Freemasons were both clearly set forth in a "declaration of principles" dated November 3, 1941, and written by Gerhard Utikal, the head of the ERR in Berlin. Its logic is a pearl of Nazi ideology. This document, addressed to the Werhmacht chief of general services, begins by drawing a distinction between what is French and what is supposedly not: "No work of art belonging to the French state or to non-Jewish French individuals has been confiscated." The declaration goes on to inform us where true guilt lies: "The war against the Great German Reich was incited by worldwide Jewry and Freemasonry, which . . . have provoked various states and European peoples into waging war against Germany."

Then Germany is presented as the liberator of the French people: "With the conquest of France, the German army has released the French state and the French people from the influence of international Jewry." And again a distinction between what is French and what is supposedly not is drawn: "The armistice with the French state and people does not extend to Jews in France . . . who are to be considered 'a state within the state' and permanent enemies of the German Reich." And finally, the impounding of art collections are justified: "German reprisals against Jews are based on people's rights . . . Jews have since ancient times, and following the dictates of Jewish law set forth in the Talmud, applied the principle that all non-Jews be considered cattle and therefore without rights, and that non-Jewish property be considered abandoned and ownerless." The Nazis, in their outrageous depiction of Jews and Jewish law, had found a way of justifying confiscation.

Of all French Jews, the Rothschild family held, perhaps, the art most coveted by Hitler and Goering.[7]

PART II

Anatomy of a Pillage

4

The Exemplary Looting of the
Rothschild Collections

In the hierarchy of precious objects to be confiscated on French soil, the paintings belonging to the French branch of the Rothschild family stood, from the Nazi perspective, at the very top. From Vermeer and Hals to Gainsborough to Velázquez, the Rothschilds' collections represented the most prestigious works of art for the Nazi dignitaries.

Ever since the arrival of James, the founder of the French branch, in the early 1800s to Paris, the Rothschilds were, then as now, an aristocratic dynasty, a network formed by both familial and banking connections, possessing vast art collections, and generous donators to French museums. The seat of the Rothschild Bank was

on Rue Laffitte, formerly the center of the art galleries. Not far from there, on Boulevard Haussmann, was the Commodore Hotel, the headquarters of the ERR. There were three branches of the Rothschild family in France, and each owned buildings located between the Place de la Concorde and the Élysée Palace: Baron Édouard, director of the bank and head of the family, lived with his family at 2, rue Saint Florentin, in a residence once owned by Talleyrand, and bought and refurbished in 1860 by Édouard's father, Baron Alphonse. Baron Robert, president of the Israelite Consistory, lived at 23, avenue de Marigny. And Baron Edmund resided on the Rue du Faubourg Saint-Honoré, where the American embassy is now located.

The immense Rothschild fortune came not only from banking but from French and European railroads and Russian oil. Among the jewels in its crown were the Château Lafite vineyards in the Bordeaux region and several racing stables. As for the family's art collection, according to the inventory completed by experts from the ERR at the time of its confiscation, it consisted of at least 5,009 works. Of the individual collections in this storied ensemble, Baron Édouard's was far and away the largest, and included such pieces as Vermeer's *Astronomer* (*see* insert A1); Boucher's *Portrait of the Marquise de Pompadour* (*see* insert C9); Memling's *Virgin and Child* (*see* insert A9); Frans Hals's *Portrait of Isabella Coymans* (*see* insert A8); *Phillip II, King of Spain*, then thought to be a Velázquez; and Raphael's *Man with a Red Hat*. To these we must add Van Dyck's *Portrait of Henriette of France as a Child*, *Woman with a Cat* by a painter of the Flemish School (*see* insert A9), several works by Rubens, a Titian, and two Watteaus: the *Standing Guitar Player* and *Minuet*. There were also two portraits from the "Soria Children" series by Goya (*see* insert A10–11), several works by Joshua Reynolds, and the famous portrait of James's wife, Baroness Betty de Rothschild, by Ingres.[1]

Though not as large, Baron Robert's collection was no less important, boasting a precious collection of Renaissance enamels (*see*

insert A8) and a number of world-class pieces: a rarely seen triptych by Jan Van Eyck, *Virgin and Child, with Saints and Donor* (to be found today at the Frick Collection in New York); Rembrandt's *The Standard Bearer*, which Baron James had bought at Christie's in London in 1840; a *Fête Champêtre* by Fragonard; a *Portrait of Lady Alston* by Gainsborough; and some modern works, including a Braque still life, several works by Derain, and one by Van Dongen.

Maurice de Rothschild possessed works of equal value: a Rembrandt, several Fragonards, and most especially a large number of Flemish and Dutch works, which were among those most coveted by Hitler and Goering, admirers as they were of artists from Northern Europe.

To this stellar collection of art we must add several libraries of old books. Painstakingly assembled, this collection comprised thousands of manuscripts, incunabulae, and precious bindings, and a rich collection of Judaica.

At the very beginning of the war, what the Rothschilds most feared were bombardments in Paris, for at that point no one imagined the plundering that would occur. Their first reflex was therefore to pack up all of the collections carefully and send them to one of several châteaus in the countryside. On the advice of his cousin the Marquise de Noailles, Robert de Rothschild decided to send part of his collection to a farm in the Lot region in southwestern France belonging to his friend Maurice Aguillon. He placed his most valuable treasure, the Van Eyck triptych, in the hands of Eduardo Propper de Callejón, the attaché at the Spanish embassy, who was a family friend.[2]

Another part of the Rothschilds' collections was placed under the protection of the director of the French national museums, who had the paintings stored in the Louvre and ensured their safety by forging documents stating that they had been donations made prior to the declaration of war.

Then their owners dispersed. Mindful of the German army's advance, Édouard de Rothschild left with his family for the United

States. Robert left not long after him, while Maurice went to
Canada. Henri de Rothschild, a cousin from the British branch of
the family, and the owner of a very handsome collection of Chardins,
took refuge in Switzerland and Portugal. Wary of the German army
on the Continent, he had his Chardins safely transported from
Switzerland to the city of Bath in England. All four—Édouard,
Robert, Maurice, and Henri—were stripped of their French citizen-
ship and their goods were confiscated, as was provided for in Vichy's
emigrant laws designed to prevent potential backers of de Gaulle
and other Resistants from leaving the country. As for the Rothschild
children, they found themselves, like other French citizens, called
up for active service and sent to the front in 1939. Alain and Élie,
Robert's sons, departed on horseback to join up with a cavalry regi-
ment. They were both captured by the Germans in the Ardennes in
May 1940, and spent five years as prisoners of war in Germany.

The Vichy government announced the seizure of the Roth-
schilds' assets with great fanfare, but the confiscation took place in
the Occupied Zone and it was the Germans who benefited. The
family's properties in the Free Zone were in a somewhat paradoxi-
cal position: In theory they were under sequester by the French
State, but in many cases they were also under the protection of the
Louvre. Among the Rothschilds' real estate, only the villa at Cannes
was put up for auction, along with all of its contents, by Vichy in
1942. Liliane de Rothschild, accompanied by Charles de Gramont,
attended the sale and salvaged family property by buying back In-
gres's portrait of Baron Alphonse.

One of the ERR's first objectives, naturally, was to get its hands on
the Rothschilds' fabulous art holdings. In the autumn of 1940, faced
with the dispersal of these works—some being moved to country es-
tates, others placed in bank vaults, still others placed in the Louvre's
warehouses in the countryside—the Germans began to employ ex-
ceptional methods to locate them. The Parisian residences were
searched first, but most of the paintings and artworks had already
been moved and there was little to be found. Hunting down Édouard

de Rothchild's collection, ERR officials went to the family châteaus at Ferrières and at Reux, located in the Calvados region in Normandy. To find Baron Robert's paintings, the Nazis went to his château of La Versine, and for those of Baron Maurice, to the château of Armanvilliers, located in Seine-et-Marne. Then they undertook a systematic, vault-by-vault inventory of art that had been placed in banks. Hence six crates filled with jewels, sixteenth-century objects, fifteenth-century miniatures, and manuscripts belonging to Maurice were found in the safe deposit boxes at the Bank of Paris, and the Netherlands.[3]

Each step was undertaken with a sometimes stunning bureaucratic rigor that would actually contribute to the art's preservation. In the Bank of Paris and the Netherlands, a Lieutenant Mewe, serving with the Devisenschutz kommando, contributed the following report: "Six crates belonging to Maurice de Rothschild were found. They were opened, and after their contents had been inventoried, they were sealed up again." Seals were affixed on these crates and then they were placed in a vault under the supervision of the Devisenschutz kommando, in the presence of a certain Peyrastre: a Vichy official representing the state property department (in the name of which Peyrastre had protested that these treasuries did not belong to Maurice de Rothschild anymore, but to France).

The Germans also lost no time in tracking down the precise location of the works placed in safekeeping in the Louvre's depots outside of Paris. ERR officials had rapidly seen through the ruse.

By early February 1941, the ERR had succeeded in assembling works from most of the Rothschild collections at the Jeu de Paume, and had finished a preliminary inventory. Nearly the entirety of the holdings—still packed in the crates in which the Germans had found them—were sent to Germany on one of Goering's personal trains on February 3, 1941. They would be divided as follows: nineteen crates numbered from H1 to H19 were to go to Hitler, while those numbered G1 to G23 would go to Goering. These two lots contained the greatest treasures from the Rothschild collections. Crate H13, for example, contained Vermeer's *Astronomer*, and H6

contained Édouard de Rothschild's Frans Hals, while H3 contained Boucher's *Portrait of the Marquise de Pompadour*. Reflecting the meticulousness that characterized this gigantic act of plunder, Baron Kurt von Behr, chief of the ERR in Paris, and in charge of the convoy taking the crates to Germany, wrote, "Unfortunately, it was not possible to find the marble tops corresponding to the antique furniture." He apologized to his two masters for this. The division of the spoils and the H and G stamping on the crates were done according to the Reichsmarschall's express orders. The Rothschild collections were famous, too famous, and Goering knew that he would have to cede the best part of them to the Führer and his Linz museum before helping himself to his share.[4]

The Reichsmarschall had to content himself with second choices: Cranach's *Allegory of Virtue*, two works by Isaac van Ostade, a portrait by a painter from the Holbein school, Fragonard's *Young Girl with a Chinese Statuette*, and a pen-and-ink drawing by Lucas van Leyden. Goering's convoy also contained four crates filled with objects he had himself chosen at the November 1940 exposition at the Jeu de Paume. They arrived in Kurfürst on February 12. In March of the same year, they were transferred by the KriminalPolizei to Neuschwanstein, the most famous of the castles built by Ludwig II of Bavaria and the most important of the ERR depots.

The final confiscation of the Rothschild collections took place in July 1941. This time, almost none of the works in provincial storehouses were spared. At the château of Ferrières, for example, the only treasures not taken were some sixteenth- and seventeenth-century tapestries, and this was due to simple oversight on the part of the ERR. The château's staff had covered the tapestries with gray cloth to protect them from sunlight, making them look like supports for paintings that had already been taken. They stayed at Ferrières until the end of the war. At the château of La Versine, owned by Robert de Rothschild, some of the furniture and clocks were also saved; they had been hidden in a farm-equipment building on the property. Unfortunately, however, they were to be damaged by Allied

bombing in 1944. Last, most of the works belonging to Maurice, which had been put in the Louvre's warehouse in the château de la Treyne in the Free Zone, also escaped the ERR's attention.

The family's great wine vintages were no less sought after than their paintings. At the Château Lafite, which was occupied by the Germans, Gaby Faux, the vineyard's manager, had had the foresight to transfer ownership of Baron Robert's wine reserves among those of his sons, Alain and Élie, who were both French POWs and whose possessions were, in theory, not subject to forfeiture. The great vintages therefore survived the war intact. The Château Lafite also housed the family's collection of Jewish religious objects; they were sealed up in a small room in the castle and they, too, survived.

Paradoxically, it was in Paris that precious objects belonging to the Rothschilds eluded the Nazi plundering with greatest success, despite the fact that it was there that ERR officials had been the most thorough. Baron Robert was one of the few to predict the German Occupation. He'd had a secret room built next to the laundry room in the basement of his home on the Avenue de Marigny before the First World War. After Robert's departure for the United States, his head butler had placed a number of statues, clocks, and bronzes in this secret room, along with buckets of lime to absorb dampness. The room was then sealed off and the wall whitewashed with lime to erase any traces, then hidden behind enormous linen armoires. The Luftwaffe officers who occupied the residence during the entirety of the war never guessed that it contained hidden treasures.

A General Hanesse, chief of staff of the Luftwaffe and a close associate of Goering's, for whom he arranged the purchase of art, lived in the residence and frequently hosted receptions for high Nazi officials and French sympathizers. He didn't fully realize that the precious objects that had given such pomp to his gala affairs were beginning to disappear, one by one. This was the work of

Madeleine Parnin, the Rothschild's linen maid, who had stayed on to serve the German occupiers. Parnin succeeded in rescuing table-cloths and armorial bedspreads by taking them out of circulation and replacing them with ordinary linen. When General Hanesse expressed his surprise, Parnin explained to him that the linen had become so worn that she had torn it up to use as rags. Félix Pacaut, the head butler, who had stayed on working with the Germans in order to protect it for the Rothschilds, to the occupiers, devised a clever stratagem that involved his cousin, a fireman: After pretending that a fire had started in the fireplace, he called his cousin. While part of the fire brigade, aided by the Germans, were trying to put out the fire, the other firemen were carrying the Rothschild family's silver out the back door on the Rue du Cirque. The silver spent the rest of the Occupation hidden somewhere in Paris.

Not all the Rothschilds' servants were as loyal. One gardener alerted the Germans that there was a cache of valuables buried somewhere on the property. The trouble was, he didn't know exactly where it was buried, and the Germans dug enormous holes in the garden without ever finding anything.

In any case, there wasn't much left to find. By the end of 1941, most of the Rothschilds' collections were sitting in the Führerbau's air-raid shelters in Munich, or in the ERR's warehouse in the Bavarian castle of Neuschwanstein; the rest was in the Château de la Treyne, the Louvre's warehouse in the Free Zone. Some of the crates in Munich and Neuschwanstein were never seen opened because of a lack of time and staff. When the Allies began intensive bombing raids in 1944, most of the crates were transferred to abandoned salt mines near Alt Aussee in Austria. That was where they were eventually found by the American army.

The Germans' methodical plundering of the Rothschilds' enormous collections served as a model of its kind. One might argue

that at the very least it kept the collections together, preventing them from being put up for auction and scattered by Vichy. The true reason for the efficiency was that these masterpieces could only have been intended for Hitler and Goering personally. Selling them off piece by piece would have been unthinkable. Such was not, of course, the case with other collections. Still, because the collections had been so exhaustively identified and tracked by the Germans, the Allied services assigned with recovery had no trouble locating them. The process began soon after the Normandy landing. Eventually, most of the Rothschilds' exceptional works were brought back to France, unharmed.

5

The Paul Rosenberg Gallery:
Modern and "Degenerate"
Art for Sale

When war broke out on September 3, 1939, Paul Rosenberg, like many other French citizens, was on vacation with his wife and children. They had gone to the city of Tours, located in the Loire Valley, not too far from Paris, and a popular summer retreat. War persuaded Rosenberg to prolong his stay in Tours indefinitely, and to close his Parisian gallery. Fifty-seven years of age, a veteran of the First World War, Rosenberg nonetheless hoped he wouldn't have to flee the country until he could evaluate where events were leading. Fearing that Paris might be bombed, he began transferring

his paintings to Tours. He also continued to run his business and to make deals all across France.

Rosenberg, an energetic man who comported himself with studied elegance, was one of the most important art dealers of nineteenth- and twentieth-century art in France. His gallery was located on the Rue de La Boétie, the nerve center in modern French art throughout the 1920s and 1930s. His father had emigrated from Slovakia in 1878, and gone into the art and antiques business in Paris, dealing in works by Cézanne, Degas, Monet, and Pissarro. Paul and his brother Léonce followed in their father's footsteps, but Paul proved particularly enterprising and tenacious. He decided to go his own way in 1908, establishing his own accounts and pursuing a more ambitious course of action.

By the end of the 1930s, an inventory of his holdings revealed a shrewd mix of paintings by artists as prestigious as Géricault, Ingres, Delacroix, Courbet, Cézanne, Manet, Degas, Monet, Renoir, and Lautrec, as well as a considerable number of modern works by Picasso, Braque, the Douanier Rousseau, Bonnard, Marie Laurencin, Modigliani, and Matisse. His clientele was equally prestigious and wide-ranging: Viscount Charles de Noailles; Count Étienne de Beaumont, patron of the Ballets russes; the Swiss collector Oskar Reinhardt; the difficult Dr. Albert Barnes from Pennsylvania, and Mrs. Arthur Sachs of New York, who bought Manet's *Plum* from him in 1924; Mrs. Chester Beatty of London; the wife of the railroad magnate Averell Harriman, who had acquired Picasso's *Woman with Fan* in 1905, which Rosenberg had bought from Gertrude Stein; and Mrs. Etta Cone, a friend of Gertrude and Leo Stein's and herself a collector of modern art— the Cone Collection is housed today at the Baltimore Museum of Art. There were also Mrs. Mary Callery, the French Rothschilds, and the discreet Dr. G. F. Reber, a Swiss collector who ended up possessing no fewer than eighty Picassos—it was to Reber that Rosenberg had sold one of the two versions of the famous *Three Musicians*, dating from 1921, the second eventually being sold to

another of Paul Rosenberg's most loyal clients, the Museum of Modern Art in New York.

In 1921, the writer and critic André Salmon, one of Picasso's oldest friends from his Montmartre days (and one of the two supposed inventors of the name given to the "Bateau-Lavoir"),[1] commented that Paul Rosenberg's ambition was to found a whole new dynasty of French art dealers: "It was for his son that the dealer Paul Rosenberg, ever the good father, bought those paintings by Picasso, André Lhôte, Marie Laurencin. He himself lives off the dead Cézanne, Renoir, Corot, and Lautrec."[2]

Rosenberg's straightforward approach and steep prices shocked Parisian art circles and made him the subject of savage criticism. When asked during an interview about the cost of the paintings he sold and his decision to sell for very high prices, Rosenberg replied, "It hurts no one. And it helps the painters." Emphasizing that it was demand that gave art its price, he added, "As for me, a painting is beautiful when it sells; in fact, I don't sell; it is my clients who buy."[3] Rosenberg never missed a single auction at Hôtel Drouot, the French State auction house, and when he saw a painting he coveted his reaction was physical. "I often went to Drouot's with him," recalled his colleague and friend Alfred Daber, "and when he saw a major work that he wanted more than any other, his body would begin to tremble like an impatient child. It would start even before the painting went up on the block, and continue until after he had outbid all competitors and the painting was his and his alone."

Devoted body and soul to his business, Rosenberg was not one to discourage potential buyers, no matter how young. The collector Georges Halphen recounts how, one day in 1936, when he was only twenty-two years old and still a student, he was returning home from class along the Rue de La Boétie when he saw a work by Picasso hanging in the window of the Rosenberg Gallery. The young Halphen was fascinated by it. The work was a "maternity" scene entitled *Mother and Child at the Seashore*, a pastel from Picasso's

Blue Period, showing a woman wrapped in a shawl walking along the seashore with a child, whose right hand clumsily but firmly clutches a portion of the shawl. The woman, who looks straight into the eyes of the spectator, has placed her hand gently and protectively on the shoulder of the child. Not long after he finished the pastel in January 1903, Picasso sold it to Mrs. Besnard, wife of his art supplies dealer, to pay for his ticket home to Barcelona.[4] Georges Halphen went into the gallery and was greeted by Rosenberg himself. "You don't know me," Halphen blurted out without hesitating, "but I must have that painting." Not at all taken aback, the dealer replied, "What a good idea! This piece quite simply won't sell. I showed it to Robert de Rothschild and David David-Weill, but they don't want it. It's yours."

In the gallery's private second-floor showrooms, Halphen discovered with delight works such as Van Gogh's *Self-Portrait with Severed Ear*, *The Man in the Fur Hat*, and *Alyscamps*. Rosenberg did not show him other Van Gogh paintings he had in his possession—*Starry Night*, *The Irises*, or *The Night Café*, which Van Gogh painted in Arles in 1888. Rosenberg later sold it to Stephen C. Clark, the American industrialist and board member of the Museum of Modern Art. During the Occupation, the Van Gogh self-portrait was confiscated by the Nazis, appropriated and sold by Goering, and finally returned to its rightful owner at the end of the war.

The young Halphen was deeply impressed by Rosenberg, whom he found to be an intelligent and refined connoisseur. This might have been because he didn't dissuade a very student-like Halphen from buying the Picasso—or actually, getting his mother to buy it, for 30,000 francs, roughly the cost of a new car then. Over time, Halphen convinced his mother to join the gallery's loyal clientele. In 1938 she bought a Cézanne, and later a portrait of a young woman by Renoir. As to Halphen himself, he put his Picasso in a Louis XIII gold frame he had bought at Drouot's and kept the

painting with him for the duration of the war. He took it to the
South when he went off to join the Resistance, and brought it back
with him when Paris was liberated.[5]

Encouraging young collectors was one of Rosenberg's favorite
pastimes. Art dealer Alfred Daber, who was in his late twenties at
the time, later recalled his routine: "I would visit Paul practically
every day, from 6 to 8:30 in the evening, and we would engage in
long conversations about lofty subjects. He would talk with great
feeling about Christ, the Jew who had founded a new religion, while
I went on about the only thing that interested me at the time, which
was love."

Paul Rosenberg and his elegant gallery, with its beautifully
maintained exposition rooms, tasteful decor, and filtered light,
were admired by colleagues and art critics (*see* inserts A2, A6). One
such critic, Maurice Sachs, sketched a flattering picture of the pro-
prietor:

> His noble bearing was part of his particular genius. It was his way
> of selling, and there was ample proof that it worked. In his win-
> dows, he would exhibit only two Picasso drawings, or two wash
> drawings by Constantin Guys, while in fact his storage rooms
> were overflowing with treasures. You went into Rosenberg's as if
> going into a temple: the deep leather armchairs, the walls covered
> with red silk—all . . . made you feel you were in a first-class mu-
> seum. . . . He knew how to give extraordinary *éclat* to the painters
> under his roof. His knowledge of art was deeper than that of other
> dealers, and his taste therefore more assured.[6]

With his taste, his first-rate eye, social connections, and com-
mercial acuity, Rosenberg became one of the prime dealers on the
Parisian art scene, and his gallery was on the crossroads between
the nineteenth-century and avant-garde art in France during the
period between the wars. He had exclusive contracts with Picasso
(signed in 1918) and with Braque (signed in 1922). Rosenberg de-
voted most of his efforts, and his exhibitions, to proving that strong

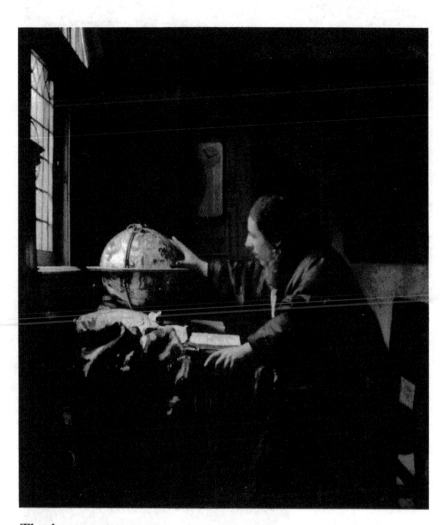

The Astronomer
JAN VERMEER, 1668
Louvre Museum, Paris, formerly Guy de Rothschild Collection
(Photo courtesy of G. de Rothschild)

One of the rooms at the Paul Rosenberg Gallery, 21, rue de La Boétie, Paris, circa 1930. *(Photo courtesy Paul Rosenberg & Co.)*

Paul Rosenberg in his Paris apartment in the 1920's. (Private collection) *(Photo courtesy Paul Rosenberg & Co.)*

Portrait of Gabrielle Diot *(whereabouts unknown)*
EDGAR DEGAS, pastel (61 × 44 cm.), 1890
Paul Rosenberg Collection
(Photo courtesy Paul Rosenberg & Co.)

Standing Nude *(whereabouts unknown)*
PABLO PICASSO–© SPADEM 1995, pastel and charcoal
(110 × 73 cm.), 1923
Paul Rosenberg Collection
(Photo courtesy Paul Rosenberg & Co.)

Woman with Red Bodice, Anemones, and Almond Blossoms
(whereabouts unknown)
HENRI MATISSE-© H. Matisse Estate, oil, 1940
Paul Rosenberg Collection
(Photo courtesy Paul Rosenberg & Co.)

Oriental Woman Seated on Floor *(whereabouts unknown)*
HENRI MATISSE–© H. Matisse Estate, oil (46 × 55 cm.), 1927
Paul Rosenberg Collection
(Photo courtesy Paul Rosenberg & Co.)

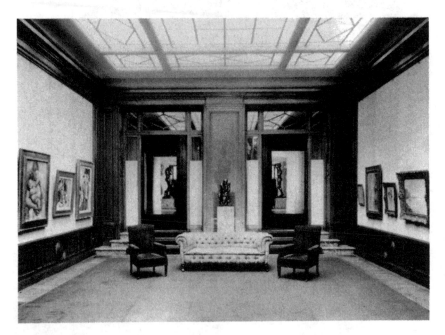

Paul Rosenberg Gallery
21, rue de la Boétie, Paris, circa 1930.
(Photo courtesy Paul Rosenberg & Co.)

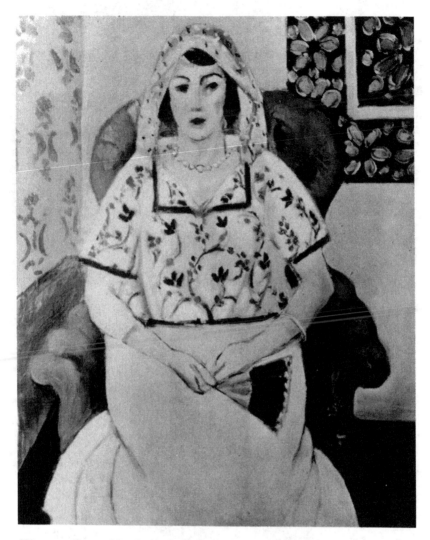

Woman Seated in Armchair *(whereabouts unknown)*
HENRI MATISSE-© H. Matisse Estate, oil (55 × 46 cm.), 1920
Paul Rosenberg Collection
(Photo courtesy Paul Rosenberg & Co.)

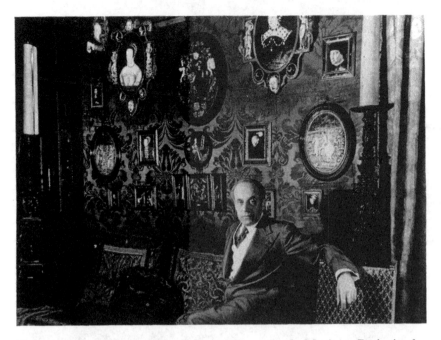

Robert de Rothschild in his salon at 23, avenue de Marigny, Paris, in the late 1930s. Part of his collection of enamels is displayed on the wall behind him.
(Photo courtesy E. and L. de Rothschild)

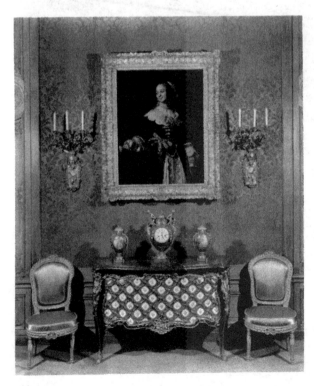

Portrait of Isabella Coymans, Wife of Stephanus Geraerdts, FRANS HALS (1650–52); Commode with Sèvres plaques, by eighteenth century cabinetmaker Bernard Van Riesen Burgh (stamped bvrb) Édouard de Rothschild Collection *(Photo courtesy G. de Rothschild)*

Above, left to right: **Surprise Entrance**, GABRIEL METSÚ (1630–67), **Woman with Cat**, Flemish School (1540), **Interior**, PIETER DE HOOCH (1629–83). *Below, left to right:* **Young Woman Drinking**, TER BORCH (1617–81), **The Violinist**, GÉRARD DOU (1635–75), **The Astronomer**, JAN VERMEER (1632–75), **Woman with a Peach**, FRANS VON MIEIRIS, THE ELDER (1635–81), **Virgin and Child**, HANS MEMLING (1433–94).
Édouard de Rothschild Collection
(Photo courtesy G. de Rothschild)

Child of the Soria Family
Francisco de Goya (112 × 80 cm.), 1804–06
Édouard de Rothschild Collection
(Photo courtesy G. de Rothschild)

Clara de Soria
FRANCISCO DE GOYA (112 × 80 cm.), 1804–06
Édouard de Rothschild Collection
(Photo courtesy G. de Rothschild)

La Goulue with Her Partner (Pause before the Waltz) *(whereabouts unknown)*
HENRI DE TOULOUSE-LAUTREC (80 × 65 cm.), 1891–92
Josse Bernheim-Jeune Collection
(Photo courtesy Bernheim-Jeune)

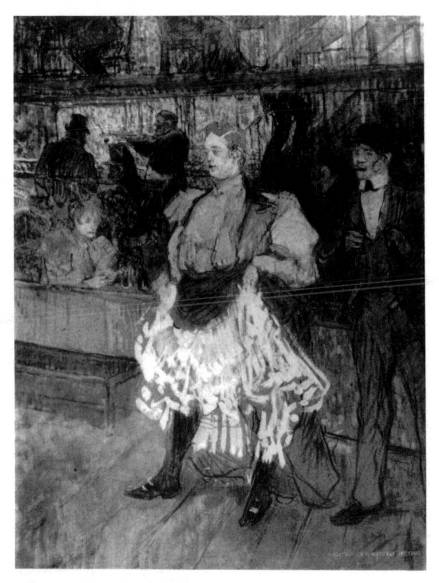

La Goulue: Ready for the Quadrille, or **The Bal at the Moulin Rouge** *(whereabouts unknown)*
HENRI DE TOULOUSE-LAUTREC (80 × 65 cm.), 1891–92
Josse Bernheim-Jeune Collection
(Photo courtesy Bernheim-Jeune)

Furnished Room, or **The Letter** *(whereabouts unknown)*
HENRI DE TOULOUSE-LAUTREC (48 × 54 cm.), 1890
Josse Bernheim-Jeune Collection
(Photo courtesy Bernheim-Jeune)

Almonds *(whereabouts unknown)*
ÉDOUARD MANET, oil on canvas (21 × 26 cm.), 1869–71
Josse Bernheim-Jeune Collection
(Photo courtesy Bernheim-Jeune)

Roses and Petals *(whereabouts unknown)*
ÉDOUARD MANET, oil on canvas (15 × 22 cm.), 1882
Josse Bernheim-Jeune Collection
(Photo courtesy Bernheim-Jeune)

Jar of Pickles *(whereabouts unknown)*
ÉDOUARD MANEt, oil on canvas (33 × 25 cm.), 1880
Josse Bernheim-Jeune Collection
(Photo courtesy Bernheim-Jeune)

connections existed between the French art of the past and the innovators of the twentieth century. One retrospective that received wide attention in 1925 involved the *Major Influences of Nineteenth-Century Art, from Ingres to Cézanne,* and featured works by Van Gogh and Renoir. One critic recalled that a favorite game among those who attended the exhibition was asking each other which painting out of the fifteen on exhibit one would most like to have in one's home.[7] The same year, another audacious exhibition went further in its bridge-building. Called *Fifty Years of French Painting, 1875 to 1925,* it began with the landscape painter Corot and the Realist Courbet, and even included Honoré Daumier, best known for his vitriolic caricatures of contemporary politicians. One of the Rosenberg Gallery's last important prewar exhibitions was the *Cézanne Centenary,* which opened in February 1939.

Alfred Daber recalls how Rosenberg's shows attracted up to seven hundred visitors a day. Today, some seventy years after he first met Rosenberg in 1925, his admiration for the dealer's capacity to impose his convictions about art remains undiminished:

> I was thrilled to find a man so passionate about art that he thought of mounting shows dedicated to Picasso or Ingres and setting them up as if they were a High Mass. He also put on very handsome exhibits of nineteenth-century painting—Corot, Manet, Lautrec. . . . The paintings always had gorgeous solid frames that were both sober and sumptuous. For the two painters on whom he had staked the most, Picasso and Braque, he organized wonderful openings animated by his profound conviction of their greatness. He was almost tyrannical about that.[8]

The avant garde was of course far from being accepted by everyone. In fact, the gulf between works by the "moderns" and those by the traditional French "masters" of the seventeenth and eighteenth centuries seemed an impossible one to bridge. Many admirers of Old Masters, as well as antique dealers, viewed art as a form of interior decoration; they remained obstinately far from

modern painting. Moreover, a number of them thought dimly of Rosenberg's methods. Henri Bénézit, an inside observer, recognized what Rosenberg was up against: "For a long time, collectors thought of paintings simply as ornaments. Fragonard or Watteau, for example, were their ideals." Then, taking the side of the moderns, Bénézit adds, "Boucher is lintel art." In the 1930s, fully aware of the climate, Rosenberg organized a show entitled *Modern Painting and Antique Furniture*. The idea was to promote the reputation of the painters he'd taken under his wing by hanging their work in rooms furnished with classical furniture—to suggest to visitors that the avant garde could have a place in traditional bourgeois interiors.

At the end of the First World War, Paris was the hub of the art world. The city was "the queen of the arts," and the center for the sale of art. "London and New York simply didn't exist," Alfred Daber recalls. Ambroise Vollard, a dealer in Impressionist and post-Impressionist works, followed Paris's growing dominance from the inside, beginning when he opened his first gallery in 1890. In his memoirs he recalls with a mixture of delight and disdain this new art market, characterized by frenzied international transactions, when "a painting sold in Paris could be bought in Berlin and sold again in New York, and then returned to Paris, all within the space of a few weeks."[9] Fearless and headstrong, Étienne Bignou was the first French dealer to fly to New York with his paintings—not long after Charles Lindbergh's 1927 transatlantic flight. This was the era of heroic aviation, when passengers had to be weighed before being allowed to board a plane. Bignou opened a gallery in New York in 1935 and set up a profitable international circuit: He would take his works from Paris to New York, sell what he could, then head to Montreal with the unsold pieces, and finally bring what remained to London, where they were practically given away to canny dealers from the continent looking to buy interesting pieces at cheap prices.[10]

Like most of the other post–World War I French galleries, the Rosenberg Gallery grew dependent on a clientele that was hand-picked, international, and cosmopolitan. Rosenberg himself criss-crossed Europe to keep up with his contacts, conclude deals, or lend works for new exhibitions. He spent one or two months of the year in the United States, visiting New York, Chicago, and the West Coast, keeping up contacts with both private collectors and the new American museums that were hoping to add French paintings—modern or classical—to their growing collections. Early on he learned the importance of coming to America in person, and formed a commercial partnership with Wildenstein and Company of New York in 1923; it lasted until 1930. Four years later he opened the Rosenberg and Helft Gallery in London, going into partnership with his brother-in-law Jacques Helft. In 1935 he seriously considered opening his own gallery in New York, and planned to send his brother Léonce to run it, but eventually abandoned the idea.

In the time-honored Old World tradition, 21, rue de La Boétie was both Rosenberg's home and his business address. Modern paintings were located on the first floor, nineteenth-century works and Old Masters housed on the second. The dealer's mother-in-law lived on the third floor. The Rosenberg family itself was installed on the fourth and fifth floors of the six-story structure (the sixth floor consisted of maids' rooms). Rosenberg was very close to his in-laws—he had married the daughter of a wine merchant named Loévi—and his whole family was bound together by solid ties. These ties would prove critical during the war.

The Rue de La Boétie was sometimes called the "French Florence." It was, in all seriousness, the "thoroughfare wherein the most important American, Swiss, and German collections were born." In his memoirs, Vollard recognized the importance of this row of houses in Paris's 8th arrondissement when admitted, at the

end of the 1930s, that the "rue de La Boétie has become what the rue Laffitte used to be: the incontestable center of the art market. Just as one went to rue Laffitte to go to the exhibitions at the Durand-Ruel gallery, today one goes to see what Paul Rosenberg has on offer."[11]

Across the street from the Rosenberg Gallery was Bignou's gallery. Like Rosenberg, Bignou organized several major shows between the wars. A friend of Matisse and Picasso, Bignou proved enterprising enough to make the odious Dr. Barnes one of his clients. After the death of Barnes's friend and principal broker Paul Guillaume, Bignou took over the task of completing the famous American collector's holdings. During the war, true to form and unintimidated by events, Bignou sold his pieces at healthy prices to the German occupiers.

At the far end of the same street, not far from the Saint-Philippe-du-Roule church, and located on the corner of Rue Miromesnil, Josse Hessel had his gallery. According to Vollard, Hessel was the first dealer in the neighborhood. He had started as a journalist for *Le Temps*, then had become a partner with the Bernheim-Jeune brothers. In 1925, Hessel took charge of the Gangnat estate, a much-anticipated auction at Drouot's. More than 125 Renoirs and numerous Cézannes were going on the block. Energetic and expansive, Hessel was a friend and agent to the painter Édouard Vuillard, and managed Bonnard and other painters from the former "Nabis" movement. He shared, along with Rosenberg, a percentage on the sales of Marie Laurencin's works, and sold works by Monet, Manet, and Modigliani. After the German invasion, Hessel, who was Jewish, lost his gallery and was forced to take refuge on the Côte d'Azur, where he continued to be active until his death (by natural causes) in Cannes in 1942.

The building at 57, rue de La Boétie housed the gallery and apartments of Georges Wildenstein, whose father and grandfather had begun dealing in antiques in the preceding century. In the 1920s, having up to that point focused the family's activities almost

exclusively on Old Masters and nineteenth-century works, Georges Wildenstein began showing an interest in Picasso and other moderns, and eventually opened a small modern art section on the premises leading to Faubourg Saint-Honoré. His art magazine, *Beaux Arts*, while continuing to promote the work of the gallery's traditional protégés, provided a detailed summary of what was going on in the Parisian art world as a whole, and therefore was widely read. Georges Wildenstein was very well known and actively involved in art circles in a number of countries, including those within the Nazi sphere of influence. Even after the French armistice and the German Occupation, Wildenstein seems to have taken advantage of this network to organize a number of deals with the Germans. Then in 1941 he abruptly left for New York, where he remained all through the war.

Paul Guillaume's exhibitions at his gallery at 59, rue de La Boétie were devoted to the works of, among others, de Chirico, Robert Delaunay, Utrillo, Kisling, and Derain. His collection, put together in a matter of a few years and later sold by his widow, Juliette, can be found today at the Orangerie Museum in Paris (the building that mirrors the Jeu de Paume in the Tuileries). When he died in 1934 at the age of forty-two, Guillaume was Albert Barnes's closest adviser, and the Barnes Foundation in Merion, Pennsylvania, owes much to Guillaume's expertise. He introduced the eccentric and finicky Barnes to the work of Henri Rousseau, Modigliani, and Soutine, as well as to the visual and tactile sensuality of African art.

Also inhabiting this same Parisian neighborhood was the dealer Henry Barbazanges, who in 1922 surprised his prosperous and successful neighbors by concluding an agreement with the Renoir heirs that allowed him to purchase several hundred of the painter's works in different dimensions and varied quality directly from Renoir's own studio. Barbazanges had actually proposed to other dealers that they join him in this enormous purchase, but they all passed on the opportunity, having decided that the prices being asked for the works in question were too high. They soon realized

that this had been a tactical mistake, and joined with Barbazanges in negotiating for hundreds of Renoir's most sought-after works. Barbazanges's competitors always recalled with envy and admiration how he had bought Courbet's large and ambitious painting *Studio of a Painter* and sold it to the Louvre.[12]

The little world of the Boétie *quartier* of Paris, inhabited by so many Jewish dealers, would be completely transformed by the Nazi occupation.

Rosenberg's contacts were extremely strong. Thanks to deals he had made with Picasso between 1918 and 1940, Rosenberg and the artist, born the same year, became close friends. Rosenberg was the painter's first established dealer, and Picasso was Rosenberg's second living client (the first being Marie Laurencin). Up to this point, Picasso had been represented by Daniel-Henry Kahnweiler and by Paul's brother Léonce. Both dealers were marginal compared to the solidly established Paul Rosenberg. But Rosenberg's approach to his profession was intensely personal; he and Picasso made each other.

They first met in 1918, in Biarritz, where Picasso was on his honeymoon with his new wife, the Russian dancer Olga Koklova. Rosenberg offered the young artist a guaranteed income, as well as financial arrangements that appealed to him. The first pictorial testimony of their friendship was Picasso's painting, *Portrait of Madame Paul Rosenberg and Her Daughter*, in which the dealer's wife, seated in an austere Louis XIII chair, meets the viewer's gaze. On her knees she holds a chubby baby in a white nightgown, her daughter Micheline; Picasso seems to be reveling in the baby's rounded forms. In a letter that same year, Rosenberg teased Picasso by writing that the painting couldn't be deemed Cubist because Micheline seemed "Roundist."[13] The painting was later impounded by the Nazis, stashed in the Jeu de Paume, seized by Goering as

"Mother and Child," exchanged for other paintings more to the Reichsmarschall's taste, and finally recovered by Rosenberg after the war. A sketch for the work Picasso also did in Biarritz was less lucky. It disappeared after being confiscated and has never been seen again.

Under Rosenberg's approving gaze, Picasso continued to move away from Cubism and toward the more classical style of the "return to order" of the 1920s. The change meant Picasso would gain a solid international clientele that would bring him the renown he continues to enjoy. And thanks to Picasso, Rosenberg was able to enlarge his sphere of influence among patrons of avant-garde art. After the first show of Picasso's work in 1919, the Rosenberg Gallery became a focal point for anyone wanting to follow the development of modernism in the decades before the Second World War.

Not long after they had met, Rosenberg suggested to Picasso that he move to 23, rue de La Boétie, and in October 1918 Picasso and Olga became the Rosenbergs' new neighbors. The Picassos' apartment in this peaceful bourgeois setting, the centerpiece being a spacious living room with fireplace and parquet floors, was a complete change from Picasso's previous house in the working-class suburb of Montrouge. The new neighbors got along famously. Picasso often went to the Rosenbergs and sketched little Micheline, who called the painter "Casso." The pencil drawings of the young girl in a sailor suit, or dressed in white in front of a bench (*Micheline Dressed as a Nurse*), or holding a stuffed rabbit (*Micheline with a Rabbit*), were also impounded by the Nazis and disappeared. Since their two buildings faced each other across a courtyard, Picasso loved standing at the window to his apartment to show Rosenberg what painting he was working on. With the birth of Rosenberg's son Alexandre in 1921, one month following the birth of his own son, Paulo, Picasso went with his patron to the city hall to act as a witness. Rosenberg's wife, Marguerite, advised Olga about maintaining a comfortable domestic life despite her husband's bohemian ways. Rosenberg called

his friend "Pic"; Picasso called him "Rosi." Rosenberg became involved in Picasso's increasingly complex finances, and undertook an inventory of Picasso's possessions when the artist once planned to divorce Olga at the beginning of the 1930s.

During the months that preceded the Second World War, Rosenberg was in constant touch with the art historian Alfred H. Barr, helping to organize a large retrospective of Picasso's work at the Museum of Modern Art and the Art Institute of Chicago, which would bring together more than three hundred works. The show opened in November 1939 when war had already started in Europe. Neither the artist nor the dealer was able to attend the opening, which attracted huge crowds. Events had prevented many of the works from arriving on time from France, including *Portrait of Gertrude Stein*, painted in 1906, which the American writer had loaned to the museums for the occasion.

☐

When war broke out, Picasso, who held a Spanish passport, found himself caught in the crossfire between French and German combatants for the second time in his life. He left Paris for Royan, near Bordeaux. In October 1939, during what is known as the *drôle de guerre*, or Phony War, when even though war was declared nothing seemed to be happening on the front and all were holding their breath, Rosenberg rented a villa in Floirac, across the river from Bordeaux, called Le Castel—two large buildings surrounded by a garden, five miles east of Bordeaux. Despite the circumstances, the Rosenbergs tried to lead a normal life. Alexandre Rosenberg, now nineteen and a student in philosophy and mathematics at the Sorbonne, enrolled in an officers' training program at the University of Bordeaux, while his father threw himself into organizing an exhibit at the city's museum. With an astounding presence of mind and optimism, Rosenberg had just renewed his contract with Matisse to act as his exclusive representative. The earlier contract, from 1936 and

including a clause outlining Rosenberg's right of first refusal, had been nullified by the war. Despite what was happening, Rosenberg went to meet the artist in Nice several times, bringing back paintings. And so it was that in March 1940, Rosenberg was carrying two of Matisse's recent works with him on the train back to Floirac: *Woman with Red Bodice, Anemones, and Almond Blossoms* (*see* insert A5), and the serene *Woman in Black Against Red Background, Sitting in a Louis XIII Chair*. He was in such a hurry that he hadn't had time to photograph them or to assign them inventory numbers. The only photos left were those taken by Matisse himself.

Many of the works in Rosenberg's possession were already housed outside France, and by sheer good luck several dozen of Picasso's works were at the New York and Chicago exhibits. Rosenberg had also sent a number of the major works in his collection to his London gallery. Nonetheless many others remained in Tours and in Paris—in all, more than three hundred, from both his personal collection and from what remained of his professional inventory. There was also his very fine library, containing 1,200 art books and catalogs, several thousand photographic plates of works that he had handled in his Parisian gallery, and all his professional records going back to 1906. All these works were then meticulously inventoried. Rosenberg was helped in his work by his son Alexandre, as well as by his chauffeur and right-hand man Louis Le Gall.

The German army's spring offensive, feared for so long, became a brutal reality during the first good weather of early May 1940. While the Wehrmacht was moving swiftly across France, Rosenberg hurriedly sent certain paintings to a warehouse in Tours, where they were registered under the name of Le Gall's brother-in-law. This proved an astute maneuver, for the works escaped German notice until the end of the war. Deciding that Tours was located too near the front, Rosenberg transferred dozens of paintings to the town of Libourne, near Floirac, and had them put in a vault of the National Bank for Commerce and Industry, where they were to await better times. Among the 162 paintings were Van Gogh's self-

portrait and a rare seascape by Seurat. Also included were two works by Cézanne, *Young Man in a Red Jacket* and *The Harlequin*; two Ingres drawings; several watercolors and drawings by Delacroix; Corot's *Girl with Red Bodice*, along with seven other paintings and drawings by the artist; three paintings by Courbet and a charming study for his *Burial at Ornans*. There was also a small drawing by Géricault; several Monets; paintings by Berthe Morisot; portraits by Renoir, Pisarro, Bonnard, and Vuillard; a Gauguin; a Toulouse-Lautrec; and, of course, works by Picasso and Braque. Fifteen or so works by Matisse were already stored there, such as *Small Blue Dress Before a Mirror* (found today at the Kyoto Museum in Japan), and the two uncataloged paintings that Rosenberg had just brought back from Nice.

Rosenberg urged his friend and protégé Braque to follow his lead and rent a vault in the same bank. Braque thought it was a good idea and did so, placing his own collection in the bank, including Cranach's *Portrait of a Young Girl*. Picasso had already put several of his paintings in Parisian banks.

Those paintings that were too large to be stored in a bank, or those Rosenberg wanted to keep with him—about a hundred in all—were hung at his residence in Floirac. For sentimental reasons, he kept the "familial" Picasso—the portrait of his wife and daughter—and the drawings of Micheline. A large pastel and charcoal from 1923, *Standing Nude* (*see* insert A4), painted during the summer Picasso had spent in Antibes with Olga and their friends Sara and Gerald Murphy, also stayed in Floirac, as did a medium-sized Degas pastel, the *Portrait of Gabrielle Diot* (*see* insert A3), which Rosenberg had acquired at an auction in 1933. He also put up a small portrait of a dancer, again by Degas, Corot's *Madame Stümpf and Her Daughter*, three works by Braque—the large *Bather with Raised Arms*, *Plate of Oysters with a Napkin Ring*, and *Fruit Bowl, Guitar, and Tobacco Pack*—a handsome painting from the *Waterlilies* series by Monet, and the large and austere *Member of the French Convention*, then attributed to David.

The news that arrived at the end of May and beginning of June 1940 was more alarming than they had imagined: the Wehrmacht continued its fearsome march to Paris, the French army was on the verge of defeat, and refugees were crowding the roads in their flight south. Accompanied by his model Lydia Delectorskaïa, Matisse was among the hundreds of thousands of people attempting to flee. On May 20, the couple boarded a night train from Paris to Bordeaux, with the idea of taking refuge with Rosenberg in Floirac. As Delectorskaïa remembers:

> During the war, we spent some of the time in Paris, some in Nice. Then when the Germans invaded France, Paul Rosenberg told Matisse to come stay with him at Floirac. "I'll put you up," he had told him. It was the time of the exodus from Paris, the panic, and everyone was fleeing. When we arrived, Matisse went into their house; but there was no room for us. We left for Bordeaux, but there were no hotel rooms to be had, so we spent the night in the apartment of Yvon Helft, Rosenberg's brother-in-law.

The next day, Matisse and Lydia, having learned that there were houses for rent near the Spanish border, left for Saint-Jean-de-Luz and stayed there until things calmed down at the end of June.

Rosenberg was still in a "wait-and-see" mood, but events overtook him. On June 10, leaving Parisians to their fate, the French government moved operations to the Loire. At midnight on the 11th, Italy declared war on France and England. And on the 14th, the Wehrmacht made its triumphant entrance into Paris. The revenge Germans had been seeking since the end of the First World War was theirs.

The Rosenbergs remained close to Marguerite's two sisters, who had married brothers, Jacques and Yvon Helft, both antiques dealers. The two couples and their children were more or less set-

tled in an apartment in Bordeaux. Sometimes as many as twenty people slept on the floor. The day the Nazis entered Paris, the three couples were in Floirac and held a family council to decide what to do. Paul Rosenberg was still inclined to optimism. He believed they should stay where they were. But Jacques Helft argued that it was more than time the family left France, and that they should not wait for either an armistice or a new German offensive. Eventually Rosenberg was persuaded.

On the night of June 14, the three families traveled by car to Hendaye on the Spanish border. There they were forced to wait, along with thousands of other panic-stricken refugees. On June 16 and 17, Pétain announced on the radio that the newly formed French government would seek an armistice with Hitler. Six weeks following the start of their offensive, the German troops were dangerously close to the Pyrenees; and to the French refugees. Finally, on the night of June 17, Rosenberg and his family, along with the Helft families, crossed into Spain. German soldiers posted on the Spanish side monitored the exodus. But something unexpected happened: The French police stopped Alexandre and his two cousins, all of whom were over eighteen and therefore eligible for the draft. The three young men had to be left behind. Another cousin of Alexandre's was let through; his eighteenth birthday was three days off. For weeks the Rosenbergs waited for news from their son and his cousins.

The boys wanted to fight the Germans. It was therefore necessary for them to find a way out of France. When they learned that a boat filled with displaced soldiers was passing near Saint-Jean-de-Luz, heading toward an unknown destination, Alexandre and his cousins tried to sneak on board. Alexandre borrowed a cap from a Polish soldier and managed to get through the checkpoints set up by the French police at the foot of the gangplank. Once aboard, he found more than fifty young French men in the same situation. Without radio, cut off from the rumors circulating on the mainland, they had no way of knowing whether or not an armistice had

been signed. They arrived in England as illegal aliens and were subjected to intensive identity verifications. When Alexandre was asked whom in England he knew, he responded, "Winston Churchill." The British authorities believed he was being insolent, but he was actually telling the truth. The British prime minister, himself an amateur painter, had regularly borrowed paintings from Paul Rosenberg to serve as models. Alexandre was eventually authorized to enter England, and joined the Free French Forces.

That August, in Lisbon, with the help of his American friends, Rosenberg succeeded in getting visas for the entire family. He gave instructions to his assistant Le Gall and to a Bordeaux moving company to send his paintings and anything else that remained in the house at Floirac on to New York by boat. Le Gall immediately got in touch with the movers, who said it would take several days to do the job because they had to ask a company specializing in packing to prepare the paintings for transport.

In mid-September 1940, three months after their departure from France, the Rosenberg clan arrived by boat in New York. Le Gall wrote to say that the moving company he'd hired was endlessly delaying sending the paintings, for reasons he couldn't understand. Twice it had requested a detailed list of the works, saying that the information was necessary for official purposes. After they'd been given this information, they maintained they couldn't start because the border had been closed. Le Gall informed Rosenberg that he was at his wit's end.

Le Gall was awaiting new instructions from Rosenberg in New York when on September 15, at 8 A.M., a group of soldiers and German police, a Frenchman and an Italian trailing behind them, arrived at Castel in five vehicles. The Germans surrounded the house and told everyone to stay inside. They demanded to speak to Louis Le Gall, knowing not only his full name but a number of details

about him. Le Gall was taken completely by surprise. The Germans had apparently known for some time that Le Gall worked for Paul Rosenberg, were aware of his devotion to his employer, and knew that Rosenberg had left him in charge. Le Gall knew resistance was futile. He was convinced the moving company had informed on him. The Germans went through the house, opening every suitcase, briefcase, chest. Then they gathered together all the crates containing paintings, loaded them onto the trucks, and drove off.

They were heading to the German embassy in Paris. As it happens, the informers were Parisian antique dealers, and though the Bordeaux moving company's complicity was clear, the real culprits were Yves Perdoux and a certain Count de Lestang. These two distinguished gentlemen had made an agreement with the German embassy's staff: They would reveal the whereabouts of Rosenberg's paintings in exchange for a commission of 10 percent of their total worth, to be paid with paintings. The two conspirators knew very well they would be able to get rid of these paintings on the Parisian market.

Everyone in the Paris art market knew everyone else. Finding out who had what when was a simple matter. It was therefore a climate very favorable to stool pigeons and extortionists, who thrived in the new era of denunciation that had descended upon France. Official British intelligence documents indicate that the Count de Lestang was a regular purveyor to the Germans, and lived at 44, rue du Bac, very near the Nazi embassy. As for Perdoux, also an antiques dealer, his professional reputation was already shady enough. Jacques Helft, Paul Rosenberg's brother-in-law, knew him well, and without being aware of the role he had played in the Floirac confiscation, described him as a "top-level antique dealer endowed with remarkable intelligence" whose "good qualities were spoiled by the passion for gambling that possessed him."[14] It may have been Perdoux's desperate need for money that had pushed him into profiting from German persecution of Jews.

At the first meeting following the confiscation at the bank at Li-

bourne, negotiations between the greedy informers and German embassy personnel took an even more repulsive turn. The diplomats had planned to pay the commission with a number of Picassos and Braques in Rosenberg's collection, works they called examples of "wild Expressionism," but by November Perdoux and Lestang still hadn't received their cut. Representing both himself and Perdoux as "intermediaries," as the Germans generally referred to them, Lestang dealt directly with Carl-Theo Zeitschel, a high-ranking embassy official in charge of arresting and deporting Jews as well as impounding their goods.[15] To speed matters along, the partners pressured the German diplomats by letting them understand that they knew of another collection owned by a Jew, one even larger than Rosenberg's, but would say no more about it until the Rosenberg matter was settled.[16]

In a brilliant strategic move, Lestang and Perdoux took advantage of the growing competition between the German ambassador and Goering, who was just then (the end of 1940) at the height of his power. They were probably bluffing when they confided to their diplomatic cohorts that the Reichsmarschall had learned of the existence of this mysterious collection, and was demanding to know where it was located. Goering's aides were surprised to learn, they said, that the embassy hadn't paid the commission, yet. Goering was in such a rush the two thieving partners added that he had given them four days to reveal the location of the collection. If the embassy didn't act quickly and pay the commission, it would be left behind.

In a secret, urgent message to Ambassador Abetz, bringing him up to speed on his talks with Lestang, Zeitschel reported that the Count had had the audacity to note that the value of the Rosenberg collection had risen to 100 million Reichsmarks, and that his and Perdoux's commission therefore should amount to 10 million marks, or 200 million francs ($80 million of today's dollars)—a sum as exorbitant today as it was then. Zeitschel asked Abetz if he should get in touch with Goering's experts to find out whether or

not Lestang was taking advantage of them. In a second dispatch to Abetz, he wrote that a new estimate provided by a German expert had brought the value of the collection to 3,415,400 francs, and that he would also seek an appraisal from an "impartial" French expert (meaning someone who would give an opinion favorable to the embassy). In his third and final dispatch, Zeitschel informed Abetz that Lestang and Perdoux had turned up unexpectedly at the embassy the day before, that they had agreed to the new estimate, and that as a consequence Zeitschel had taken them into the rooms where the Rosenberg collection was stored so that they might choose from among the "wild Expressionists." There was a last minute snag, however: Under the pretext that they would never find a buyer for the works, the two Frenchmen informed the Germans that they no longer wanted modern paintings. Still, they indicated that they would be prepared to accept two paintings by Pissarro, estimated at 220,000 francs, and a Renoir nude, valued at 200,000, as payment. Zeitschel didn't want to let go of the Renoir, which "represented a certain value to Germany." He proposed to offer in its stead Pissarro's *The Garden at Pontoise*, which came from the Rothschild collection, and whose estimated value was twice that of the Renoir. "Pissarro being a Jew," he concluded in his reports, "I believe that his works are of less interest to Germany, and that it would be preferable to offer a Pissarro, even though its value was twice that of a Renoir."[17]

In New York, Paul Rosenberg had resumed his professional activities. The United States was still neutral, and given that the war in Europe was expanding, Rosenberg had his paintings from his London gallery sent over. He'd hoped that the works at Floirac and at the bank in Libourne would soon follow, still believing that because Libourne was in the so-called Free Zone the works there were safe. Mademoiselle Roisneau, his loyal assistant at the Parisian gallery,

was unable to get his mail through to him, hence Rosenberg was unaware of the scope of the Nazi plunder of his possessions.

Rosenberg finally received a letter in March 1941. The news was devastating. "Everything is gone, gone, gone," Roisneau wrote, referring to the paintings and other objects Rosenberg had left in Floirac. Even more disturbing was the news that the Nazis had discovered the existence of the vault in Libourne. Not only that: They had opened it and gotten an estimate of its contents' total value (7 million francs) from the director of the École des Beaux Arts, a Mr. Roganeau. German officials then sealed up the vault and waited for orders from Paris. The two strongboxes Braque had rented met with the same fate. There was an additional affront: Bank officials presented the painter with a bill for 1,200 francs: 1,000 francs to cover the cost of estimating the value of his works, and the additional 200 francs for the "distress and concerns" the German intrusion had caused them.

The letter from Roisneau, who was a witness to the Nazis' and Vichy officials' looting from the galleries on Rue de La Boétie, provided testimony to what was happening in Paris. She had been unable to prevent the German soldiers from taking the paintings and documents from Rosenberg's gallery and his home. A friend did manage to burn the gallery's inventory book before it could fall into German hands. The Wildenstein Gallery was also pillaged. Nonetheless, Roisneau wrote that Roger Dequoy, the art dealer's right-hand man, had been able to deal with French officials rather than with Nazi authorities. The Bernheim-Jeune Gallery was also requisitioned and placed under provisional administration, which meant Aryanization. Josse Bernheim, one of the brothers who had founded the company, was dead.

Rosenberg wrote back immediately, asking for more detailed information about the paintings taken from him. He is aware by now that the Nazis had started to seize goods owned by Jews, Freemasons, and political opponents. New Vichy laws concerning "fleeing" citizens meant that his passport had been revoked and that he

had lost all his rights as a French citizen. He was also aware of the Vichy's anti-Semitic laws. But his letter reveals that Rosenberg, like so many others, did not yet grasp the full significance behind these confiscations, nor did he suspect their extent. He could not make out the secret plan taking shape throughout France. In his reply to Roisneau, therefore, he asked where and why the paintings had been taken, whether the Germans had paid for them, and whether there was a way of getting them back. He was particularly worried about the portrait of his wife and daughter by Picasso. Lastly, he wanted to know whether it would be possible to send the paintings kept at the bank in Libourne to the Free Zone, where they might be safe. He was as yet unaware that the seizure of his works had been orchestrated at the highest level of Nazi authority, and that it was among the implacable measures being taken against "enemies of the Reich" in those areas occupied by the German army.

Rosenberg had lost none of his passion for dealing. He did not forget, either, his professional reflexes nor "his" painters. In the same letter to Roisneau, he asked whether Picasso and Braque could have their work transferred to the United States, and whether they intended to come join him in the New World.

The coup de grâce came several months later. On September 5, 1941, a German officer assigned to the ERR arrived at the National Bank for Commerce and Industry in Libourne, carrying a letter granting him authority to remove the 162 paintings located in safe number seven, rented by Paul Rosenberg. The works were sent directly to Paris, but this time their destination was not the German embassy but the Jeu de Paume, where Goering would look them over. Rosenberg would not discover this until the liberation of Paris in 1944, by which time the war was nearly over.

6

The Bernheim-Jeune Collection, or The Burning of *The Jas de Bouffan*

One of the oldest art dealership dynasties in France started like many of the others: as an art supplies store. In the town of Besançon in 1795, a man named Bernheim opened a shop that sold canvasses, paint, and brushes. He probably acquired his first paintings by accepting them from artists in lieu of payment for these goods. The true founder of the Bernheim dynasty, however, was Alexandre Bernheim. Born in 1839, he transformed his father's art supply business into an art dealership. In the 1860s, on the advice of his friend, the painter Gustave Courbet, Alexandre moved his business

from Besançon to Paris. Soon after that, following the example of other dealers and collectors, he opened a store at 8, rue Laffitte. Durand-Ruel, the great art dealer of the Impressionists, had his gallery there, until the beginning of the twentieth century, as did Ambroise Vollard and Clovis Sagot, one of Picasso's first dealers. Vollard wrote, "Rue Laffitte was the street of paintings . . . for young painters it was a place of pilgrimage." Alexandre Bernheim himself specialized in the work of Corot, Courbet, and painters of the Barbizon School.

A battle between the generations erupted in the 1890s. Alexandre's sons Josse and Gaston broke with their father's style and introduced Impressionist paintings to the market. After Durand-Ruel and with Vollard, they were part of a second generation of Impressionist art dealers. Soon the brothers started buying directly from Monet, Renoir, Pissarro, Sisley, and Cézanne. They showed a gift for finding new painters beyond the first Impressionists: Seurat, Bonnard, Signac, as well as Félix Vallotton, who married their sister. So determined was Durand-Ruel not to show any Post-Impressionist art that he refused to organize a posthumous exhibit of Van Gogh's work. The Bernheim-Jeune brothers—who had added Jeune (Young) to their surname to stress the difference from their father's business—stepped in and organized one in 1901, just eleven years after the painter's death. Following other art dealers and clients, they moved to a new shop on the Boulevard de la Madeleine, at the corner of Rue Richepanse, and in the first years of the new century began to profit from the internationalization of the market. The gallery's couriers took trains to Russia, Switzerland, Germany, and England, delivering and hanging the paintings in the homes of their new owners.

The brothers began then a long partnership with Bonnard that lasted until the beginning of the Second World War—nearly forty years. No contract was ever signed; the business relationship was based entirely upon friendship and trust. Bonnard gave the Bernheims his bills and they paid them. Loyalty such as this was not common, since modern painting was far from being accepted by most of French society. One day in 1910, for example, a well-

dressed gentleman went into the gallery and asked to see Josse. He wished to express his indignation at being forced to look at Bonnard's "decaying bodies displayed in the windows." The same year, a man accompanied by a pregnant woman passed by the gallery, in which Bonnard's *Bathing Nude*, also known as *Reflections in a Mirror*, or *The Tub*, was on display. Outraged, the man complained to the dealers and demanded that the painting be taken down lest it cause his wife to have a miscarriage. The testimony to this enduring and important partnership, the portrait Bonnard did of the Bernheim brothers in 1921, now hangs in the Musée d'Orsay.

In the early days of the century the Bernheim brothers began associating with literary figures and taking up political causes. During the Dreyfus affair, they accompanied Émile Zola to the Versailles tribunal, along with Albert and Georges Clémenceau, with whom they remained friends for nearly thirty years. Their renown grew. In 1905, they beat out Durand-Ruel and became the fortunate auctioneers of the Paul Bérard collection, one of the most valuable collections of Impressionist work, especially of Renoir, among which was his masterpiece *Children's Afternoon at Wargemont*.

"Josse was the serious one," said the dealer Alfred Daber, who knew them, "and resembled one of Rembrandt's Syndics. Gaston was the salesman, the seducer." In 1901, Josse and Gaston married sisters, Mathilde and Suzanne Adler. As an engagement present, they had Renoir paint their fiancées' portraits. They were married on the same day and used the same witness—the playwright Georges Feydeau. For nearly thirty years, the two couples lived together in a townhouse located on the elegant Avenue Henri-Martin.

Gaston and Josse bought paintings, not only to resell them, but for their own personal collection, and before long that collection became such a center of interest that they were forced to charge admission. One of the key pieces was Seurat's *The Circus Parade*. Their living room and dining room contained the most important works. On one wall in the dining room were *Saint Martin Sharing His Cloak with a Beggar*, which El Greco had painted for the San José Chapel in

Toledo between 1597 and 1599 (El Greco's work was then being re-discovered in France), Seurat's circus painting, Monet's *The Waterlily Pond*, Corot's *Saint Sebastian*, and a very handsome *Judgment of Paris*, by Cézanne (*see* insert B14). On another wall in the same room were six or seven works by Toulouse-Lautrec, including *La Goulue with Her Partner* (*see* insert A12) and *La Goulue: Ready for the Quadrille* (*see* insert A14). There was also Corot's *Agostina* and a dozen works by Cézanne, such as *The Jas be Bouffan* (*see* insert B11) and *Portrait of the Artist with Long Hair* (*see* insert B12). The fourth wall of this little domestic museum was decorated with twelve Cézannes, including *The Card Players* and *Snow Scene at Auvers-sur-Oise* (*see* insert B9), as well as a work by Gauguin and several by Lautrec. The adjacent living room, called the "Renoir Room," contained forty-five of his paintings, seven nudes among them.[1]

The ties between Gaston and Josse Bernheim and Renoir grew stronger and stronger. Josse even monitored the painter's uncertain health, and found a Viennese doctor who could treat his rheumatism. In 1907, they commissioned two family portraits, one that came to be called *Madame Gaston Bernheim-Jeune and Her Son*. However, the portrait did not please Mathilde, Gaston's wife, who thought the arm holding the child far too fleshy. Having said as much one day to Auguste Rodin, she invited him to eat with Renoir in the hopes that the sculptor would succeed in convincing his friend to touch up the arm. But after dinner, Rodin expressed his admiration for the painting. He told Renoir that it was the best arm he'd ever done. "It's true," replied Renoir, "I do love flesh."

Between 1900 and 1910, the Bernheims reinvented themselves yet again, embracing the Fauves. Matisse and Van Dongen joined their stable in 1909.

Matisse appears to have had enormous confidence in the brothers' commercial skills, for he signed an exclusive contract with them. He regularly brought over work he had just finished, or invited the Bernheims to his studio, so that they might choose from among his most recent work. As soon as one of the brothers had selected a

painting, Matisse would invariably decide to keep it for himself, as was his privilege; he doubtless thought that it must be the best. Eventually the Bernheims began choosing only mediocre works, which Matisse always opted to keep, leaving the Bernheims with the best pieces. On the whole, however, the relations between Matisse and his gallery were excellent. Until the Second World War, the painter had all of his paintings photographed at the Bernheims, even though by then he was under contract with Paul Rosenberg. Thus in March 1940, when Matisse had finished *Woman with Red Bodice, Anemones, and Almond Blossoms* and *Woman in Black Against a Red Background Seated in a Louis XIII Armchair,* Rosenberg, unable to send them to the Bernheim Gallery to be photographed, had to content himself with smaller, poorer-quality photos taken by Matisse, before carrying off the paintings to Floirac.

In the period between the wars, the Bernheim brothers managed their stock patiently. Their last gamble on the future involved Chagall, taken at "half account" (a 50-percent commission) in the 1920s, and Utrillo. The Bernheims also remained Vlaminck's dealer after his Fauve period. The critic Félix Fénéon, a friend of Signac, Seurat, and Toulouse-Lautrec who served as the Bernheim Gallery's artistic director for twenty years, joined with them in publishing the bimonthly *Bulletin de la vie artistique* between 1919 and 1926. All through this period, the Bernheims were still the major dealers of "color paintings" in the Impressionist style and relatively uninterested in other modern modes, such as the Cubism of Picasso and Braque. In the early 1920s, they and Etienne Bignou bought George Petit's old Impressionist gallery and, following the taste of the day, turned it into a large auction house.

Gaston and Josse separated their living quarters in 1929. One brother moved to the Avenue du Général-Maunoury, on the edge of the Bois de Boulogne, and the other to a residence on Avenue Des-

bordes-Valmore. The collection was also divided between these two addresses. During the same period, Josse's two sons, Jean and Henri, began taking over their father's business. The center of the art market, as well as the center of high fashion, had moved from the Madeleine neighborhood to Faubourg Saint-Honoré and Rue de la Bóetie. In 1924, the Bernheim-Jeune Gallery also moved there, occupying an entire building at the corner of Avenue Matignon, bought from a certain Mr. Borionne, a goods dealer. The Bernheims were, then, right in the middle of the Right Bank, near the Paul Rosenberg, Wildenstein, and Cailleux galleries. Across the street at number 120 was Worth, the couturier, while Vionnet had his famous boutique on Avenue Montaigne. The modern decorators, such as Groult, Poiret, and Mare, had their shops in the vicinity.

From the first moment of the Occupation, the art galleries belonging to Jews in the Faubourg Saint-Honoré neighborhood became focal points of Vichy and Nazi greed. Because of its elegance, its luxury stores, and the entertainment it offered, a certain class of German officer was partial to the area. One of Ernst Jünger's ordinary days, as recounted in his *War Diary*, offers a view of the aesthetic activities of a German occupier of Paris. On this day, Jünger, a young lieutenant in the Wehrmacht, and a book lover, would first visit the Bérès bookstore on Avenue Friedland. Then he would go to the Ladurée pastry shop on the Rue Royale. Finally, while waiting to attend a formal-dress evening at the Georges V Hotel, he strolled in civilian clothes along Faubourg Saint-Honoré, where he said he "always had a feeling of well-being."[2]

Like all other Jewish properties in the neighborhood, the Bernheim-Jeune Gallery was sequestered, and between the fall of 1940 and the spring of 1941 the ERR confiscated a portion of the collection—the portion owned jointly by both brothers, which was housed in the gallery. The building itself was seized by the GCJA and put up for sale. In one of those war coincidences, it was bought back by the same Mr. Borionne who'd sold it to the Bernheims twenty years earlier, and for the same price. Borionne took advantage of his situation

by renting it out to several retailers. A young tailor opened his first store on the ground floor and used the small round room that had been used for the Bernheims' special clients as a dressing room.

The Bernheims' other paintings were better protected, for during the Phony War, Gaston Bernheim had transferred all his paintings to Monte Carlo, where they spent the Occupation years uneventfully. His son Claude took refuge in the French Alps, but was betrayed by a nurse who was taking care of him. He was arrested and deported to Auschwitz in 1942, where he died during the massive transfer of inmates sent from the camp shortly before the arrival of the Soviet army.

Jean and Henri, Josse's sons, escaped persecution. Both had been drafted into the air force. Jean was wounded at Chantilly and sent to Dax, as was his brother. They rejoined their father in Lyon, where he had gone with a few of his paintings. Josse died in Lyon in 1941. After several attempts, Jean and Henri finally succeeded in crossing into Switzerland, where they managed to smuggle several paintings in 1942, thanks to help from a Japanese diplomat, an old high-school friend posted in Paris. The "Aryan" status of the gallery's secretary had allowed her, uneventfully, to give the diplomat the paintings. The paintings served as the brothers' bank guarantee in Switzerland, and permitted them to survive.

Unlike Claude, Josse's children survived, but his collection took the full brunt of the war. A good part of it, notably the ancient Greek and Roman statuary, had remained behind in his Parisian home. On April 9, 1941, the heads of the right-wing Rassemblement National Populaire (RNP), ideologically close to the Vichy government, with leaders Marcel Déat and Eugène Deloncle, came to his residence with a requisition order. Mr. and Mrs. Deloncle had planned to move in. A neighbor moved into the garage, while his gardener-chauffeur took up residence in one of the outbuildings, into which he also put several statues from the collection. The townhouse became the headquarters for an association of members of the RNP Party who were former POWs, and after that was occupied by the

Germans. When the Nazis moved in they found a good portion of Josse's collection: medieval statuettes, masks, Egyptian statuary, as well as Greek sculpture. They also found Cézanne's *L'Estaque* and two works by Corot—*Venice, the Gondola on the Grand Canal in Front of San Giorgio Maggiore* and *The Turkish Woman* or *Greek Woman*—and modern works by Dufy, Marquet, Vlaminck, Vallotton, and Roussel. Added to that were several collections of medals, notably those of Grand Duke Cosimo de Toscane.

The German ambassador was probably the first to help himself. Then the ERR took its cut, followed as always by the GCJA, and then a "provisional administrator" of the collection. The house's later occupants made off with what little remained. One work that had been particularly dear to the family was a large panel painted by Bonnard; it hung on a pier between the doors to the sitting room and dining room. Entitled *The Venus of Cyrène*, the painting depicted a table with a flower vase and some books, one of them bearing the name of the painting, which was also that of a novel written by Josse Bernheim. It was taken away by one of the provisional administrators of the collection. In the end, only two pieces escaped the plunder: another Bonnard, *The Mediterranean*, which was concealed behind a mirror, and a statue by Maillol, *Eternal Desire*, hidden behind a chest at the beginning of the war.

As for the final portion of the collection, which consisted of some thirty paintings, it was placed in the keeping of an Anglo-American family named the Lauwicks, friends of Jean Bernheim's in-laws. The Lauwicks had convinced Josse that the works would be safe in their château in Rastignac, near Bachellerie, in France's rugged Dordogne region, located in the Free Zone. The husband of the gallery's secretary secretly transported the paintings there, having first taken them out of their frames, rolled them up, and packed them in brown paper. These were works from Josse Bernheim's collection (*see* inserts

A and B for illustrations): *The Bathers, The Jas de Bouffan, Portrait of the Artist with Long Hair, Snow Scene in Auvers-sur-Oise*, all by Cézanne; Renoir's *Algerian Woman Leaning on Her Elbow* and *Portrait of Coco*, which had been given to him by the artist; three handsome Toulouse-Lautrecs, *La Goulue with Her Partner, Moving In*, and *La Goulue: Ready for the Quadrille*; and an important work of Van Gogh's dating from the important Arles period, *Flower Vase on Yellow Background*. All of them made it to Rastignac intact.

The Rastignac château had been built in 1811 and was an imitation of the White House in Washington. All the canvases were hidden under the eaves, rolled up inside an old trunk of uniforms with a false bottom. The house on Rue Desbordes-Valmore may have been plundered; here the works would surely be safe. The family was so convinced of this that it took a small but valuable Renoir there—*The Moss Roses*—believing that it was the safest course of action. The painting had been in the house of Jean's family, who had taken refuge not far from Rastignac at Terrasson. The guardians of these treasures were the widow Lauwick, her son Jacques, who worked at *Vogue* magazine, and her daughter, Madame Fairweather and her young son.

By the end of 1943, because of the reverses experienced by the German army in the south of Europe and the growing effectiveness of the resistance movement, there was a sharp increase in the number of Nazi exactions and abuses in the region. On March 30, 1944, around 8 A.M., a German column, the Brehmer Division, whose commander was billeted at La Bachellerie, occupied the road above the château, while a section of the Sicherheitspolizei (security police) took over the town hall in the nearby town of Azerat. Rastignac was therefore caught between these two forces. At 9 A.M., an SP car carrying five men arrived at Rastignac: Obersturmführer Thalmann, an officer, a junior officer, and two regular soldiers. According to Jacques Lauwick, Thalmann was "young, brown, slender, arrogant, and wore frameless glasses"; he ordered all the building's occupants into the courtyard.

There they remained for three hours, watched by the two soldiers. The others ransacked the house. "We heard them emptying drawers, breaking down doors, and pushing over furniture," recalled Lauwick. Sometime around 11 A.M., the sound of gunfire came from the valley: The SS had shot the mayor, his assistant, and the town clerk. At noon, Thalmann left the château and had Madame Fairweather, her son, and Jacques Lauwick taken under guard to the Azerat town hall. Madame Lauwick and the others were ordered to leave for La Bachellerie. The Germans forbade Madame Lauwick from returning to the château, even for the purposes of retrieving her identity papers and some money.

After waiting at the town hall for three hours, Jacques Lauwick was interrogated. At first he thought that since they had not discovered the safe hidden behind a false door, and had collected a total of only a few thousand francs from the house, the Germans wanted to know where the family's money was hidden. Instead, the officers began asking him "architectural questions," such as when the château had been built, and about some of the finer points of its construction. They were clearly looking for hiding places that might contain either money or weapons.

Unbeknownst to Lauwick, a little past noon, a team of German soldiers wearing asbestos suits, having methodically pillaged all the rooms in the château, set fire to the structure with sulfur. It burned for over a day. Neighbors saw five trucks leave the château laden with furniture, linens, bedsheets, large Flemish tapestries, and antique Persian rugs. The silver was distributed to the soldiers, the clothes to civilians. A dairy farmer pressed into service by the Germans to help with the heavy lifting later declared that "the Germans carried packages of every size out of the château and loaded them onto trucks." When the Germans had left, the Lauwicks were released.

The plundering of Rastignac seemed purely utilitarian. According to Lauwick, who summarized in writing what had happened that day to the Bernheim brothers, "the Jerrys did not seem like connoisseurs. I am certain that had they discovered the hiding places of your beautiful canvasses, they would not have taken them, not knowing what they were worth. No one will ever recover them now, unfortunately. They were destroyed along with everything else."[3]

Still, a mystery endures to this day. What were the Germans looking for at Rastignac with such fanatic determination? Just money? Were they hoping to destroy a secret meeting place of the Resistance, or find a hidden store of weapons? Did they know about the paintings? Was the burning of Rastignac revenge for receiving stolen goods, or the opposite, for not having received any? To this day no one knows whether those five trucks carried away the canvasses, rolled up inside the large tapestries—a hypothesis not without foundation. There are clues that point to the conclusion that these thirty masterpieces, including *Odalisque in Red Pants* and *The Jas de Bouffan*, were not burned at Rastignac.

7

David David-Weill, or The Patron Stripped Bare

This story begins in San Francisco, for it was there that David Weill, son of Alexandre, was born, on August 30, 1871. Alexandre Weill was a French goods merchant who had left Phalsbourg, in the Lorraine region, in 1853 to join his brother Raphael, his cousins, the Lazard and Cahn brothers. The Cahns had founded an export-import business in New Orleans, moving to San Francisco in 1848, the year of the California Gold Rush. The Lazard brothers exported cotton and imported cloth and manufactured products. After the Civil War, the company was gradually transformed into a bank, with headquarters in New York and branch offices in London and Paris. Alexandre's brother, Raphael, then went on to found one of the largest department stores in the West: the White House.

In 1884 Alexandre Weill decided to return to France with his entire family. He wanted his son David to be educated there. Before settling in Paris, the Weills did a "grand tour" of Europe, during which the young David visited museums in every city. When he returned to Paris he was enrolled at the Lycée Condorcet, where one of his fellow students was Marcel Proust. By the age of eighteen, David had already bought his first miniatures, and some enamels. He fell in love with and married Flora Raphaël, who shared his artistic tastes, in 1897. A year later he was appointed senior banking executive at the family bank and, along with his Lazard and Thibaut-Cahn cousins, began controlling it. The number of bankers in his own family inspired him to add his first name to his patronym, and from that point on he called himself David David-Weill.

The true beginnings of the David-Weill collection were in 1904, when Alexandre Weill had a townhouse built in Neuilly for David and his young family. To furnish it they bought eighteenth-century art and furniture. The collection gradually began to include serious works by artists from the Le Nain brothers to Dufy and Picasso, and included works by Delacroix, Ingres, Corot, Degas, Monet, and Renoir. There were many eighteenth-century works as well, such as Fragonard's *White Bull*. In very short order, this burgeoning new collection grew in all sorts of directions, from tiles and Chinese bronzes, to sixteenth- and seventeenth-century gold pieces, to silver and miniatures. What they had in common was their collector, a man of sure taste with an eclectic and wide-ranging curiosity. Heterogeneous though his collection might seem at first, each of David-Weill's acquisitions seemed to fit together to the whole.

Enamels from Limoges and porcelain from Japan were displayed alongside Egyptian antiquities and Islamic ceramics and metalwork. There were prints by Degas, Manet, Renoir, Toulouse-Lautrec, Gauguin, Bonnard, and Vuillard, who was a friend of the family. There were sculptures by Sarrazin, Houdon, Caffieri, and Carpeaux, as well as *Dancers and Horses* by Degas and female figurines by Maillol. In the garden was Rodin's *The Age of Bronze*.

A bibliophile, David-Weill accumulated an enormous collection of incunabulae, rare editions, and books made by the very finest binders. The range of the objects in his collection made it seem more like a great aristocratic collection of the eighteenth century, rather than like one of the nineteenth century. Actually, however, David-Weill was ahead of his time, not behind it. He was among the first to show interest in pre-Columbian arts and objects from the Caribbean Indians. In 1928 he helped organize the *Exhibition of Ancient Art from the Americas*, which was as much a revelation to the Paris public as it was for the Surrealists and young Latin American writers like Miguel Angel Asturias and Alejo Carpentier.

His collection was becoming so extensive that David-Weill hired a private curator, Marcelle Minet. She began working for him full-time in the 1930s. David-Weill solicited advice from experts in every field. His silver collection was assembled by Jacques Helft, who bought hundreds of pieces on his behalf—from a seventeenth-century tureen by Germain to a curious silver feeding bottle designed for an invalid, which came from the Rheims hospital and dated from the fifteenth century.

David-Weill spent much of his life at auctions and in galleries. He got up early each morning, and before going to his bank office would visit antiques and art dealers, who would show him paintings and sculptures that they knew would arouse his interest. His office in the bank's headquarters on Rue Pillet-Will was decorated with medieval statuary, including a copper statue of Saint John dating from the fourteenth century, and a fifteenth-century Burgundian statue of the Virgin in sheeny marble, which was perhaps his favorite piece.

Jacques Helft's memoirs, which were written after David-Weill's death and therefore not inspired by sycophancy, include the following: "I truly venerated David David-Weill, who was one of my most loyal clients. . . . Besides the numerous visits that I made to Neuilly, David-Weill often received me at his bank and between bank meetings enjoyed listening to the latest gossip about the art

business." Helft emphasized David-Weill's loyalty. One day, after
Helft had told David-Weill about the sizable profit he had gotten
from an object he had just sold to him, a jealous competitor went to
see David-Weill to tell him what it had cost Helft to purchase it.
David-Weill knew very well what Helft's commission had been. He
was outraged by the man's methods and politely but firmly re-
quested that he never call again.

So well developed was David-Weill's sense of patronage that
museum curators could point out rare works from his own collec-
tion to him, knowing it was very likely he would donate the works
to their museums. He was one of the few collectors to make dona-
tions during his lifetime. He made his first donations to the Louvre
in 1912, in the form of a Hispano-Mauresque platter and some
Chinese bronze sculptures (the first ones dating from the Middle
Empire). At his death, the catalog of his donations to French muse-
ums would occupy three hundred pages and include more than a
thousand recognized gifts, among them Ingres's *Turkish Bath*,
Courbet's *Studio of a Painter*, Manet's *Portrait of Stéphane Mal-
larmé*, and Renoir's *Frog Pond*, as well as drawings such as Wat-
teau's *Study of Young Negroes* and several works by Constable. Most
of these were given anonymously, but their number grew so large
that when a new object would arrive the Louvre's directors—who
knew the identity of the donor—would say, "Ah, another gift from
Anonymous!" In fact, David-Weill's support of the museums of
France had become a sort of institution. He even supplemented the
meager salaries of some of the museum's employees. In the 1920s
he gave money to the young René Huyghe, who was to become the
Louvre's director of paintings, so that he could travel to other mu-
seums in Europe and study their conservation techniques.

In 1931, David-Weill became president of the Board of Direc-
tors of National Museums; he remained in that post until his citi-
zenship was revoked by Vichy. (The owner of the Samaritaine
department store, Gabriel Cognacq, took over from him.) Inter-
ested in museums wherever he went, David-Weill had started in

1938 to become concerned about what would happen to the enormous collections in the Prado and Escorial, which were seized during the upheaval of the Spanish Civil War. Taken first from Madrid to Valencia and from the Valencia region to Catalonia, these collections were being threatened by the Franco forces' final assault. David-Weill helped to organize an international committee to save the works. In January 1939, twenty trucks made seventy-one trips between the warehouses and the border. From there the art was put on trains bound for Geneva to await an end to hostilities. This is, generally speaking, what would happen several months later to the Louvre's holdings, as well as to a part of David David-Weill's own collection.

In 1939, like all art collectors in Paris, David-Weill most feared bombing. Marcelle Minet inventoried, prepared, and crated a large number of the paintings. Some of the most significant works, such as those by Corot, Renoir, and Goya, were sent directly to the United States. One hundred and thirty of these crates, those filled with the most valuable objects and marked DW, left for the facilities housing art from France's national museums—the château at Sourches, where Germain Bazin was in charge. It had been the director of France's museums, Jacques Jaujard, who had proposed to David-Weill that he place his collections in Sourches for safekeeping, and that he, Jaujard, would indicate that they were gifts to France made before the declaration of war. The collection of old clocks, the sculptures, and a part of the collection of engravings and several paintings therefore went to Sourches. Another portion remained at the house in Neuilly, this consisting of furniture, part of the collection of paintings and sculptures, and the art library. Finally, twenty-two crates filled with works were sent to the château at Mareil-le-Guyon in the Seine-et-Oise department of France, including rugs, rare Japanese prints, and some paintings.

In 1940, David-Weill left with his wife and some of his children for Evian, in the French Alps. There he learned that the Lazard Frères Bank and its headquarters on Rue Pillet-Will had been sequestered and that his own home in Neuilly had been impounded. He obtained papers that would have permitted him and his family to emigrate to Switzerland, but changed his mind and decided to leave for America via Portugal. In Portugal, he learned that the Free Zone had been formed, so he and his wife returned to Lyon, where he met with Marcelle Minet. Minet had already realized that David-Weill's art was in real danger; she was preparing the crates for transport to the United States. While in Lyon, in accordance with Vichy's new laws, he identified himself as a Jew. He then received a message from a friend named de Fontenille, inviting him and his family to take refuge at de Fontenille's home in the Montauban countryside. David-Weill's daughter, Madame de Bastard, would join them there. She was the wife of the owner of the château at Hautefort, which was already serving as a safehouse for works from museums in Alsace and Lorraine. So as not to arouse any suspicion, daughter and parents left separately and met up at a Perigueux grocery store, before warning de Fontenille of their arrival.

The crates stored at the château at Sourches were no longer safe. The ERR had extended its operations into the Occupied Zone and had become interested in the Louvre's warehouses in the provinces. On April 8, the Kunstschutz, that small division of the German army whose role had been increasingly marginalized by the wave of confiscations, informed the museum's directors that the ERR was intending to go to Sourches to take David-Weill's collection. Jaujard sent his deputy director of the Administration of French museums, Joseph Billiet, there and on April 10, in the company of Gabriel Cognacq, vice president of the museums' board of directors, Billiet went to the home of M. de Brinon, the general delegate

of the French government in the Occupied Zone, to warn him of the threat to the David-Weill collection. The imminent seizure disturbed Vichy officials. David David-Weill, after all, was a former president of the museums' board of directors.

Nonetheless, on April 11, 1941, an ERR representative arrived at Sourches with four trucks to begin carting the work off. Bazin and Billiet were there to receive them. They could do nothing beyond request that two inventories of the works be compiled, one by the Germans, the other by the French. The crates were taken to Paris. Jaujard filed a protest with the Wehrmacht, but he was powerless against the ERR. The 130 crates therefore arrived at the Jeu de Paume, where they were sorted, inventoried, and sent on to Germany. The French government was indignant about the whole business. The deputy minister of education wrote a letter to Admiral François Darlan, then Vichy's most powerful minister after Pétain, asking him to intercede; but as with other Nazi internal projects, the Vichy government held no sway.

In Mareil-le-Guyon, the confiscation of the art resulted in an episode that was both silly and wasteful. René Lasne was the principal of the Lycée de Neauphle-le-Vieux. He traveled throughout the region at the end of June and the beginning of July to inform his pupils when the school would reopen. His travels took him by a château, which, he learned, had recently been sacked by local plunderers. He had heard that paintings from the national museums had been stored there. Accompanied by mayors from two neighboring boroughs, he went to inspect the premises. They found the building was wide open. Scattered about were twenty-two crates that had been left more or less untouched by the pillagers; a few paintings were still hanging on the walls. In one room they found some opened crates, and from one of them removed two Degas monotypes. A conscientious public servant and an amateur painter, Lasne believed it was his duty to save these works of art. He took several home with him, then contacted the national museums, which refused to have anything to do with him. Lasne felt he had to take

matters into his own hands. He returned to the château with a cart and took the rest of the collection away with him. Consulted a second time, the Louvre's directors informed him that the art did not belong to France, but to David David-Weill. Lasne also learned that regulations required French citizens to declare any collections whose worth exceeded 100,000 francs. Good Mr. Lasne duly informed the Germans and asked them to provide him with means to transport the crates to the Louvre. No sooner had he made this request (in August 1940) than the ERR came and took the crates away. Had the school principal been less scrupulous, the crates might have survived the war.

Finally, as regards the works that had been left at David-Weill's residence in Neuilly, they were confiscated in a series of raids that began when the house was requisitioned on July 9, 1940, and continued until 1944.

David David-Weill's collection was not the only family art pillaged by the Nazis. Of his seven children, David's son Pierre most closely followed his father's example, and went into banking as well as art collecting. Pierre's collection of avant-garde works had by the late 1930s become a veritable private museum.

In the 1920s, Pierre decorated his first apartment in the latest Art Deco style, and had accumulated an impressive collection of drawings by La Fresnaye, Matisse, Picasso, Derain, and Balthus. From early on he was particularly interested in the work of the Surrealists and the Montparnasse artists, and in 1929 had asked the painter André Masson to do a series of decorative murals. He had also commissioned Jean Lurçat to do some tapestries, and Jacques Lipchitz to fashion andirons. When he asked Masson to find him a sculptor, Masson pointed him toward Alberto Giacometti. Giacometti asked Masson what sort of sculpture Pierre David-Weill was seeking. Masson was unable to say and left it to Giacometti's

imagination. What Giacometti came up with was a "radiator cover" for Pierre's apartment. All this happened in 1929, a decisive year for the two artists: Masson was about to break away from the Surrealists; Giacometti was strengthening his connections to them.

Masson's large mural paintings, one an impressive green one called *Animals Devouring Each Other* and the other done in dramatic autumnal yellow and entitled *The Family in Metamorphosis*, were hung on the walls of the smoking room and the dining room, respectively (*see* inserts C2, C3). Measuring 4.5 x 1.75 meters (about 15 x 6 feet), they were the largest works the painter had ever done. Masson had also done a study for *Animals Devouring Each Other* that today can be found in the Museum of Modern Art in New York.

Drafted into the army in 1939, Pierre had not had time to find a safe location for his collection. Demobilized following France's defeat in 1940, he left for the United States, and spent the war directing the New York branch office of Lazard Frères. Pierre's apartment was sequestered in 1940 and served as an office for several high-ranking Wehrmacht officers. For the duration of the Occupation they disposed of the entire collection of decorative objects as they saw fit.[1]

8

The Schloss Collection, or
Dutch Painters for Hitler

At the turn of this century, Adolph Schloss installed his art collection in his private townhouse at 38, avenue Henri-Martin (*see* inserts C4, C6); at the time, it was considered one of the most elegant addresses in all of Paris. A goods and commodities broker for large department stores in France and North America, as well as a purveyor to the Russian court, Schloss made a considerable fortune and had assembled some 333 paintings, including a number by seventeenth-century Flemish and Dutch masters. There were paintings then thought to be by Rembrandt and Frans Hals, as well as a Pietà by Petrus Christus, several Ruysdaels, and the *Portrait of Clément Marot* by Corneille de Lyon. The paintings were hung throughout

his home. The dining room contained only still lifes with fruit and vegetables. The living room featured early Italian works.

Born in Austria, Schloss had become a French citizen in 1871, and acquired his collection with patient determination, using a whole network of intermediaries from across Europe to track paintings for him. The most famous of his paintings were bought from the son of Countess Hanska, Balzac's mistress. At the time of his death in 1911, Schloss was in the process of considering selling fifty paintings in order to acquire a Vermeer. The deal didn't go through in time but, today, his heirs do not seem to regret it, considering what ultimately happened to the collection.

Until 1939, Schloss's widow and his four children maintained his collection with religious devotion. During the Phony War, fearing that Paris might be bombed, Lucien Schloss, Adolphe's oldest son, quietly had it moved to the château of Chambon, near Tulle, in Corrèze in central France. The château belonged to a friend of the family, a Jacques Renaud, who was director of the Jordaan Bank in Paris. Following France's defeat in 1940, members of the family moved to the South.

Few in the Paris art circles knew what had become of the Schloss collection. The Germans were very eager to locate it, particularly since it included a number of paintings by the Northern European artists preferred by both Hitler and Goering. Moreover, since the collection belonged to a Jew, it could easily fall within their grasp. A number of collaborating art dealers, such as Roger Dequoy and a man named Destrem, took steps to locate the collection, first by offering bribes to the Schloss family and then by threatening them. Given that Hitler wanted the works for the Linz museum, huge commissions could be affected. The value of the collection was then put at 50 million francs (the equivalent today of $20 million—an enormous sum at the time). Haberstock, the Nazi dealer who was very active in Paris during the war, kept tabs on the search, and, using his own network, succeeded in gathering some information on his own. In December 1942, Destrem informed Haberstock that the

Schloss family wished to sell off the main part of the collection. Haberstock immediately told Destrem to tell the family he would buy it. But Destrem's information turned out to be wrong.

Getting their hands on the coveted Dutch and Flemish masters of the Schloss collection proved more difficult than the Nazis had thought. Vichy's Darquier de Pellepoix and the GCJA sometimes found themselves competing with the German confiscators, sometimes working with them. Eventually they managed to pull ahead of the Germans. Darquier had interrogated the employees of several Parisian moving companies and learned nothing. But through a man named Liénard, one of his informers, he learned that a chauffeur named Jean Nériec had been put in charge of transporting the collection to its safe place in 1940. Nériec was able to provide only approximate directions to the château. By then, however, Liénard had found out where the Schloss family was hiding. He followed up on research done by Darquier and by Jean-François Lefranc—the Parisian dealer who was to be named temporary administrator and liquidator of the collection, once it was found—who had followed the trail of the Schloss children. When he learned that the GCJA had discovered the whereabouts of several family members and was intending to arrest them, Liénard was gripped by remorse. He warned someone they knew, a man named Meyer, who lived in Cannes. Meyer immediately sent an anonymous letter to Henri Schloss, one of Adolphe's sons, telling him to warn his family. Unfortunately, Henri ignored the warning.

On April 8, 1943, members of the Marseilles branch of the GCJA, led by Lefranc, arrested Henri Schloss in Nice. A search of the small villa in Saint-Jean-Cap-Ferrat where he was living turned up nothing. Lefranc already knew that the collection was being housed somewhere in Corrèze, and threatened Henri into divulging the name of the château. Lefranc also wanted Henri to tell him where his brother Lucien was living. Henri said he didn't know. At that very moment the mailman arrived with a telegraph from Lucien to his brother Henri. The envelope had a return address, a

place called the Commerce Hotel in Lamastre, located in Ardèche. Lefranc is overjoyed; he is on his way to find the collection.

To make sure Henri would not warn his family, Lefranc had him jailed in Marseilles, under the pretext of further questioning. "Don't worry about Lucien Schloss," he told his colleagues. "The Germans will take care of him." He then told the Germans where Lucien could be found. The next morning they descended upon Lamastre, which was indeed where Lucien, his brother Raymond, and his brother-in-law Dr. Prosper-Émile Weil were living. Miraculously, Raymond and Prosper had gone out for a walk and managed to escape capture. Lucien wasn't so lucky. On April 10, Lefranc and the Germans received the information for which they had been waiting. Lefranc went to the *préfet*—a Vichy government head official—in Tulle with a letter from Darquier de Pellepoix of the GCJA. He told him what they had learned about the Schloss collection and was issued a search-and-seize order.

That was how the Schloss collection was discovered at the château of Chambon, where it was mixed in with modern works from the collection of Prosper-Émile Weil, including paintings by Toulouse-Lautrec, Vuillard, Odilon Redon, and Bonnard. Lefranc hoped to take them all back to Paris without delay. But once Darquier had learned about the discovery of the collection, he sent a telegram to Vichy, dated the evening of April 10, urging the Tulle *préfet* to authorize the transport of the works to Paris for purposes of identification and evaluation. The *préfet* sensed an illegal German sweep in the French Unoccupied Zone and consulted with the Vichy's minister of the interior, asking whether he should grant Darquier's request. The answer came back: no. The *préfet* then ordered the château placed under protective custody by the gendarmes.

In the meantime, a report arrived from the GCJA in the French Unoccupied Zone—which was at odds with Darquier in the German Occupied Zone—recommending that given the collection's importance it should not be taken far. The report went on to say that since this was a matter of confiscation of Jewish property in the

Unoccupied Zone, the collection should be evaluated not in Paris, but in Vichy. The report even suggested the collection be auctioned off in Vichy. Lefranc responded by reminding them that Vichy Prime Minister Pierre Laval, like Goering, had expressed keen interest in the collection. He returned to Paris to wait for further instructions. There he told his colleagues that he was going to organize the transport of the paintings to Paris, that the Germans wanted to take everything, and that he was working for them in the matter. He made it clear that if he pulled the operation off he stood to make a sizable profit.

Not long after Lefranc's departure—and while the collection was still housed at Chambon—a touring car followed by a truck driven by a Frenchman turned up at the château unexpectedly. The passengers got out of the unmarked car and flashed French police badges at the château's warden. They were armed and under the command of a "French Alsatian," who spoke French with a very thick German accent. Inside the château was a man named Petit, the representative from the Limoges branch of the GCJA, whom Lefranc himself had placed in charge of the château in his absence. His job was to make sure the collection stayed where it was. In any case, the *préfet* in Tulle had already ordered that the works not be moved. When these French "policemen" began loading up the truck with art, the GCJA put up resistance, and it was then that the Alsatian revealed himself to be a German police lieutenant named Hess. The Frenchmen under his command were named Charles, Abel, Lucien, and Edmond. It later turned out they were all members of the so-called Bony-Lafont gang, the infamous "French Gestapo" of Paris's Rue Lauriston. This group of criminals and outlaws set up by the Gestapo served as its henchmen in most of its operations. The truck belonged to a certain Charles Hubert Cazauba, the owner of the Bijou Bar in Saint-Ouen. Clearly, the Germans had felt they needed a French cover to hijack the works—the confiscation, after all, was taking place in the Unoccupied Zone—and had therefore enlisted the help of the Bony-Lafont gang,

through the assistance of von Behr, head of the ERR. Lefranc, while playing a double game, had stage-managed the whole business.

Lieutenant Hess proceeded to load the paintings onto the truck. He managed to convince Petit and the Jordaan Bank representatives also living in the château that they were being placed under arrest. Taking Petit as hostage, Hess and his "policemen" drove off in the truck. Petit's men warned the *préfet* in Tulle, which ordered that the vehicle be stopped on the road to Masseret. Hess's response was to warn the Gestapo in Limoges. On the road to Limoges, therefore, were Hess, the *préfet*'s chief of staff, and the Tulle police chief, each hoping to take charge of the truck. The three parties agreed that the truck would be escorted by French police cars, German police cars, and vehicles belonging to the local gendarmes, and that the convoy, thus protected by members of Vichy's para-military Milice report to police headquarters in Limoges. (The Milice was an organization set up by the Vichy government to do various police duties and assist the German army.) The truck's driver and the Milice members pretended not to know where these headquarters were located. They told the others they were going to follow the German cars. Instead of taking the road that the *préfet*'s chief of staff indicated to them, they stopped at a house occupied by German soldiers and parked the truck in the courtyard. The house was off-limits to the French. The next morning, the driver drove the truck to a nearby German army base. Three days later he returned with an empty truck, declaring that its contents had been dropped off at the Banque de France in Limoges. Finally, on August 10, 1943, the crates carrying the Schloss collection went to Paris in yet another truck—driven by none other than Nériac, the chauffeur who had taken them to Chambon three years earlier.

As a matter of fact, the night before the collection's departure for Paris, the *préfet* in Limoges received a telephone call from a Monsieur Guéraud, a high official in Prime Minister Laval's staff, ordering him to let the crates through to Paris. The order came from the Vichy minister of education, Abel Bonnard. The same or-

der placed Lefranc in charge of the collection. Once in Paris, the crates were unloaded in the vault in the building housing the GCJA, located on the Rue de la Banque in what had formerly been, until it was seized, the Banque Dreyfus.[1]

The same day, Jacques Jaiyard, the head of the French state museums board of directors, having learned that the Schloss collection had been confiscated, demanded it be allowed to exercise its preemptive right in order to protect it from Nazi looting. René Huyghe, curator of the Louvre's department of paintings and sculpture, and Germain Bazin, who was in charge of the Louvre's storage facility at Sourches, came to select the works they wanted to protect. The paintings were examined in the vault in the presence of Darquier de Pellepoix, a German curator, and other experts. Huyghe and Bazin chose forty-nine paintings, whose total value was estimated at nearly $7.5 million in today's currency. They selected Jan Bruegel's *Enchanted Island*, several paintings by Adriaen Brouwer, Petrus Christus's *Pièta*, *Landscape with Swans*, then attributed to Rembrandt, Ruysdael's *Woodland Swamp*, and Corneille de Lyon's *Portrait of Clément Marot*. Bazin later recalled that when he showed the works to the Louvre's advisory board on of its members, poet Paul Valéry, he told him sarcastically that he was "opposed to the whole notion of spending so much money for paintings of little masters." Nonetheless the Louvre bought the paintings from the GCJA and they were sent off to be photographed and examined. The three years they had spent at the château had slightly damaged the paintings. They were covered in an opaque layer of grime. Moreover the lighting found inside the bank's vault was very poor. That may have been why the Germans, who went over the collection after the French had finished, chose only 260 works.[2]

Goering had followed the Schloss affair very closely, anxious as he was to have some of the works for his own collection. Again, however, he was forced to concede to Hitler's wishes first. This was now 1943, and the Reichsmarschall's position was not as strong as it

had been earlier. He could no longer risk direct conflict with his Führer. A further complication from his perspective was that this time the looted collection fell within the scope of the German embassy, since it involved direct negotiation with the French government. The embassy, through the mediation of Consul General Gerhardt, controlled those dealing with Abel Bonnard. Moreover, Dr. Erhard Göpel, member of the special committee for the Linz Museum, was placed in charge of examining the collection. The Germans asked that Bruno Lohse, the associate director of the ERR in Paris, be permitted to be present during the examination. They sent the paintings they had selected to the Jeu de Paume, where other first-rate looted collections were stored. What remained of the magnificent Schloss collection, twenty or so paintings, went to Lefranc for his pains. Lefranc also took charge of Dr. Prosper-Emile Weil's collection of modern works; he appointed the Belgian art dealer Raphaël Gérard to put them up for sale on the Paris market.

PART III

Art for Sale

9

Visitors to the Jeu de Paume

Built under Napoleon III, in the second half of the nineteenth century, as a court for a traditional game called "royal" or "court tennis" (*jeu de paume*), the building known today as the Galerie Nationale du Jeu de Paume, in the Tuileries Gardens, served in the 1930s as the "Museum of Foreign Contemporary Schools." Founded in order to show foreign modern painting and sculpture, this small museum housed its own collections of artists linked to "past traditions" on its first floor, while the works of foreign modern artists living in Paris—like Picasso, Modigliani, Gris, Chagall, Van Dongen, and Zadkine—were exhibited on the second floor.

In July 1937, the museum's curators organized an important contemporary art exhibition, *The Origins and Development of International Independent Art*, that was most assuredly not to the taste of the

Germans. Opening just a few months after the Nazi propaganda show, *Degenerate Art (Entartete Kunst)*, held in Munich, this unique and daring modern art exhibition offered a wide panorama of the origins and present situation of contemporary art. Hence, some of the painters who were being shouted down by fanatics in Munich were being glorified, at about the same time, in Paris. Paintings by Degas, Renoir, Cézanne, Seurat, Van Gogh, or Le Douanier Rousseau were standing side by side with works by Matisse, Picasso, Braque, Ernst, Dali, Tanguy, Miró, Klee, and Kandinsky.

The last important exhibition held at the museum before the beginning of the war in September 1939 was an innovative show: *Three Centuries of Art in the United States*. Organized, from May to July 1938, jointly with the (then new) Museum of Modern Art in New York, this show was the first important presentation and retrospective of American art in France. From paintings by James Whistler and Winslow Homer to photograms by Man Ray and sculptures by Alexander Calder, 380 works were shown to French visitors.

The exhibition also turned out to be one of the first multidisciplinary shows in the French capital. It helped to introduce the little-known American photographers Berenice Abbott, Alfred Stieglitz, and Edward Steichen. Visitors could also watch some of the best American movies of the 1920s and 1930s by or with D. W. Griffith, Charlie Chaplin, Buster Keaton, and Erich von Stroheim.

But after the German Occupation in 1940, the Jeu de Paume would be used for a very different function, far from the freedom and innovation of the avant garde. At the end of October and beginning of November 1940, the museum's premises were commandeered by the ERR.

Since their unexpected summer arrival in Paris, the Nazis had allotted space at the German embassy and three street-level rooms at the Louvre to deliver, sort out, and select the booty gained in their art looting. But now that Alfred Rosenberg's ERR and Goering were gaining the upper hand over Foreign Affairs minister

Joachim von Ribbentrop and Ambassador Otto Abetz, and that the quantity of confiscated artworks was increasing day by day, the German looters needed a secluded spot exclusively dedicated to this semi-military operation, which had to remain secret.

As a matter of fact, the small museum built on top of an artificial terrace overlooking the Place de la Concorde, at the northwest corner of the Tuileries Gardens, is discreetly located just off the pedestrian and central paths of the garden. This modest-sized building offered two other singular advantages: First, it could be directly and unobtrusively reached by cars and trucks from the Place de la Concorde; second, its row of large, equal-shaped rooms made it the ideal warehouse for the storage and selection of thousands of artworks confiscated in France's Occupied Zone.

The French national museums' administration, in order to stay informed of the Nazis' looting schemes and to stall their plundering efforts, had requested to make its own separate inventory of every single work of art the Nazis confiscated, and in the early days of the Occupation the Germans complied. Soon enough, however, they went back on their word; thus French authorities needed other ways of finding out what had been looted. Rose Valland, who had been the Jeu de Paume's curator, was in charge of the French "parallel" inventory and was, therefore, one of the few French citizens who continued to work there during the German Occupation. She managed, indeed, to stay abreast of its operations and gather spectacular information. Valland was able to copy the Nazi confiscation inventories and photo archives to keep track of the destinations to which confiscated works were being shipped.[1]

Not long after the Occupation had begun, more than four hundred crates were deposited and unpacked in the spacious rooms near the building's main entrance. These were the subject of the first inventories, and contained paintings, sculptures, tapestries, and other objects the Nazis had impounded. In a room toward the back of the building—called, in one of history's ironies, the "Room of Martyrs"—were stored the works the Germans had determined

to be "degenerate": the Picassos, Légers, Chagalls, Max Ernsts. Most of these paintings were either sold or used in exchanges.

Nazi bureaucrats, German art dealers, and French employees all worked side by side, cataloging and evaluating the plundered works. Given Paris's size, the number of Jewish collectors who lived there, and the fact that it was the world's largest art market, the volume was enormous, requiring a high degree of efficiency. Confiscated art went to one of several warehouses before going to the Jeu de Paume, where a kind of triage was performed. The works were divided up and, depending on their quality and desirability, either transported to Germany or put up for sale. Between the autumn of 1940 and early 1941, the volume of work was such that the ERR, with its sixty employees, was overwhelmed. This was the period when the largest confiscated collections, such as those of Paul Rosenberg and the Rothschilds, were arriving. (The Schloss collection, as we've seen, didn't arrive until 1943.) By the spring of 1941, most of the works had been inventoried and sent on to Germany— testimony to the ERR's considerable organizational skills. Information about where confiscatable works could be found came from the Sicherheitsdienst—the German security police, which included the Gestapo—as well as from the French police, who were assisted by a network of well-placed French and German informants. The first shipment left for Germany in February 1941. In March, another large convoy left Paris for Neuschwanstein castle at Füssen, which housed some of the works from the Rothschild, Bernheim-Jeune, and David-Weill collections. The ERR requisitioned some twenty first-class (and heated) passenger cars for the purpose—an indication of the importance accorded their work.

On March 20, 1941, after the convoy had reached Neuschwanstein, Reichsleiter Alfred Rosenberg wrote his "Report to the Führer." "I am pleased to inform you," he wrote, "that the main shipment of cultural artifacts abandoned [*herrenlose*] by the Jews and taken into custody by my Einsatzstab in Paris, has arrived. . . . The special train placed at our disposal by Reichsmarschall Her-

mann Goering contained paintings, furniture, tapestries, objects, and jewels of the greatest value." The report then almost casually provides the names of those from whom the art was plundered: Halphen, Kann, Weil-Picard, Wildenstein, Lévy-Benzion, and the others mentioned before. The Reichsleiter boasts of the work that the ERR has done: "The art historians of my Einsatzstab have compiled a scientific inventory of all art works, each one of which has been photographed . . . and I will soon be able to submit to you a complete list of all confiscated works."[2]

Effective it certainly was, but the ERR was not actually brilliantly run. Colonel (and Baron) Kurt von Behr permitted slightly anarchic conditions within his organization. Rose Valland described him as "large but handsome." "His hat," she went on to say, "concealed his face, and this had the advantage of also concealing his somewhat watery eyes. He wasn't without charm, and spoke French quite well."[3] Von Behr was not held in the highest regard by his staff. He had a reputation for being an amateur with more ambition than expertise. To the art historians who worked under him, his ignorance could seem boundless. In the final analysis, von Behr was little more than a playboy fond of giving receptions to ingratiate his organization with the Nazi military authorities in Paris. Perhaps inevitably, the work climate at the Jeu de Paume was heavily, even poisonously, political and characterized by fierce rivalries.

The ERR's main function, confiscation, was carried out in a manner that was simultaneously systematic and chaotic. The organization's art historians were good bureaucrats who grumbled about not being able to perform their tasks under ideal conditions. They complained that the ERR was understaffed and that the inventorying of confiscated paintings had to be undertaken without benefit of an adequate library. They warned von Behr that at the pace at which they were being forced to work, mistakes were inevitable. They would be in the middle of cataloging and measuring works when they would be interrupted by the arrival of a truck crammed with more confiscated art, and delivery men announcing

that "this came from the Rothschilds," or, more typically, that "these are from the Avenue du Bois." The delivery men—rarely the same men each time—would dump their booty in the first room available and then take off. Even later, when von Behr was about to leave his post and the ERR had undergone a complete overhaul that included composing a new inventory, it was often impossible to know where many of the confiscated works were from; all ERR workers could do was note that they were of "unknown origin."[4]

Von Behr's assistant was a young art historian named Bruno Lohse. A specialist in seventeenth-century Dutch art, as well as a member of the Nazi Party, Lohse had arrived to help catalog the art confiscated from Alphonse Kann's collection.

This exceptional collection, comprising a sophisticated mix of Old Masters, nineteenth-century and modern paintings, sculptures, medieval and Renaissance tapestries, Oriental art objects, and precious manuscripts, had been seized at Kann's townhouse in Saint Germain-en-Laye, west of Paris. The ERR inventory, finished belatedly by an overwhelmed staff, described 1,202 items. These magnificent pieces, unfortunately, became a true windfall for the Nazis' exchange and barter dealings, which would end up scattering them across Europe.

The Kann collection included more than twenty Picassos—including a 1915 Harlequin—numerous Braques, Klees, Matisses, Massons, Cézannes, one of the most exquisite portraits painted by Degas (*Madame Camus at the Piano* [*see* insert C10]), several Courbets, Manets, Renoirs, fifteenth- and sixteenth-century Italian masters and French eighteenth-century paintings. Even though most of the collection did not quite fit Nazi taste, it quickly interested Goering as a source of high-quality lots, easy to sell or to barter for artworks closer to his own taste.

Alphonse Kann, born in 1870, the elegant man who created this collection and left it behind before the Nazis arrived, was a refined art lover and connoisseur. A key figure in the French art-collecting world, Kann was a difficult and irascible man respected and ad-

mired for his sure eye and exceptional taste. In his townhouse, Kann displayed a Matisse next to a Gothic tapestry, or would place pre-Columbian art side by side with medieval or Renaissance sculpture, or hang a Bonnard next to archaic Chinese bronzes.

It was said at the time that the name Kann, written with double "nn," was "le plus chic du chic." The writer Marcel Proust—who probably integrated some of Kann's features into his character Charles Swann—had lovingly admired Kann since their playmate days on the Champs-Elysées. Proust would show up early in the morning at Kann's and imperturbably watch him get dressed while Kann would get angrier and angrier.

In 1927, Kann had done the unthinkable among classical art collectors of the time: He had sold the greater part of his excellent Old Masters collection at a New York auction sale—paintings by Tintoretto, Bruegel, Rubens, Fragonard, and important thirteenth- to fifteenth-century Italian masters, like Cimabue and Pollaiuolo—in order to make room for nineteenth-century and modern paintings. But Kann's unusual decision turned out to be disastrous, since Lohse and the ERR had no use for this rich collection unless they dismembered it.

Lohse soon adapted to the confusion that reigned at the ERR. He helped von Behr organize the schedule of German confiscations and arranged matters with French officials, while at the same time keeping an eye out for Goering's interests. On September 10, 1941, for example, von Behr and Lohse met with Darquier de Pellepoix of the GCJA and Jean-François Lefranc, the dealer involved in the Schloss confiscation. The Frenchmen offered to tell the Germans where certain Jewish collections could be found—in return for a 25-percent commission, which, in principle, would be due the French government. Lefranc was passing himself off as Darquier's "attaché," and as an "artistic adviser" to the Swiss collector Oskar Reinhardt. Von Behr and Lohse were interested in the offer, so much so that Lohse dispatched a letter to Goering's office, recommending that an agreement with Lefranc be made right away. "After all," he noted, "these

Frenchmen are betraying their own country. Traitors need to be paid." Meanwhile, von Behr had invited a German art historian working for the ERR named Dr. Eggemann to dinner at Maxim's to talk about the famous Schloss collection, which at that point had still escaped their clutches. At the restaurant, the German official introduced Darquier, and the three men began to talk about the Schloss business. So began the first Franco-German collaborative effort between the ERR and the GCJA. It would eventually lead to the discovery of Schloss's trove.[5]

During a private exhibition at the Jeu de Paume, Lohse was introduced to Goering, who asked the young historian to scout for art for his collection at Carinhall. Lohse threw himself into the task. Goering granted him special privileges, such as letters of introduction that opened practically every door. Assisted by the art historian Gunther Schiedlausky, Lohse organized private showings for Goering. This was no small feat: Between November 1940 and December 1941 Lohse and Schiedlausky mounted no fewer than ten displays.

Goering's visits to Paris were generally short and nothing could be left to chance. The works had to be carefully chosen before the Reichsmarschall's arrival. Hofer, the curator of Goering's private collection, sometimes came to Paris and preselected works himself. He would attend auctions, then visit the Jeu de Paume to examine the most recent confiscations. In a letter to Goering dated September 26, 1941, Hofer describes what he found at the Jeu de Paume, namely, works from the Rosenberg collection, which had been seized at the bank in Libourne only three weeks earlier and were already on display:

> As regards the collection belonging to the Jew Paul Rosenberg, Paris.
> I asked von Behr to reserve the following works: two drawings by Ingres, seven paintings and a drawing by Corot, four pastels and a painting by Degas, a Pissarro, a painting by Van Gogh, and a painting by Toulouse-Lautrec. They are all of exceptional quality, amazingly inexpensive, and particularly well suited for exchange

purposes. I will provide the names of those who might be well disposed to purchase the works. . . .

As regards those paintings that remained of the property of the Jew Paul Rosenberg, I left them with the ERR. For the most part they consisted of nineteenth-century degenerate art and were not, in my opinion, of any value as exchange pieces.

The pieces unworthy of exchange were of course paintings by Picasso, Matisse, and others. Having told Goering in detail what was contained in the collection of the "Jew Seligmann," Hofer mentions the collection of paintings owned by Braque, which were also confiscated at the back in Libourne:

Braque is an Aryan who works as a painter in Paris. The sequestration of his collection in Bordeaux [Libourne] will therefore have to be lifted. I have negotiated personally with him for his *Portrait of a Young Girl* by Cranach, and indicated to him that were he prepared to sell his Cranach it would be possible to arrange a rapid release of his collection. . . . He has reserved the painting for us, though he had not intended to sell it, and will notify us of his decision. . . . His other works are of no interest to us whatsoever.

Hofer had his eye on other collections. In the same letter to Goering, he continues:

I have inspected the paintings of Baroness Alexandrine R. [Rothschild]. They are truly *sensational!* Her collection consists of twenty-five paintings, each of the very highest quality and greatest importance. Among them is the charming *Infanta Margarita* by Velázquez, which you must use any means necessary to acquire for your collection. You will never find a Velázquez of such exquisite quality and in such perfect condition. The painting is a marvelous addition to your collection, which does not yet have a Velázquez, without a doubt the greatest of painters. . . . This collection also includes a large number of modern jewels. Naturally, everything will remain where it is until you decide what you want.[6]

Hofer wasted no opportunity to demonstrate to Goering his usefulness as a dealer and negotiator; he expedited the processing of the works the Reichsmarschall chose and used the "degenerate" pieces from the Rosenberg collection to buy the Velázquez. After the war, it would be discovered that the painting was a mere copy from the original.

Few artworks escaped Goering's agents and the ERR's watchful officers at the Jeu de Paume—including, ironically, paintings owned by other European Jews that had been sent to Paris for safe-keeping before the outbreak of the war. Dutch-German banker Friedrich ("Fritz") Gutmann was the unfortunate owner of some of these foreign-owned looted works. A well-known collector who lived with his wife and two children near The Hague, Fritz Gutmann was also the youngest son of the founder of the powerful Dresdner Bank in Germany. His parents had belonged to Berlin's cosmopolitan high society and high-finance elite, which cultivated well-established links to European bourgeoisie and aristocracy. Gutmann had two sisters, one of whom was married to Lucca Orsini Baroni, an Italian ambassador to Berlin, and the other to Baron von Essen, a Swedish ambassador. His niece was married to the head of the German Rothschilds.

The family's collection of Renaissance gold and silver—whose most important piece was a splendid beaker by the Nuremberg Renaissance goldsmith Jamnitzer—and jewelry and bronzes had been entrusted to him. Gutmann and his wife, Louise von Landau, also owned a series of portraits by Old Masters and other important pictures: *Portrait of a Young Man* by Botticelli, a *Hercules and the Lion* by Cranach, *Sitting Madonna and Child* by Memling, a landscape by van Goyen, and the small *Portrait of a Man* by Dosso Dossi. In the late 1920s, Gutmann added to his classical collection three paintings that were then considered to be "modern": *Landscape with Smokestacks*, a Degas pastel over monotype (*see* insert C8); *Woman Drying Herself*, another pastel by Degas; and *Apple Tree in Bloom* by Renoir. These three paint-

ings hung in Mme. Gutmann's drawing room on the ground floor of their house.

In 1939, feeling war coming, Gutmann kept one part of his collection at home, sold another portion, sent some artworks to New York, and decided to consign some thirty of his own paintings, sculptures, and art objects to the art firm of Paul Graupe et Cie at 16, place Vendôme, in Paris. By the time the Germans occupied France, the Paris art firm had removed most of Gutmann's paintings for storage at Wacker-Bondy's, its forwarding agent, located on Boulevard Raspail.

When war finally broke out, Gutmann, believing his art collection was safely protected in France but sensing that the war's outcome was not clear, sent a note to his daughter Lili, married and living in Florence: "Very Important! For your information later, remember that . . . the firm Paul Graupe in Paris . . . has a lot of valuable pieces," and he went on to describe them, signing "P." for "Papi."

While in Occupied Holland, Gutmann was soon harassed by a traveling Hofer, who forced him to sell silverware and bronzes from his superb family collection to Goering. In Occupied France, by July 1940, part of the Gutmann collection on the Place Vendôme had already been seized by the Germans. As for the rest, in early 1941 German art dealer Karl Haberstock, close to Nazi circles, had managed to extort a letter from Fritz Gutmann addressed to the Paris art company allowing the German dealer to take possession of a few of his paintings held at Wacker-Bondy's. Haberstock took the Cranach and the Memling, among six other paintings.

Finally, between 1942 and the spring of 1943, the ERR visited Wacker-Bondy's on Boulevard Raspail and seized the remaining paintings of the Gutmann collection, registering them on an inventory list under the initials MUIR (markings of undetermined meaning). The Degas paintings and the Renoir, considered too modern for Nazi taste, were designated for exchange and trade. As for the small Dosso Dossi, it joined the Goering collection on November 25, 1942.

While Goering was most certainly the most powerful visitor to the Jeu de Paume, he was by no means the only one. Dozens of French dealers and German brokers very quickly realized what sort of profits were to be made from this fabulous storehouse of stolen goods. Gustav Rochlitz, an art dealer with a gallery at 222, rue de Rivoli (very near to the Jeu de Paume), became a regular. Of the twenty-eight official exchanges—mostly of modern art for classical works—that took place at the Jeu de Paume during the Occupation, Rochlitz organized eighteen. Two large exchanges were organized by Adolphe Wüster, a cultural attaché at the German embassy, two by the dealer Max Stoecklin, and one by the Maria Dietrich Gallery in Munich. Still others were organized by Swiss dealers.

But it was Rochlitz who was the Jeu de Paume's most dedicated visitor. He had lived in Paris since 1933 and established extensive contacts in the art world. French authorities arrested him in September 1939 because of his German citizenship. Liberated when the Germans arrived, he very quickly took advantage of the new demand for art, using the embassy as a brokerage house. He began a collaboration with Lohse and the ERR in early 1941. Lohse bought six paintings from Rochlitz for Goering, and the result was that Rochlitz was given a visa enabling him to travel freely between the French and German-occupied zones. As a result, he became something of a traveling salesman, in the Free Zone particularly. Goering didn't offer such privileges without expecting something in return. Rochlitz had to give the Reichsmarschall an option on every work of art he came across. In February 1941, their partnership grew even closer. Learning that Goering was planning to be in Paris for a week, Rochlitz proposed he buy *Portrait of a Man* (attributed to Titian) and a still life by the Dutch painter Jan Weenix. Lohse duly put these paintings in the show being prepared for the Reichsmarschall's arrival. Goering, who never wanted to pay for anything,

proposed an exchange (Rochlitz also might have suggested it). In exchange for the Titian and the Weenix, Rochlitz received eleven paintings by nineteenth- and twentieth-century French masters— among them, a very important Degas, a Braque, and a Cézanne, all from the Alphonse Kann collection, and a Corot, three Matisses and two Picassos from Paul Rosenberg's. Most were well-known paintings that we will track down later in this book. Ever the sly man, after the war, during the course of his interrogation, Rochlitz would maintain that had he not taken these paintings, the Nazis would have destroyed them. From the eighteen exchanges in which he was involved, Rochlitz came away with no fewer than eighty-two paintings. He had arrived on the scene just at the moment when the wave of plundering was cresting, and the ERR was looking to get rid of hundreds of works that were aesthetically unsuitable to Nazi ideology.

During the course of his long collaboration with the ERR, Rochlitz disposed of a number of his paintings among art dealers and collectors on the Paris market and elsewhere in Europe.

He must have been satisfied with the bartering system he had established with the ERR. Thanks to Nazi contempt and ignorance on matters concerning modern, or so-called degenerate art, Rochlitz obtained many excellent paintings he could easily sell.

Hence, on February 2, 1942 Rochlitz delivered an *Adoration of the Magi* by an unknown sixteenth-century Flemish painter. He received, in exchange, eight modern paintings, including a still life by Picasso, two Matisses and a Braque, all from the inexhaustible Kann collection; a Pissarro titled *Country Scene*, signed and dated 1887, coming from the looted Meyer collection and missing to this day. And, finally, a Léger listed as *Knight in Armor* (105 x 82 cm.) in the Nazi inventory, and probably looted from the collection of Léonce Rosenberg, Paul Rosenberg's brother. Being incapable of looking at and understanding modern art, Germans at the ERR most probably made a mistake while registering this painting, since nothing in Léger's work fits this description or these dimensions.

A few months later, on May 21, 1942, for example, Rochlitz was given three paintings by Matisse, all dated 1937, and all from the Rosenberg collection: *Seated Woman Wearing a Blue Dress*, *Seated Woman Wearing a White Blouse and Red Jacket*, and *Reclining Woman with Still Life of Flowers and Fruit*. There was also a painting by Corot entitled *Wooded Countryside*. These he received in exchange for two still lifes, one by Van Schooten and the other by Peter Klaes, both of which ended up hanging at the Reichstag in Berlin. Martin Bormann himself approved the swap. Rochlitz later also admitted selling *Woman in Blue Dress*—still another work confiscated at Libourne—to the Parisian dealer Paul Pétridès, and *Woman in White Blouse* to a broker named Isidore Rosner.

A second barter took place on July 24, 1942. Rochlitz had come into possession of Gauguin's *Yellow Christ*, and two more works by Matisse from the Rosenberg collection, for which he exchanged a painting depicting the Three Graces, attributed to the Fontainebleau School. One of the Matisses he sold to Rosner. As for the Gauguin and the other Matisse, Rochlitz maintained after the war that they had vanished. Out of eighty-two paintings that he'd obtained from the Jeu de Paume, Rochlitz sold seven to Pétridès, eleven to Isidore Rosner, and six to his associate Hans Wendland in Switzerland.

Another client of the Jeu de Paume who was very welcome—though she never actually appeared in person—was Maria Dietrich, friend of Eva Braun and art dealer for Hitler. Dietrich had a reputation in art circles for hopeless incompetence; many of the paintings she declared to be masterworks turned out to be fakes. Still, this reputation did not prevent her from buying works for Hitler's museum and for her Munich clientele. Lohse once spent a day in her gallery, showing her photos of recently confiscated objects. One was Pissarro's *Port of Honfleur in the Rain*. Dietrich im-

mediately agreed to exchange it for two sixteenth-century Franco-Portuguese panels.

The Germans were not the only ones to profit from the confiscated works in the Jeu de Paume. Plenty of ordinary, opportunistic French citizens also managed to tap its treasures. For example, two ERR workers, Amical Leprael and Valentin Breton, told what they knew about the Nazi stockpile to a dealer named Charles Collet. Collet acted on what they told him and ended up buying an enormous quantity from the ERR. By the war's end, enough works to fill fifty two-ton trucks were found in his home. Collet's methods were adopted by others. Another pillager, named Dupont, went to various ERR warehouses and bought damaged furniture at a discount. On occasion, in exchange for a percentage, a warehouse manager would even help him damage the goods.

Some French dealers, such as Martin Fabiani and Roger Dequoy, profited handsomely from German confiscations. Dequoy was the manager of the old Wildenstein Gallery and the gallery's secret representative during the Occupation. The close contact between the Wildenstein house and the Germans before and during the war gave Dequoy a nearly unbeatable advantage during negotiations. On January 26, 1944, sixty modern paintings, all from Jewish collections, arrived at the former location of the Wildenstein Gallery on the Rue du Faubourg Saint-Honoré. Adolph Wüster, the cultural attaché at the embassy, had inspected the paintings. This would have been the largest exchange ever executed between the ERR and a dealer. Dequoy, seconded by Fabiani, delivered an eighteenth-century landscape attributed to Hubert Robert and to Boucher, and six smaller works, four of which were by Guardi, the painter of Venetian scenes, and two by Pannini, the Rococo painter. All were to go to the Linz museum. The paintings in question, valued at 2 million francs, were paid for with fifty-two modern paintings whose value approached 20 million francs. Unfortunately for the two dealers, the transaction never happened. It was canceled by the administrative head of the ERR, who was just then visiting

from Berlin; he thought the terms too unfavorable. The disappointed dealers had to return the sixty paintings.[7] The landscape was later sold in Berlin for 3.5 million francs to the art dealer Lange, who in turn sold it to the Linz museum.[8]

☐

One of the few Nazi dignitaries to appreciate the French moderns, and to seek them out for his collection, was the Nazi minister for foreign affairs, Joachim von Ribbentrop. Using his faithful cultural attaché Adolf Wüster as his broker, von Ribbentrop was one of the Jeu de Paume's regulars. On November 24 and 27, 1942, for example, an exchange between von Ribbentrop and Goering was organized by Wüster and the ERR. The Reichsmarschall gave Delacroix's *Lion with Snake* and Utrillo's *Rue de Sannois*, both from the Rosenberg collection, as well as *Forest Scene* by Courbet, confiscated from the Bing collection. In exchange, the ERR received, on Goering's behalf, a Gobelin tapestry, a Jodocus de Momper, and a work attributed to Albert Cuyp, the seventeenth-century Dutch landscape painter. The Utrillo, valued at the time at 10,000 francs, has never been found since.

Shipments of confiscated art to Germany continued until the summer of 1944. The final ERR report, written in July 1944 in Berlin, gives a clue as to the scope of the plunder. Between April 1941 and July 1944, no fewer than twenty-nine major shipments of works into Germany from Paris took place; for the first one, as we might remember, Goering had provided a Luftwaffe escort. In all, 120 railway cars filled with 4,170 crates of art crossed the French border into Germany. From France alone—leaving aside Holland and Belgium—21,000 objects from 203 different collections were confiscated. Most were paintings, drawings, and engravings—10,000 in all. Though many of these works were naturally not masterpieces, they were all shipped to one of six Nazi warehouses, including the one at Neuschwanstein. Some of the paintings, draw-

Woman's Torso, or **Sitter for "The Washing,"** or **"The Laundry"**
(whereabouts unknown)
ÉDOUARD MANET (73.5 × 60 cm.), 1875
Josse Bernheim-Jeune Collection
(Photo courtesy Bernheim-Jeune)

Woman in White *(whereabouts unknown)*
BERTHE MORISOT
Josse Bernheim-Jeune Collection
(Photo courtesy Bernheim-Jeune)

Watering Place at Marly in the Snow *(whereabouts unknown)*
ALFRED SISLEY, 1876
Josse Bernheim-Jeune Collection
(Photo courtesy Bernheim-Jeune)

Banks of the Seine in Snow *(whereabouts unknown)*
ALFRED SISLEY, (27 × 46 cm.)
Josse Bernheim-Jeune Collection
(Photo courtesy Bernheim-Jeune)

Reclining Nude, or **Nude Hiding Her Face** *(whereabouts unknown)*
ÉDOUARD VUILLARD, 1904 © by SPADEM, 1995
Josse Bernheim-Jeune Collection
(Photo courtesy Bernheim-Jeune)

Breakfast *(whereabouts unknown)*
PIERRE BONNARD, 1910-© AdAGP, Paris
1995, © by SPADEM, 1995 (63 × 91cm.)
Josse Bernheim-Jeune Collection
(Photo courtesy Bernheim-Jeune)

**Arcachon. Two
Women Conversing**
(whereabouts unknown)
PIERRE BONNARD–©
AdAGP, Paris
1995 © by SPADEM,
1995
Josse Bernheim-Jeune
Collection
*(Photo courtesy
Bernheim-Jeune)*

Portrait of Coco
(whereabouts unknown)
PIERRE-AUGUSTE
RENOIR, 1910
Josse Bernheim-Jeune
Collection
*(Photo courtesy
Bernheim-Jeune)*

Algerian Woman Leaning on Her Elbow *(whereabouts unknown)*
PIERRE-AUGUSTE RENOIR, 1881–82
Josse Bernheim-Jeune Collection
(Photo courtesy Bernheim-Jeune)

Vase with Anemones *(whereabouts unknown)*
PIERRE-AUGUSTE RENOIR, 1869
Josse Bernheim-Jeune Collection
(Photo courtesy Bernheim-Jeune)

Still Life with Herrings *(whereabouts unknown)*
PAUL CÉZANNE (32 × 40 cm.), 1864–66
Josse Bernheim-Jeune Collection
(Photo courtesy Bernheim-Jeune)

Snow Scene at Auvers-sur-Oise *(whereabouts unknown)*
PAUL CÉZANNE (38 × 46 cm.), 1872–73
Josse Bernheim-Jeune Collection
(Photo courtesy Bernheim-Jeune)

Red Flowers in White Vase, or **Flower Vase on Round Table**
(whereabouts unknown)
PAUL CÉZANNE (49 × 36 cm.), 1873–77
Josse Bernheim-Jeune Collection
(Photo courtesy Bernheim-Jeune)

The Jas de Bouffan *(whereabouts unknown)*
Paul Cézanne (58 × 71 cm.), 1875–76
Josse Bernheim-Jeune Collection
(Photo courtesy Bernheim-Jeune)

Portrait of the Artist with Long Hair *(whereabouts unknown)*
PAUL CÉZANNE (41 × 32 cm.), 1865–68
Josse Bernheim-Jeune Collection
(Photo courtesy Bernheim-Jeune)

Gennevilliers, or **The Walls at La Glacière** *(whereabouts unknown)*
PAUL CÉZANNE (54 × 65 cm.), 1879–82
Josse Bernheim-Jeune Collection
(Photo courtesy Bernheim-Jeune)

The Judgment of Paris *(whereabouts unknown)*
PAUL CÉZANNE (52 × 62 cm.), 1883–85
Josse Bernheim-Jeune Collection
(Photo courtesy Bernheim-Jeune)

Flower Vase on Yellow Background *(whereabouts unknown)*
VINCENT VAN GOGH
Josse Bernheim-Jeune Collection
(Photo courtesy Bernheim-Jeune)

Odalisque in Red Pants *(whereabouts unknown)*
HENRI MATISSE–© Estate of H. Matisse, circa 1920
Josse Bernheim-Jeune Collection
(Photo courtesy Bernheim-Jeune)

ings, and sculptures from the David-Weill, Alexandrine de Rothschild, and Paul Rosenberg collections were taken to the warehouse located in the Nikolsburg castle, in the Sudetenland.

The other major result of German confiscation was that the Parisian art market was inundated by stolen art put up for sale. Matisse, who had stayed in France, informed Paul Rosenberg's brother in Paris in 1942 that he had seen some of his own paintings taken from Libourne on the market. These included *Pineapples on Rose Background, Sleeping Woman in Gypsy Blouse on a Violet Marble Table with Fruit, Daisies and Fruit Against Black Background,* and one more still life, *Pewter Pot with Lemons on Green and Black Table.*

An "Institute for the Study of the Jewish Question" was set up where the Rosenberg Gallery once had been. When the institute was being moved in, 4,500 photographs of paintings from the gallery were discovered. Officials decided to sell them. Picasso got news of the sale, and asked the Louise Leiris Gallery—formerly the gallery of the dealer Kahnweiler, newly "Aryanized" by his daughter-in-law—to buy the plates of his work, and those of Braque's. Picasso was extraordinarily cautious by nature but even he was taken in by the art dealer Fabiani. While visiting Picasso's studio on the Quai des Grands Augustins, Fabiani offered to sell him a work by Henri Rousseau. Picasso demanded that Fabiani provide him with a certificate guaranteeing there was nothing illegal about the sale. He carefully kept this guarantee. After the war, he learned, completely by chance, that the painting had been part of the confiscated collection belonging to Pierre Wertheimer.[9]

The complex circuit of the confiscated art can be understood only in the context of the vast Parisian art market created by the war. This market evolved through several phases, driven by the new German clients, the confiscations, and the peculiarities of Nazi taste.

10

Business as Usual: The Paris Art Market During the War

The Paris art market continued uninterrupted during the war years; indeed, it flourished. After a brief hiatus following the Phony War of 1939–40, public auctions rapidly picked up again, attracting more buyers than ever and getting prices far higher (for French art at least) than had been the case before the war. So, for example, in December 1941 Seurat's *The Little Blue Peasant*, which had come from the collection of the art critic Félix Fénéon, sold for 385,000 francs at the Drouot auction house. A year later, in December 1942, again at Drouot, *The Valley of the Arc and Mont Sainte-Victoire* by Cézanne, estimated at 5 million francs when it was auctioned off

from the collection of Dr. Viau, brought the highest prices of any sale during the war.[1]

Most French buyers, as well as most dealers and brokers, went after works by Cézanne, Degas, Monet, Renoir, Corot, and Courbet. Sensing the new demand for French art, the dealer Alfred Daber went to Giverny to see Claude Monet's son Michel. He bought fifty paintings by Monet and Renoir from the painter's collection, then sold them off for a large profit. Works by older painters who had declined in popularity before the war were going for higher prices. This surging demand for French art embraced works even by artists who were resolutely modern, like Matisse, or classified as Jews, like Pissarro and Modigliani, and by all those artists whom the occupying Nazis looked upon as degenerate. Galleries were continually mounting shows and organizing auctions that attracted large crowds—and brought hefty commissions.[2]

In fact, the war was a godsend for Paris's art market. It brought an end to the crisis of the 1930s, when art prices declined by as much as 70 percent from what they'd been earlier; forcing a third of Paris's galleries to close their doors. New collectors and speculators eager to get rid of banknotes, whose value was unstable, started buying paintings, antiques, and rare books. These they saw as solid investments in a troubled time. Significant liquidation sales occurred; the uncertainties of war stimulated both supply and demand. "People had plenty of cash," recalled Alfred Daber, "but there were no pretty clothes, no new cars, no vacations, and no restaurants and cabarets in which to spend money. All you could do was buy butter on the black market. That was why everyone started investing in the art market."

These latecomers gradually transformed the market itself. The demand for decorative works, especially landscapes and still lifes, and small works, which were easier to move and would fit in smaller accommodations, was enormous.[3] On the other hand, Paris was no longer accessible to foreign buyers. Before the war, the world's greatest collectors, curators from foreign museums, and brokers

regularly came to Paris, for it was still incontestably the world center for painting. Parisian dealers routinely went to England or the United States to find clients. The most powerful French dealers, such as Durand-Ruel, a specialist in Impressionism, Knoedler and Wildenstein, who handled older works, and Paul Rosenberg, who dealt in avant-garde works, continued doing business with foreigners, mounting shows with works that came from all over Europe. But access to London was problematic, and even before America entered the war in December 1941 it had become increasingly difficult for French dealers to get to the wealthy collectors who lived in New York or Hollywood. In the Occupied Zone at least, doing business with the English-speaking world was too risky. In the Unoccupied Zone, the Vichy government had imposed complex administrative regulations on the exportation of France's "national patrimony," and visas were increasingly difficult to obtain, even when they were for crossing into a neutral country such as Switzerland. The international clientele that had kept French galleries and antique stores afloat before the war was rapidly ceding its place to the Nazi conquerors.

The "Aryanization" of art galleries and magazines taking place in France, a process reinforced by Vichy's anti-Semitic laws, had an immediate impact on the market. Many Jewish dealers, respected and admired for their judgment and experience, were now barred from doing business, or even forced to go into exile. Their absence soon became painfully apparent. Deploring the lack of experts available to advise German clients, a member of the Nazi information services based in Paris explained that this was because most of the prewar art experts had been Jews. Since the 1920s, they had contributed to the development and maintenance of a worldwide network of wealthy art buyers. This network collapsed as soon as they were denied a role in Europe's largest art market.

The new Vichy government tried—in truly blundering fashion—to use new administrative measures to take advantage of the bullish market. In June 1940, after confiscating possessions belong-

ing to emigrants—primarily Jews who had fled the German advance in France and who'd been stripped of their French citizenship—Vichy began to sell off some of their collections. Profits from these sales were to go to the "National Assistance," an official charitable organization. The first works to be put up for sale were to come from the Rothschild family's collection. Vichy trumpeted the event, and its announcement was echoed zealously by the press. The Rothschild collection, after all, was said to contain more than five thousand artworks and to include masterpieces of every period, as well as antiques, silver, rugs, sculptures, and thousands upon thousands of rare books.[4] The proceeds from the sale would jump-start the French economy.

Instead Vichy had jumped the gun, for the celebrated collection had been preempted by the occupiers, who had labeled the works "abandoned goods." They were earmarked for Hitler's and Goering's personal use, quietly and efficiently confiscated, and placed in storage at the Louvre and in the Jeu de Paume, beyond the reach of French authorities.[5] For months, Vichy officials registered indignant protests. Liquidating French assets was their prerogative. And here they were supposed to be grateful that the Germans even cut them in for a share. In this mock-heroic battle (consisting mainly of letters) between the victorious and all-powerful Germans and French authorities stubbornly insisting on their rights to deprive former citizens of their property, a battle in which the Jews were double losers, it was the Germans who carried the day. By the time the ERR finally condescended to offer a detailed reply to Vichy's claims in November 1941, the fabulous Rothschild collection had been safely stowed in Germany for some eight months. What was to have been a grand public sale sputtered to nothing.

What most changed the French art market during the war was the sudden arrival of large numbers of German buyers with deep pockets. By the end of the Occupation, these Germans had established complex commercial relations with French dealers. We have already seen how Hitler, Goering, and the ERR agents succeeded in

satisfying their seemingly insatiable appetite for art through sales and confiscations. They were soon joined by representatives from the Reich's museums and galleries, by diplomats, civil servants, bankers, Nazi Party dignitaries, and wealthy private citizens, all of whom arrived right behind the Wehrmacht. They profited from the enormously disadvantageous exchange rate imposed upon the French franc by the armistice (twenty francs to each Reichsmark), and from all the commercial and psychological advantages that come with being conquerors. In their wake came the Austrians—the Germans' new compatriots—the Belgians, and the Dutch, and not far behind them were the Swiss, who for all their vaunted neutrality were to be found everywhere. Working in conjunction with each, they soon succeeded in taking over the coveted collectors' market. Certain French dealers welcomed them with open arms and assisted them in their task.[6]

The Reich's museums took full advantage of the favorable conditions and immeasurably enhanced their holdings of European art. Thanks to the exceptional deals being made in France and their growing acquisition budgets, the museums purchased a remarkably large number of works in a remarkably short time, and by so doing made the German brokers who acted on their behalf in Paris very rich. Ministries and institutions started renovating their offices and decorating new spaces with paintings and antique French furniture, acquired at a "fair price." The National Socialist Party also profited from the windfall, opening new offices throughout the occupied and repopulated territories of Central and Eastern Europe. Party leaders, many of them art and antiques amateurs, furnished their homes and offices at minimal cost. Plenty of European collectors whose incomes had risen with the war realized how much could be made by seizing the moment and buying art.

The new players were so active, and their transactions so numerous and varied, that it would be impossible to track down every deal. And the process of buying artworks in Occupied France and then exporting them to Germany was both more restrictive and

more circuitous than during peacetime. Not only was it necessary to extract an export license from the finicky French authorities, a process that could sometimes take months, one also had to be prepared to take a hit from the Reichsstelle, the governmental agency monitoring business dealings during wartime. Once a buyer had paid for a painting in Reichsmarks, he had to obtain approval from the appropriate French customs agent, generally a Nazi confederate. To avoid wasting time and losing sleep, many German collectors obtained safe-conduct passes from the Wehrmacht in Paris, thus getting around French regulations. They got around Berlin officials by paying dealers in cash. These dealers would return the favor by not reporting the transaction. Most of the deals were therefore neither recorded nor honest. When he was being debriefed by the Allies after the war, one German official told them he thought that "the cleverest buyers and sellers never filled out forms or issued receipts. . . . Many of the transactions were done in complete secrecy, or using third parties." The Germans nearly always got their way in a deal. They could back up their offers with threats, or with promises of favors, such as "assuring an owner that his son would be released from a prisoner-of-war camp" were he to agree to their conditions.

We will never know how much German buyers spent on art, nor how many works they bought. What we do know is that they were most interested in paintings and drawings by German, Dutch, and Flemish artists of the fifteenth, sixteenth, and seventeenth centuries, which were abundant in France. Works by Dürer, Holbein, Cranach, Ruysdael, Rembrandt, Hals, Van Dyck, and Vermeer were usually at the top of their shopping lists, and the prices for works by these artists went very high. In 1942, many were openly surprised that two works by Rembrandt, *Portrait of Titus* and *Countryside Near a Castle*, which had belonged to the wine merchant Etienne Nicolas, were sold to the Linz museum for 60 million marks.[7] So obsessed were these newcomers with art originating north of the Alps that they sometimes paid handsomely for works of mediocre

quality. (Some dealers also tried to pass off art as Northern European when it wasn't.) These same wealthy clients were also attracted by French labels, particularly when it came to antique furniture, tapestries, and rugs.

Thanks to recently declassified information coming from various intelligence services, it is possible now to get a more precise idea of what the Germans were doing on the French market—which works they bought and which French dealers were involved.[8] These files are among the vast number of documents collected by British and American officials after the war, as well as by the DGER in France, and they deepen our understanding of what went on in the French art market during the war. Until recently, any investigation into the subject was stymied by the impossibility of getting at essential documents because they were still classified—and by the confidential nature of many of the transactions.

The Schenker Papers in particular have proven to be a gold mine. A classified document of merely twenty-nine pages, the report was filed by the English army. Its name comes from the fact that it reproduces records and documents seized from the Paris offices of Schenker International Transport, a large German transport company that specialized in transporting and moving works of art. Schenker was used by several German buyers, and enjoyed close relations with the German embassy in Paris, which hired it to warehouse, pack, and transport confiscated art to Germany. Douglas Cooper, who led the official British investigation into Nazi confiscations, gathered the abandoned files from the firm's Paris offices. He realized they provided priceless information about Franco-German deals. For one thing, they contained evidence of both legal and illegal transactions that took place between January 1941 and July 1944: descriptions of artworks sent off to the Reich, long lists of German buyers and the works they bought, the names

of the French dealers involved, and the dates of the transactions. Appendix A to this book features excerpts from "The Schenker Papers" including a list of the names and addresses of French dealers who made the largest deals with the Germans. We ought to keep in mind that some of the family names listed there are misspelled. We ought also to keep in mind that while some dealers were forced to do business with the Germans, others welcomed the wealthy new clients with open arms. These reservations aside, these unpublished documents, combined with known facts, permit a realistic idea of what went on during the war.

The Schenker Papers reveal that many of the purchases were made by German museums. There were the Rheinisches Landesmuseum and the Provinzialdenkmalamt in Bonn, the Städtische Kunstsammlungen in Dusseldorf, the Folkwang Museum in Essen, the Kaiser Wilhelm Museum in Drefeld, the Städtisches Museum für Kunst und Kunstgewerbe in Wuppertal-Eberfeld. These transfers meant that a group of curators in Bonn and Dusseldorf, acting as brokers for those institutions and therefore in close contact with some established French dealers, were kept very busy.[9] These five museums paid at least 31 million francs for at least 204 paintings, drawings, engravings, and sculptures, as well as for a number of antiques. An impressive quantity, to be sure, but the amount paid to purchase them was also huge for the time. The report confirms that these curators had chosen the right moment to buy nineteenth-century art, particularly given the favorable exchange rate. However, most of the German museums were not interested in French painting or sculpture from the nineteenth and twentieth centuries, though the confiscation of many Jewish collections meant that the market was flooded with it.

For all these reasons, the Folkwang Museum in Essen found itself in a particularly advantageous position. A small institution, the Folkwang was located in the heart of the Ruhr Valley, a region of Germany blighted by heavy industry (coal and steel). Essen was the family seat of the Krupps, the armaments dynasty that was one of

Hitler's main sources of support and a major cog in the German war machine. Aided by the SS, the Krupps ran forced-labor camps whose workers were decimated by tuberculosis and malnutrition.

The museum began to be active on the French market very early on, and expanded its already impressive collection of nineteenth-century French art, one of the most complete in Europe. In just five months, from January to May of 1941, its curators acquired at least 44 works in Paris. The works were immediately dispatched to Germany. Among them was Courbet's superb 1869 oil painting *The Cliffs at Étretat, after a Storm* (*see* insert C14), which the Parisian dealer André Schoeller sold for 350,000 francs. The Folkwang Museum seemed anxious to increase its collections, for it bought three works by Corot from three different galleries: Etienne Bignou, Schoeller, and Fabiani. The Fabiani Gallery, particularly close to the Germans, sold the museum an unidentified Corot for 1.5 million francs. The museum also purchased five drawings and an engraving by Delacroix, four paintings and an engraving by Géricault, Ingres's *Portrait of Madame Gabriac*, which was sold by the dealer Raphaël Gérard, and a clay sculpture by Maillol. Unfortunately, all the prices and all the names of brokers don't appear in the Schenker Papers, though we know that the Folkwang officially spent a minimum total of 6.9 million francs in Paris.

The German museums' official purchases should have in theory reflected Nazi artistic tastes: No degenerate art was supposed to find its way onto sacred German soil. Only a few modern artists appear in the transport lists. There were sculptures by Maillol and Rodin that went to Essen, and Utrillo's *Country Road* went to Dusseldorf. Nineteenth-century French painting, on the other hand, was abundant, particularly works by Delacroix, Courbet, and Renoir. There were practically no Post-Impressionists, nor avant-garde artists, and of course no Matisses or Picassos were bought. The sole exception was a work by Gauguin, *Flower Vase*, which Etienne Bignou sold to the Krefeld Museum for 300,000 francs. French eighteenth-century art, with its sense of "measure" and its

use of classical subjects, was very much appreciated by the Nazis. The Schenker Papers list many works among others, by Fragonard, Hubert Robert, and Quentin de la Tour.

Most of the "unorthodox" choices—artists of the late nineteenth and early twentieth centuries—figure in documents involving private buyers. Some German dealers and art collectors were brave enough to ignore Hitler's directives and even bought work by artists classified as Jewish. Schenker also transported works by Pissarro, Seurat, Signac, Vlaminck, and Vuillard into Germany.

The curators of the Folkwang Museum, as well as a number of German clients who were little concerned where their purchases were from, acquired a number of works of suspicious origin. Courbet's *The Cliffs of Étretat, after a Storm*, which today hangs in the Musée d'Orsay, offers a prime example. The Parisian market was glutted with confiscated art the Nazis hadn't bothered to take into Germany. But if stolen works are to be found on the list of works purchased by German museums, part of the blame lies with the French brokers who sold the paintings to them. These brokers were not among Paris's most respected professionals; some were even in cahoots with the German and French officials in charge of confiscations. Fabiani, the Belgian Raphaël Gérard, or Alice Maneau, who sold at least seven works to the Folkwang during this period, were implicated in a number of suspicious transactions involving paintings the Nazis had stolen and stored at the Jeu de Paume. After the liberation, Fabiani was indicted for trafficking in stolen art. Gérard and Manteau managed to avoid prosecution by helping the original owners get their paintings back.

One of the Schenker Papers' biggest surprises is the presence of the renowned dealer André Schoeller, an expert in nineteenth-century French painting. Schoeller's name figures prominently in the list of transactions done for the Folkwang Museum, to which he sold a minimum of eight major works whose total worth was at least 963,000 francs—a sizable sum. He is also frequently mentioned as supplying works to the Krefeld and Wuppertal-Eberfeld museums.

More troubling still is the fact that he is credited with selling Courbet's *The Cliffs of Étretat, after a Storm*. At the beginning of the war, Schoeller ran the Syndicat des Éditeurs d'art et Négociants en Tableaux Modernes (Association of Art Publishers and Brokers in Modern Painting). This dynamic group of dealers included several Jews, who in the 1930s had broken off from the venerable Association des Antiquaires. These ambitious young dealers in modern art could no longer abide the Association's conservatism, and the schism between the two organizations had profound repercussions in the Parisian art world.

Some evidence seems to defend Schoeller. According to Léonce Rosenberg, Schoeller had refused to appoint members from his association as "temporary administrators" to preside over the liquidation of Jewish collections and to redistribute the art to Aryans, as had been required by the GCJA. But there is, equally, evidence that his activities during the German occupation were suspicious. In November 1943, he was responsible for assigning a value to a stolen Matisse painting, *Woman in Yellow Chair*, as well as to a Bonnard work, also stolen, entitled *Corner of a Table*. The works were from the collections of Paul Rosenberg and Alphonse Kann, respectively, and were to be found in the Jeu de Paume. The ERR had planned to exchange the paintings for a work by Rudolf Alt, *The Temple of Faustina*, which was to be given to Hitler. Once the exchange had been made, the Matisse was smuggled illegally into Switzerland. The transaction raises a number of troubling questions. Who paid Schoeller to evaluate the painting? The ERR? Or Max Stoecklin, the owner of the Alt painting? Stoecklin was an unscrupulous dealer who had set up shop in Paris; Schoeller must have known with whom he was getting involved.

Schoeller also seems to have been very cozy with the GCJA in 1943, when it had confiscated the Schloss and Weil collections. Darquier de Pellepoix and the GCJA, which had sought the works from the beginning of the war, intended to put them up for sale in Paris and to leave only a small number of insignificant works for

Hitler and Goering. When Darquier brought them in from the Free Zone, it was Schoeller who inspected and stored some four hundred of the paintings in his own gallery. The Schloss family suspected he was the informant who had revealed where they had concealed their possessions.

☐

The curators from the Dusseldorf Museum wasted no time, buying sixty-eight paintings during the first months of 1941 that can be identified. This was a period of relative stability and therefore conducive to trade. The moment France was occupied, legal buyers and official confiscators went into action. Dusseldorf spent, sometimes judiciously, a minimum of 6.5 million francs, acquiring remarkable works such as the valuable wood panel *Venus and Cupid* by the sixteenth-century Fontainebleau School, two works by Fragonard, a pastel portrait by Quentin de la Tour—for a mere 50,000 francs—two paintings by Renoir, two by Hubert Robert, three by Tiepolo, one by Utrillo, and two works by Murillo and Rubens—which were, understandably, not described in the documents. Given such an ambitious purchasing policy, the Dusseldorf Museum, like the museum at Essen, ended up buying works that the Nazis had impounded and put up for sale. Among them was a pretty Chardin, signed by the artist in the lower left of the canvas, and sold by an unidentified broker for 400,000 francs. Called simply *Still Life* in the transport lists, this painting, which is actually called *Cauldron with Ladle*, can today be found in the Louvre.

Predictably, some of the brokers working for the museum were not honest practitioners of their profession. There was Gustav Rochlitz, who was closely allied with the Nazis implicated in the Paris confiscations, and lengthily interrogated by the American OSS (precursor to the CIA) after the war; he was indicted for trafficking in stolen art and for fraud. We have already come across Alice Manteau, whose name appears on the list. The most interesting

brokers listed in the Schenker Papers are Paul Cailleux, J. O. Lee-
genhoek, and Schmit and Company, all three respectable dealers
still in business today.

Like his father George before him, Paul Cailleux has an excel-
lent reputation and is a widely respected authority, and is a special-
ist in classical paintings, drawings, and antiques. The Cailleux
Gallery, with its sober and harmonious decor, is still located at 136,
rue du Faubourg Saint-Honoré, at the heart of the "art triangle"
that includes the Rue de La Boétie and the Avenue Matignon.
Given its longstanding interest in the field, the gallery created the
"Cailleux Prize," given each year for the best book of drawings
published in France.

During the war, Cailleux, like his colleagues, made substantial
deals with German clients. The sixty-three paintings, drawings, ta-
pestries, items of furniture, and objects whose sale he negotiated
were mostly from France's national treasures, created by artists and
artisans of the seventeenth and eighteenth centuries. The Düssel-
dorf and Krefeld museums were among Cailleux's best clients.
Düsseldorf acquired Fragonard's *Portrait of Man in Cape* and Hu-
bert Robert's *The Gorges of Ollioules* in June of 1941, while the
Krefeld Museum mostly bought works in a classical vein, such as
the *Woman with Coiffeuse* by Aved, *Portrait of Madame de la Mar-
tinière* by Alexis-Simon Belle, and *Portrait of the Marquis de
Marigny* by Jean-François de Troy.

The list of thirteen private German clients with whom Cailleux
did business proves to what degree the Franco-German market was
exclusive, active, and competitive: Everyone knew about everyone
else and knew what they were doing; none could say with any cer-
tainty that they were getting preferential treatment. The Cailleux
client list contained some of the major German players, beginning
with Maria Dietrich, Hitler's personal broker, who bought hun-
dreds of pieces for the Linz museum, and who was one of
Cailleux's most assiduous clients. Dietrich's incompetence was well

known but not exploited: None of her purchases were forgeries, and they included authentic works by Heinsius, Teniers, Am Berger, and Hubert Robert, paintings that she immediately sent on to Munich. The German embassy's dynamic art expert Adolf Wüster, widely known in circles specializing in deals both legal and not, bought several works from the Cailleux Gallery, including one Heinsius for the Krefeld Museum.

Looking for art to decorate their Berlin offices, high-level German officers and civil servants came to Cailleux's gallery: Doctor Wolff, the official architect and decorator of Germany's central bank, the Reichsbank, departed Paris with eight tapestries, among them four outstanding eighteenth-century Spanish examples depicting scenes from *Don Quixote*, woven at the royal works in Madrid, and signed by the Van der Goten brothers. Paul Cailleux did not report the sum he earned for handling this transaction to the DGER, but according to an expert at the Reichsbank it involved some 2.5 million francs—for the four works. Wolff also bought several eighteenth-century paintings and some antique furniture to spruce up the bank offices.

For his part Cailleux worked conscientiously for his German clients. He was not content simply to sell art to the Reichsbank, but also served as an expert consultant when the bank searched for works elsewhere. In a letter to Margot Jansson, the bank's Paris agent, brimming with good will and self-satisfaction, he wrote: "At the request of Dr. Wolff, you had been kind enough to ask me to come examine two important paintings at your home, one depicting Venus in the Underworld, and the other Olympic Gods, and to offer my opinion of the works. I was deeply flattered by this display of esteem and confidence, and visited your home on Saturday, May 24 [1941], when I conducted a thorough analysis of the two paintings placed at my disposition." Cailleux went on to provide his considered professional assessment that the two works could not be attributed to Boucher, as some other experts believed, but that they were

probably copies of exceptionally high quality, involving subjects often treated by this Rococo master of the eighteenth century. He suggested that further research, "which I was not in a position to undertake," might determine whether Boucher might have handled the subjects in question, and concluded by offering his respects and best wishes. It was this sort of discreet advice that must have put the Parisian expert in the good graces of the German authorities.

Other highly placed clients, such as Friedrich Welz, a Salzburg dealer, were fond of tapestries and bought several. Cailleux sold him a work by Tiepolo, a preliminary sketch for a fresco intended for the ceiling of the throne room that the Italian Rococo and trompe-l'oeil artist painted at the Royal Palace in Madrid.

The ubiquitous Gustav Rochlitz is the last name to appear on Paul Cailleux's client list. Cailleux sold him a small rectangular wood panel showing Christ being wrapped in his shroud, painted by an early Italian artist who was never identified.

With such varied clients, Cailleux enjoyed unlimited access to circles whose commercial ethics were not constrictive, and where he was admired for his professional abilities. A French dealer who could not or would not deal with the Germans, and who knew Cailleux, thought that he had gone further than most dealers normally would in accommodating his clients. Léonce Rosenberg, one of Cailleux's colleagues, didn't mince words when talking about him. Rosenberg, who was Jewish and therefore barred from professional activity, had seen his own gallery sequestered. He nonetheless remained in Paris for the entire war and followed closely what was happening in the art market. Rosenberg made serious accusations about Cailleux in a letter dated February 22, 1945. The letter was addressed to the Commission de Récupération Artistique (CRA), which had been set up by French authorities to investigate stolen art and to handle restitution claims. Rosenberg maintained that when André Schoeller and his association refused to appoint "temporary administrators" to assist in the liquidation of confiscated Jewish art galleries, the GCJA had

asked Paul Cailleux, an art dealer from Faubourg Saint-Honoré, who agreed to get involved in the . . . dirty business, and forthwith convoked every last member of the Association des Antiquaires, of which he was of course president. He made them believe they would earn a commission from the sale of the art from these galleries. Many agreed to be—excuse the crudeness of this word, but it describes their role—vultures. A peculiar situation developed: modern art collections being sold off by antique dealers. And Cailleux, who was in charge of naming temporary administrators, appointed himself as administrator over the Josse Hessel, Bernheim-Jeune, and Wildenstein galleries! . . . At the time the *Journal officiel* printed the names of these administrators and the galleries they were assigned. I believe that if you follow this line of investigation, you will learn quite a few interesting things, unpleasant though they might be.

J. O. Leegenhoek was just making his modest but opinionated beginnings. At the time, his gallery was located on the Boulevard Raspail. Like Raphaël Gérard, he was Belgian, and had arrived in Paris in 1942. Beginning in 1941 he began selling a number of paintings by Flemish masters—readily available in his country—to the museums in Bonn, Dusseldorf, Karlsruhe, and Krefeld. With his Belgian colleague Maurice Lagrand, he was chosen by the DGER to add to Goering's collection and granted special privileges for this. Lagrand used Schenker's services to send small amounts of furniture and sculptures from 13, rue de la Régence to Belgium. In spite of the restrictions imposed on movement between the different parts of German-occupied Europe, the two men frequently traveled to Brussels during the war.

Far from the painting dealers who catered to Parisian high society, Left Bank or Right, some of the dealers who thrived in the wartime Paris art market seem to have come from nowhere, attracted by the sudden enormous demand and eager to find new ways of meeting it. Schmit and Company started out as a small furniture manufacturer, but began selling older paintings to the Folk-

wang Museum. To its clients, Schmit offered a wide variety of deals, such as a Gobelins tapestry and two hurried "attributions" that were proliferating in Paris at the time: In this case, a series of sketches attributed to the great Italian Baroque painter Francesco Solimena and a painting called *Nymphs*, purportedly by Watteau.

This ambitious cabinetmaking firm made contact with Germans who could exert influence on the art market, but in the end lost the chance of a lifetime to establish its presence in that market. The incident amply demonstrates how greedy Goering was to acquire art for his own uses, and the merciless competition among Germans—competition that very often benefited the French. Schmit had gotten hold of a Rubens, which it had been given to sell on consignment in its store. During the course of one of his visits to Paris, the Reichsmarschall heard about the work and went to see it; he coveted works by Rubens. He seemed interested in the work but didn't make an offer. No sooner had Goering left the premises than the tireless art dealer Karl Haberstock, always on the lookout for the good deals to be found off the beaten path, appeared at the Rue de Charonne and acted as if he were going to acquire the Rubens. Given that the Reichsmarschall had not yet made his decision, Schmit refused to sell the painting to Haberstock, who left. He spent the next few days finding out who the owner of the painting was, and succeeded. Going around Schmit, Haberstock went directly to the owner, who was finally convinced to sell it to him, and who accordingly asked that the painting be brought back from the Schmit store.

The story continues. Returning to Paris, Goering once again turned up at Schmit's, determined to buy the Rubens. When the French dealer told him what had happened, Goering flew into a rage, and immediately went to see Haberstock, whom he proceeded to threaten with all sorts of evils. Shaken by the Reichsmarschall's ire, Haberstock gave him the work. He had little choice in the matter. After the war, the Schmit family quit cabinetmaking and opened a gallery on the Rue St. Honoré specializing in art of the nineteenth and twentieth centuries.

The Düsseldorf curators were not the last ones to turn Paris into a supply center for their collections. In one sweep they bought "an enormous number of the most varied objects—tables, china, medals, Dresden figurines, tapestries, antique ivory, clocks, jewelry, sculptures, cameos, chests, timepieces, and three to four hundred art books." Everything in France was for sale, and even in the middle of the war some German curators went to Paris often to do their shopping. Hence the director of the Krefeld Museum of applied arts, which would be destroyed during an air raid with most of its holdings, came to Paris to increase those holdings.

Specialists in classical and Near Eastern art from Berlin institutions also realized they should take advantage of the moment. The departments of Islamic and Egyptian art thus acquired stone sculptures, steles, bas-reliefs, marble plaques, and vases, of which they give only the vaguest description—unfortunately, few details about these transactions appear in the Schenker Papers—and found Brummer, Hindamian, Sambon, Indjoudjian, and Kalebdjian works for them.

Not one museum in the Third Reich, not even one of the respectable ones, wanted to miss the opportunity of going to Paris to buy art. Using Hans Herbst, an Austrian agent who had settled in Paris, as their intermediary, the Dorotheum auction house in Vienna spent 15 million francs, buying tapestries and furniture as well as twenty-five paintings, including a work by Bruegel the Elder tersely described as a "landscape with animals," and a *Virgin and Child* attributed to Cranach (a work that almost certainly dated from the period before the painter's conversion to Protestantism). The Kunsthistorisches Museum, which since the Anschluss had been part of the Reich's museums—but whose curators did not wait until 1938 to collaborate with the Gestapo and confiscate the Rothschilds' collection in Vienna—distinguished itself in November 1942 by acquiring a clavichord constructed by Pascal Taskin for 127,500 francs from the Parisian manufacturer Pianos Labrousse. Throughout the war, German curators proudly announced in their

local press the arrival of each new acquisition, providing details about the paintings they had bought and where they were to go.

A crowd of art brokers and dealers of every stripe, attracted by the art market's activity, settled in Paris permanently, or went back often for visits, usually staying in hotels near the main Parisian galleries. The German embassy, not content with the contributing role it had played in art plundering under the leadership of Ambassador Abetz, was one of the centers in the trafficking of stolen art in France. Abetz and the German foreign minister von Ribbentrop, both equally unscrupulous, had understood the part that major works of art could play in extending the power and prestige of a political regime. They knew that their desire to accumulate art could only be satisfied by systematic purchasing. They therefore brought to the embassy a small team of experts and gave them the rank of commercial attachés; they were to devote themselves exclusively to buying art in France. This was probably the first time in history that a government had appointed diplomats to research, evaluate, and purchase works of art full time—all for the greater glory of the Third Reich, naturally..

Located at 78, rue de Lille, the Nazis' Parisian embassy was situated in the same neighborhood as the most famous antique dealers and galleries on the Left Bank. From this strategic vantage point, "cultural attaché" Adolf Wüster and his collaborators could keep German officials abreast of what was available, and undertook all the transactions the ministry of foreign affairs or other governmental branches asked them to make. Wüster, who did work on the side for other German citizens, visited the galleries often, stayed in constant touch with French brokers, and in short monitored the market's daily activity. His privileged place allowed him to make profits, without having to conceal that fact. In spite of his diplomatic status, he always required a healthy 20-percent commission from his clients. He also served successfully as a scout for the Dusseldorf and Krefeld museums, and as a broker for Maria Dietrich and Karl Haberstock.

Knowing exactly when a pillaging raid was in progress, Wüster also understood what was to be gained from looted works: Twice he exchanged paintings in his possession for works that had been confiscated and were being stored in ERR warehouses. He also involved himself more subtly in the pillaging through his role as an expert: When Goering arrived in Paris to look at works for his collection, Wüster and other specialists accompanied the Reichsmarschall, evaluated works, and assisted him in his choices.

To stay on top of the Parisian market's finer points was no easy task for outsiders, especially when they were also occupiers. Wüster was not actually an outsider; the Kunstreferent had lived in Paris since 1928, a member of that surprisingly large group of "fake" German newcomers who, like Otto Abetz or Arno Breker, had long frequented Parisian art circles. None of this would prove of any use to Wüster when he was hastily let go by the German embassy in the summer of 1944. He fled first to Alsace, then to Germany, and finally tried to find a house near Salzburg, for which he proposed to pay not with hard cash but with paintings he had brought from France. Some German brokers took their booty and tried to find refuge in their homeland. Others, like Wilhelm Jakob Mohnen, an agent with the German secret service in Paris, sought asylum as near as possible to their place of work. After spending two years in Paris, Mohnen was posted to the Reich's embassy in Rome. In the summer of 1944, he took asylum in the Vatican, where he was eventually arrested by the Allies. Mohnen, who also used the name Ernst von Mohnen and who was an expert in Flemish art, personally bought and exchanged paintings in Paris, where he maintained close ties with the German embassy's art division. He had worked long enough in Paris to provide the OSS with crucial information, offered in a detached and haughty manner, when they interrogated him about the Paris art market during the occupation.

While in Paris, Mohnen lived at the Hotel Claridge, located on the Champs-Elysées, and very close to the galleries on Faubourg Saint-Honoré. The archives of the Charpentier Gallery, located on

the same street, show that in August 1942 Mohnen bought two modestly priced paintings. Mohnen had observed firsthand the great activity and high quality of works on the market. He told the OSS about brokers working for Hitler, Goering, Goebbels, and von Ribbentrop. Von Ribbentrop, he said, had the best taste. According to Mohnen, he was the only one to seek out avant-garde art and to buy French Impressionists. Hitler's agents were "especially interested in second-rate Viennese art," and Goering was obsessed with acquiring works by Cranach, Dürer, and Holbein. Mohnen's testimony confirmed that "all the large German museums" had agents in Paris and that the circle of active players was very small, consisting of "only a dozen big buyers" who divided up the lion's share of the market. German dealers, he told the OSS, never did any favors for each other, and the French traders' competition with one another was fierce. In Mohnen's opinion, none of them possessed a brilliant or profound appreciation of art.

Given that there was an enormous amount of money floating around, and that the works available were often German paintings of which the French were not huge fans, buying was easy: "The French owner of a Brouwer, for example, was perfectly aware of its importance to his collection, but more inclined to sell it at a high price than to do without his Boucher," recalled Mohnen. The buying process generally proceeded without a hitch; only a few sales weren't concluded freely, even if sometimes they were done discreetly. According to Mohnen, the newly arrived Germans generally sought out exiled White Russians to act as their brokers, notably Prince Youssoupov, the legendary murderer of Rasputin. A cousin of Czar Nicholas II, and a handsome man who cut a swath through Parisian salons, the prince had fled the Bolshevik Revolution and taken refuge in France, where his contacts with European nobility got him access to the art market. During the Occupation, he collaborated with certain German circles.

Mohnen's testimony provided the first real look at the ERR, and at how other Germans in Paris regarded its activities. Unsurpris-

ingly, Mohnen believed that the ERR was simply the largest group of German prospectors in France and that its some "sixty personnel," organized into shock troops under Goering's command, entered cities "with or right on the heels of the expeditionary forces, and immediately set to work looking for art collections." He calmly added that the ERR "didn't content itself with buying works, but either requisitioned them or simply stole them." Perhaps this German "diplomat" never grasped the ERR's prime objective, or perhaps he didn't want his interrogators to know that he knew exactly what it was.

Mohnen's testimony also gives us the first glimpse at the French stolen-art market. He described this market as "enormous." He told how the inflated prices for all kinds of German art led Swiss dealers and collectors to put their works up for sale on the Parisian market, and that he believed that these works "were then exchanged for French Impressionist paintings that had been requisitioned or stolen." He was aware enough to know about a sale of French Impressionist works in Bern. The sale didn't attract a huge number of potential buyers because everyone knew that any transaction would be nullified should Germany lose the war. He added that Switzerland and Spain, being neutral countries, admitted a considerable number of stolen works that were hidden away in the event that the Nazis were defeated.

Mohnen was interrogated in September 1944 in the Vatican, where he had been hiding out since the previous June. Calling himself an anti-Nazi, he described his work at the German embassy in Paris with singular naïveté, as if he had been performing a function that would exonerate him from blame. Despite the evidence to the contrary, he emphasized that official German art purchases proceeded fairly, and that a "number of German brokers were put in prison for having tried to enrich themselves personally in the process." It was Mohnen's belief that the only pillaging that took place occurred outside of official circles, and while all the documents and testimony—even his own declarations—point to the opposite

conclusion, he maintained that the works bought by the Germans "had nothing to do with organized or systematic process" and that there was no official Nazi policy in the matter.

It is indeed difficult to argue that there was a centralized plan, since practically all the senior officials, and all the Reich's institutions and government branches, pursued their own interests. But there was nonetheless a general tendency on the part of the Nazis to appropriate artistic treasures, an orientation that would explain the Kümmel Report, the creation of jobs performed by people like Wüster and Mohnen, the formation of financial divisions (the Reichstelle), the appointment of customs agents in Germany, and finally—and most especially—the actions of Goering's ERR. This policy was a direct reflection of Hitlerian ideology and obviously benefited from the considerable assistance of the army of occupation. But Mohnen, like so many of his compatriots at the time, could not be brought to believe that, anti-Nazi though he proclaimed himself to be, he had accepted the self-justifying precepts of German expansionism, a self-justification that influenced even those who opposed the Führer at the end of the war, as Hannah Arendt has demonstrated so well. Another explanation for his apparent innocence is that as a member of the information services, he did not want to reveal everything he knew; after all, at the time of his interrogation the war was not yet over.

The ambitious prospecting engaged in by the Reich's museums and the German embassy's ceaseless efforts to acquire artworks both pale in comparison to the systematic, "all-out" policy of buying on the part of the Reichsbank. Fully assuming its role as the central bank of a conquering and expansionist nation, the Deutsche Reichsbank was one of the principal players on the French art market. The bank was definitely on the prowl for works, and amply demonstrated its determination to use its enormous power, power that stemmed from

the implacable financial conditions imposed by the armistice with France, a war economy that was filling its coffers, and the revenue brought in by the war reparations and Occupation debt extracted—or extorted—from the conquered nations.

Money was everywhere, but that didn't keep the Reichsbank from getting involved in even the most macabre operations. In the summer of 1942, when the Final Solution was already being implemented, the president of the bank, Walter Funk, signed a deal with the SS chief Himmler whereby all cash, all objects of value, such as gold watches and dental prostheses, that were piling up each day at the concentration camps would be sent to and stored at the Reichsbank. The zealous bank directors would turn them into legal tender.

Not including its honorary founder, and other high officials who regularly went to Paris to "do their shopping," the bank also had two full-time French agents who looked for bargains. Its purchasing normally took place behind the scenes, after the selling party had provided a discreet screening, and involved several carefully chosen intermediaries or independent advisers, like Cailleux. Some of the art objects had royal pedigrees, something that fascinated Funk and his closest cohorts; the money men were thrilled to have access to works bearing France's royal seal. François-Hubert Drouais's *Portrait of the Countess du Barry* was one of the bank's most important acquisitions. At the bank's offices you could find Louis XV's mistress, smiling, sitting on a blue velour couch and holding a lyre in her right hand, a crown of flowers in the other. In his evaluation report, the expert appointed by the bank got a little carried away in his enthusiasm. "This painting is so impregnated with beauty," he wrote, "so full of grace and an exceptional natural quality, that it might be compared to the most beautiful portraits of the royal family at Versailles." Having placed the work in this royal context, a context so precious to the German bankers, the expert described the small, privileged group that had had the honor to own this portrait: The countess had kept it in the neoclassical château of Louveciennes, where it was found and seized during the French Revolution. Much

later, the parfumier François Coty bought the portrait to give as a wedding gift to his daughter Christiane when she became Mrs. Paul Dubonnet. Enchanted by all this background, the Reichsbank believed that 1 million francs was a bargain.

Of the total amount the Reichsbank spent in France, at least 40 million francs went for works of art and for antiques. Each week, one or two deliveries, by truck or train, each one valued at somewhere around 1 million francs, left Paris for Berlin. The transport lists remind one of Ali Baba. In addition to the Aubusson tapestries and the Louis XV chairs were mirrors, rugs, mantelpieces, dozens and dozens of armchairs and furniture, hundreds of napkins, ten tablecloths designed for tables that could accommodate one hundred people, a trunk of liquors, wool blankets, silk throws, hundreds of yards of tulle for curtains, books, and luxury items from the best couturiers and finest shoemakers in Paris, as well as an astounding variety of canned goods: pheasant, turkey, duck, and, for the really discerning palates, tripe braised in Madeira.

Throughout the war, the bank's upper management continued to traffic in goods that catered to their fantasies about royal opulence, such as the Sèvres setting for seventy that had once belonged to Louis-Philippe, and which had required twenty craftsmen working three full years to complete; or the exquisite examples of mahogany furniture made by the king's cabinetmakers Riesener and Beneman in the eighteenth century; and the four rose hors-d'oeuvre serving dishes that Napoleon had had made for Bernadotte, the future Charles XIV of Sweden and Norway—following tradition, the seated dog on the cover symbolized Napoleon's desire to see his vassal assume a canine attitude of fidelity and obedience. The bankers' obsession with royal lineage was such that they even purchased a fountain ornament from Versailles's gardens: a monkey astride a dolphin.

The abundant number of works on offer, and their reasonable prices, stimulated grandiose, indeed royal, projects of renovation and redecoration in the Reichsbank's headquarters in Berlin. Mar-

got Jansson had a hand in many of the bank's purchases. In her quiet apartment near the Eiffel Tower, she could invite Paul Cailleux over to give an estimate for a work as easily as she could play host to her German employers.

The collaborating French art expert Albert Bourdariat was a witness to the ways in which the bankers conducted their transactions in this pleasant setting. During the course of a dinner at Jansson's apartment, to which only German VIPs were invited, a Dr. Boettcher, the Reichsbank's representative in France, and a Dr. Woolf, the bank's chief architect, thought up ways of slipping enough gold and silver out of the Banque de France to make a complete rose-gold dinner set, consisting of one hundred and fifty place settings, which could be used for the bank's official receptions in Berlin. Finding precious metals during wartime was no easy matter, and it was practically impossible to transfer them between Germany and France legally. The two German dignitaries found a way: They shipped the ingots out of the French reserve and deposited them with L. V. Puiforcat, the famous Parisian jeweler (whose bill to do the elaborate tooling for the setting would be 5.5 million francs). Bourdariat maintained that nothing like this enormous collection of rose-gold pieces—which included table settings, soup tureens, tea and coffee sets, and table decorations—had ever been seen before. Puiforcat, whose shop was then-located on Boulevard Haussmann, did other table settings and metalwork for the Reichsbank, to which he regularly submitted his requests for the gold and silver necessary for the job.

This fabulous collection was to remain in Berlin, but it was naturally a French house, Jansen, the famous decorating company, which alone was capable of designing a space elegant enough for it to lie in state. While Puiforcat was still at work, Jansen designed a luxury vault in the basement of the Berlin bank worthy of a king: Built into the wall, the shelves were made entirely of rosewood and had silver handles; the pieces would sit on velvet and red silk. The Jansen shop was perfectionist, and in the cause of pleasing its

German clients, it left nothing to chance. A team of its finest crafts-men was dispatched from the Bastille workshops to Berlin so that things would be done right. The job brought Jansen a million francs.

This famous decorator did not need to be recommended to the Germans. Before the war, the House of Jansen was an ambassador of French tradition throughout the world. The store on the Rue Royale was frequented by a clientele that included powerful people from across Europe, the United States, even South America and Egypt. Because of its enormous workshops on Rue Saint-Sabin and its highly trained team, Jansen could satisfy the most discerning clients. During the post-defeat calm of early 1941, when the wealthy Berlin bankers asked Jansen to take charge of redecorating their headquarters, the company immediately accepted. A large amount of money was at stake. Funk wanted to completely overhaul the bank's interior—to build a new staircase, create a dining room and smoking room, as well as a winter garden and salon for the ladies—in short, to create an environment that would mirror the Reichsbank's new role as Europe's most important financial institu-tion. Jansen again sent an entire team to Berlin, though they also re-lied on the use of French prisoners of war being held in Germany to do the job. Jansen's cabinetmakers created a table capable of seat-ing one hundred and fifty—as many as there were place settings—and selected furniture, paneling, wall decorations, lace tablecloths (embroidered with the initials DRB—for Deutsche Reichsbank—on a background with an imperial eagle), curtains, and lamps. The dining room alone cost the bank 5 million francs.

After the war, Jansen tried to make sure that its clients forgot about, or never knew about, the services it had provided the Nazis. Among those pre- and postwar clients were the Duchess of Wind-sor, the Rothschild family, and the French foreign ministry, which chose Jansen to decorate a number of embassies around the world. Nonetheless, in their quest for royal surroundings, Jansen's Ger-man clients had brought the company more than 42 million francs.

Jansen had provided the Wallraf-Richartz Museum in Cologne,
Nazi ministers, and a number of Berlin merchants with paintings
and rugs. The House of Jansen performed services for Hans Frank,
who had once been Hitler's legal adviser before the war, and, as
Nazi Governor of Poland, saw to the Germanization of that coun-
try. Frank therefore supervised the confiscation of Poland's art trea-
sures and in the process started his own collection by appropriating
a Leonardo da Vinci and a Rembrandt. Jansen sent its decorators to
Poland to work on Frank's home and office there; he had ordered
Louis XV chandeliers and Louis XVI armchairs both for his home
in Berlin and for the palace he had moved into in Cracow. Nazi ad-
ministrators in Poland ordered more than 1.5 million francs' worth
of furniture and statues. Arrested at the end of the war, Frank
protested that he was not a thief but an enlightened amateur. When
the undeniable proof of his plundering, financed by Goering, was
presented at the Nuremburg trials, the former governor of Poland,
who was also one of the lawyers for the defense, exclaimed, "How
can you steal treasures for your own use during wartime?" He was
found guilty at the trials and hanged.

The German embassy in Paris also called upon Jansen's services
to provide it with antiques and tapestries; so did Arno Breker, the
sculptor who pronounced himself "Parisian by adoption" and who
lived at the Ritz Hotel. Breker ordered a number of Louis XV–style
wall lamps and two elegant, marble-based candelabras whose
branches interlaced. French decoration was all the rage with Ger-
mans, particularly in embassies such as the one in Paris, redeco-
rated by Herr von Waldhausen, and the Madrid embassy, which in
1942 was entirely done over with furnishings and artworks ordered
from France by a certain Frau May, who was a protégé of Ribben-
trop. There was also a museum of local interest in the Sudetenland,
which, wanting to form the base of a future collection, or simply for
the purpose of redoing its reception rooms, bought glass and china
for half a million francs.

After the war, Jansen offered feeble arguments to explain how

business had been so good, even at the grimmest of times. The firm had been compelled to serve the Nazi occupiers, it insisted, in order to conceal the work it had done for the French air force during the First World War and then between 1939 and 1940.

There were of course brokers who used their personal contacts to buy works for private clients. Werner Grote-Hasenbalg, a Berlin dealer who specialized in Oriental rugs and tapestries, started coming to Paris in December 1940 with the goal of finding items to decorate the offices of the Prussian minister of finance. After staying for two weeks, he left for Germany with five Beauvais tapestries and two Aubusson rugs, bought for 2 million francs. His business trips became so frequent that finally he rented an apartment in Neuilly. Grote-Hasenbalg soon became a familiar figure in certain Parisian circles, and his wife, the Czech actress Charlotte Anders, took part in the famous televised program that the Nazis filmed at the Eiffel Tower.

According to his own testimony, Grote-Hasenbalg spent a total of (at the very least) 8 million francs in France, buying Hitler a Gobelin tapestry entitled *Dance of the Satyrs,* based on a drawing by Vouet, and several seventeenth-century tapestries for Albert Forster, the Nazi leader in Danzig, that were to be used in the Gauleiter residences in Poland. Grote-Hasenbalg made friends in France, among them the head of the Gobelin factory, where he had the works he had bought restored. Among his closest contacts were reputable antiques dealers such as Alexandre Popoff and Jean Nicolier.

Certain French galleries organized auctions specifically designed for independent German buyers. This was the case with the Charpentier Gallery located on the Rue Faubourg Saint-Honoré, which remained conspicuously open throughout the war. After the war, when the CRA (Commission de Récupération Artistique) asked the gallery's owners for explanations, they admitted to having organized forty-four sales between 1942 and 1944, twenty-three of their partners having been, as they said with diplomatic ingenuity,

"clients who appeared to be of German nationality." Among those clients were Mohnen and Arno Breker, who spent 22,000 francs for *Seated Hunter*, attributed to the eighteenth-century painter Jean-Baptiste Pater. One is surprised to learn that an artist as modern as Van Dongen was appreciated by the German clients at the Charpentier Gallery.

One of the gallery's visitors—one who cannot be said to correspond in the slightest to the gallery's euphemism about its clients (a fact that may well explain why his name was conveniently left off the gallery's client list)—was Goering. The Allies' interrogation of Goering, and their investigation into the Rose Valland dossiers, brought to life a whole new side to the Charpentier Gallery's wartime activities. Even before the gallery opened in 1941, Raymond Nasenta, director of the gallery, together with the German dealer Josef Mühlmann, had organized a private show for the Reichsmarschall consisting of medieval and Renaissance works. The gallery badly needed working capital. Goering, who was their only potential client, examined the works for forty-five minutes and then, as was his custom, decided to take everything.

Karl Haberstock, the enterprising Berlin dealer who was so active on the Paris market, also appears on the Schenker lists, though his transactions were for the most part limited to a small circle of colleagues and friends. Among more than thirty paintings, frames, and statuary, he acquired *Leda and the Swan* by Veronese. Hitler was not fond of the painter, but on the other hand was wild about the sensuality of the painting's subject, which made it one of the most valuable pieces in the country. Other agents sifted through huge quantities of art and antiques looking for what might suit the unspecified purposes of the Führer, the Reichsmarschall, and other Nazi dignitaries. The Munich dealer Fritz Pössenbacher and his Paris agent Paul Lindpainter, for example, were authorized by Bormann to "obtain furniture and objects from France, Belgium, and Holland that could be used in the setting up of residences to be occupied by the Führer and Reichsmarschall Goering, residences that

must be completed as soon as possible." They applied themselves with diligence, spending 2.7 million francs for furniture and nearly 1.8 million for paintings.

It is sometimes difficult to distinguish between private collectors and those acting in an official capacity, but in both cases collectors' searches inevitably led them to stolen art. Philip Frank, the head of the Mannheim branch of the Reichsbank, went to Paris to buy art in February and March of 1941. His taste was good, and he brought with him back to Germany a handsome group of paintings and drawings and a fourteenth-century wooden statue of the Virgin and Child. Were they bought to decorate the bank, or for Frank's own purposes? We simply don't know. In any case, Frank also acquired two landscapes by Cézanne and Courbet, a Pissarro, and a crayon drawing of a dancer by Degas.

The unknown fate of this last work, the Degas, which was very likely stolen, is impossible to establish in the absence of precise details about the drawing—and given that Degas did a considerable number of works like it over the course of his lifetime. What we do know about the missing work is that it depicted a dancer on pointe, her arms apart, and that it was signed in the lower left-hand corner. We also know it had belonged to Paul Rosenberg. There is good reason to suspect foul play when we learn that the dealer who had sold it to Frank was Raphaël Gérard. During the war, Gérard hadn't flinched at handling a number of works from the Rosenberg collection. After the war, Gérard gave back to Rosenberg what was left, hoping to avoid trial. In the ERR archives, mention of the Degas is accompanied by the phrase "to be used for exchange." The drawing could easily have been transported to Paris, where it is very possible that Gérard acquired it and then sold it to Philip Frank. Whatever the case, Degas's dancer left for Mannheim and has never been seen again.

Following in the wake of their more powerful cousins came the Austrian agents and dealers: A certain Karl Schwarzinger of Vienna bought over 200,000 francs' worth in furniture; another Viennese dealer spent 86,000 for various works. The Fellner Gallery in Linz, the very city in which Hitler planned to build his gigantic museum—and part of the reason the Nazis were pillaging art in such systematic fashion—sent representatives to Paris, though unfortunately we have no details about the transactions. On the other hand, there are traces of the pieces bought by the famous Welz Gallery of Salzburg: Friedrich Welz had been commissioned by the city's Nazi government to buy various works, to prepare for the creation of a regional museum at Schloss Klessheim, near Salzburg. He found a number of paintings, including three by Corot and seven by Courbet, plus works by Daumier, Delacroix, Goya, Lépine, Monet, Pissarro, Poussin, Rodin, Rubens, Seurat, Signac, and Van Dyck. We might note the conspicuous presence of Pissarro and other post-Impressionists.

It hardly seems surprising that certain Nazi officials figure prominently in the Schenker Papers as expediters of works bought in France; their choices say a great deal about their characters. Goering is not among them, save for a brief mention, but this is because he used far more discreet channels to do his dirty work. After all, he had the entire ERR at his disposal. What need did he have for a private moving company such as Schenker when he was the head of the Luftwaffe and had four trains reserved for his exclusive use? Ribbentrop is mentioned only once, concerning an unspecified painting bought in the summer of 1941, but here again this is because he would have had other means of transporting confiscated art. Albert Speer used Schenker's services to deliver purchases he made between October 1941 and August 1942: furniture, sculptures, and various other objects. Arno Breker was also a Schenker client. He instructed the company to use military convoys to send him statues, twenty tons of plaster (probably for use in designing

Switzerland: The Importance of Being Neutral

A small, sleepy country located in the geographic heart of Europe, Switzerland simply shut its eyes when it came to the art entering its borders from the warring countries. Swiss laws governing ownership and receipt of stolen objects are rich in subtleties of every sort. For example, after five years of possession by an "owner in good faith" the work in question is to be considered his; or, in the event that a stolen painting passes into the hands of a dealer or appears in an auction, the person from whom it was stolen must reimburse whoever bought it before the painting can be returned. Laws such as these facilitated art trafficking and provided an ideal refuge for both sellers and buyers. There were even a number of Swiss dealers

working the Parisian market. But if the French capital was the place to stock up on art, Switzerland offered an outlet.

Neutrality was quite obviously an enormous blessing. The profits the war had generated, particularly those produced by the German war machine, circulated freely. Swiss collectors had more cash than they knew what to do with. Deep pockets and the complete freedom to move around made Swiss industrialists and art dealers the only true international clientele in wartime Europe. The strong Nazi demand for older paintings, Dutch and German especially, allowed Switzerland to become one of the biggest exporters of small older paintings, and a huge importer of modern works.

What's more, many Swiss art professionals were well known by the Nazi hierarchy. The Fischer Gallery in Lucerne was a sort of clearinghouse for stolen art. Beginning with the huge "degenerate art" sale of 1939, when a huge number of modern paintings purged by the Nazis from their national museums were sold, Fischer had high-level contacts within the Third Reich. Indeed, the gallery became the partner of choice for a dozen major German dealers, such as Karl Haberstock in Berlin. Fischer was therefore able to import hundreds of paintings into Switzerland during the war. Other Swiss galleries were the Neupert Gallery, the Dreyfus Gallery, and the Schmidtlin Gallery in Zurich.[1]

Once again it was most certainly Goering, through the ERR, who profited most from the "Swiss system." Between February 1941 and the end of 1943, the ERR organized at least twenty-eight exchanges of confiscated paintings—all completely official—using various intermediaries. Disposing of a rich collection of nineteenth- and twentieth-century works that were of no interest to the Nazis, the Reichsmarschall and his henchmen were blessed with a fantastic capacity for making deals. Their zeal had proven infectious not only in France, but also on the small but dynamic Swiss market. Confiscated works would become more precious than the foreign currency that might have governed this kind of buying, but which was rationed because of the war. Given the lack of Swiss

francs, modern paintings had become a most controllable and readily available form of exchange.

Thus, on this new stock exchange, there were on the one hand the noble paintings belonging to a bygone golden age—German, if possible—and on the other the "degenerate" and depreciated painting of the modern world. An older work was worth ten modern works—a perfect reflection of the Nazi aesthetic.

The first Swiss exchange took place between Goering and the Fischer Gallery in Lucerne, through the mediation of Walter Andreas Hofer, the Reichsmarschall's roving adviser. In February and March of 1941, while confiscation was in full swing in Paris, Hofer went to Lucerne and chose six works for his boss from the gallery: four Cranachs, including *Madonna and Child in a Landscape* and *Crucifixion with Praying Knight*, a triptych, and a sculpture by the Nuremberg School, as well as a work by the Master of Frankfurt that came from the collection of Prince Lippe of Bückeburg. The works were dispatched immediately to Germany and to Carinhall. The Brauner moving company took them as far as Basel. At first, Goering gave his agreement that payment for the works would be made in Swiss francs, but given the difficulties in getting cash, he changed his mind and asked for an exchange instead.

At the end of May, Hofer once again found himself in Switzerland. In June he wrote to Goering's office: "Fischer agrees in principle on an exchange of the French Impressionists whose photos I showed him. He will be in Berlin in the middle of next week and will come and see the paintings." On July 12, 1941, the twenty-five paintings were fetched from the ERR warehouse in Neuschwanstein, where they had been stored since leaving the Jeu de Paume. In mid-July, Fischer arrived in Berlin and Goering's secretary showed him the works. Fischer agreed to the deal; he knew very well that finding buyers in Switzerland would be easy. Among the twenty-five works were four by Corot, including *San Giorgio Maggiore*, which came from the collection of Lévy de Benzion; five by Degas, of which four were from the collection of Alphonse Kann, a

British citizen living in Saint-Germain en Laye; and two works by Van Gogh—*Flowers in a Vase*, from the Lindon collection, and *Portrait of a Man*. The group also included a Manet, Renoir's *The Forest at Fontainebleau*, a watercolor of a nude by Rodin, and three works by Sisley. Fischer easily obtained an export permit through his agent Bümming, a bookseller from Darmstadt, and Goering's secretary provided an official certificate, declaring that Fischer had the Reichsmarshall's approval to leave the country with the works. On October 22, 1941, the paintings entered Switzerland. Fischer sold nine of them almost immediately.

The second official exchange of which I am aware took place between Goering and the German dealer Hans Wendland, who was living in Geneva. Goering again used Hofer, who went there in November of 1941. Once again barter was involved. Wendland gave a Rembrandt, *Portrait of an Old Man with a Beard*, which he'd bought from a French collector in Marseille in 1941 and which was valued at 400,000 Swiss francs at the time, as well as two sixteenth-century Belgian tapestries done from the designs of Lucas van Leyden and valued at 120,000 Swiss francs. The tapestries had been given by Napoleon to the Princess of Franceville in 1808, at the Château Bezanos near Pau, and it was there that Wendland had found and bought them.

Wendland managed to get half his payment in Swiss francs; the other half came in the form of paintings. He picked up twenty-five Impressionist works, shown to him by Goering's secretary in Berlin. Twenty-four of them were from the Paul Rosenberg collection. And for 260,000 Swiss francs he also got four works by Corot, including *View of Toulon* and a drawing entitled *Young Girl Sitting in Landscape*; four works by Degas—which were some of the works Rosenberg had placed in the Libourne bank—including three drawings and a painting of a jockey. Every one had been earmarked by the ERR, "to be used for exchange"; that is indeed what happened to them. Finally, Wendland was able to obtain two works by Ingres, four by Renoir, including a drawing of the painter's brother,

and three by Seurat—*Seascape, Nurse,* and *White Shirt*—two works by Sisley, one by Pissarro, and Monet's *Still Life with Melon.* The twenty-fifth painting, a Van Gogh landscape, was from the Myriam de Rothschild collection. The quality of the works shows just how clever Wendland was—and that he was an even shrewder connoisseur than his colleague Fischer.

It was Wendland's suggestion that the paintings be taken into Switzerland via German diplomatic pouches in April 1942. This sped up the process, and got around both the Swiss authorities and the need for a German export permit. Goering gave his approval to this new method. The infraction was minor, given that at the time Swiss import taxes were paid on the basis of weight rather than on value. Hofer himself saw to the transfer of the works. He accompanied a Mr. Riekmann, who was in charge of the diplomatic pouch belonging to the German legation in Bern. Once in Switzerland, Hofer took the twenty-five works to Lucerne and handed them over to Wendland.

Included in the same shipment were Corot's *Girl with Red Bodice,* a seascape by Monet, and a Sisley—all three from the Rosenberg collection—which Wendland had also chosen in Fischer's name. There were also two paintings purchased by the Swiss industrialist Emil Bührle, whose collection can be found today in Zurich. A weapons manufacturer and a major arms supplier to the Wehrmacht, Bührle profited enormously from the Third Reich. He had recently purchased the paintings in Paris, at the gallery of Roger Dequoy, a former employee of Wildenstein. Again it was Hofer who handled the third exchange involving Swiss dealers, in which Fischer traded three sixteenth-century Belgian tapestries, showing scenes from the life of Scipio, for three paintings. Hofer had seen the tapestries in Lucerne and had taken photos of them to show Goering.

Another major swap was organized directly with the ERR in Paris. Under orders from Goering's secretary, eleven confiscated works being held at the Jeu de Paume were given to Rochlitz and

Wendland. Rochlitz had gone to the Jeu de Paume himself to make his selection, which Goering approved on March 3, 1941. The two German partners thus got *Still Life with Grapes and Peaches* by Braque, *Sorrows* by Cézanne, and Degas's *Madame Camus at the Piano*, all of which came from the Kann collection. As usual, Rochlitz had had his eyes on the works confiscated from Paul Rosenberg, including the very well known Corot painting *Madame Stümph and Her Daughter*, three works by Matisse—*Woman at a Table*, *Flowers and Pineapple*, and *Woman with Elbows on Table*—and finally *Portrait of Madame Rosenberg and Her Daughter*, which Picasso had painted at Biarritz in 1918 and which had been confiscated at Floriac and taken to the Jeu de Paume. In exchange, Rochlitz and Wendland had given the ERR *Portrait of Bearded Man* by an anonymous Northern Italian painter, and *Hunting Still Life* by Jan Weenix. The deal was complicated by the fact that two of these works had been bought in partnership with the clothes designer Birtschansky. Wendland eventually took a Braque, a Corot, and a Degas back to Switzerland.

These substantial transfers of works involved a large number of Swiss dealers and galleries. Dr. Alexander von Frey, a Hungarian citizen living in Lucerne, gave two paintings, including *Figure Study* by Mackart, in exchange for three modern pieces: Renoir's *Portrait of a Young Girl*, Picasso's *Apple*, and Pissarro's *Country Road*—all from the Rosenberg collection. Goering himself offered the Mackart to Hitler. The Picasso was bought by the Aktuaryus Gallery in Zurich. Once art made it to Switzerland, it quickly disappeared.

One of the more famous German-Swiss swaps involved the Parisian dealer André Schoeller and the German dealer Max Stoecklin. Schoeller exchanged *Temple of Faustina* by Rudolph von Alt for works by Matisse and Bonnard, which Stoecklin himself se-

lected at the Jeu de Paume. Then Matisse's *Woman in Yellow Chair* turned up at the Neupert Gallery in Zurich. There seems to be no memory of how this work made it across the border. No customs declaration has survived.

The same Neupert Gallery was involved in another transaction. It had been holding a painting, *Painter Sitting on the Branch of a Tree*, by Ludwig Knaus for the Frankfurt dealer Alfred Boedecker. Boedecker had offered the work to the ERR as part of an exchange. A photograph of it was shown to Bormann and to Hitler, who decided they wanted it. Without even consulting Boedecker, and without giving him a chance to see the work, they offered Renoir's *Young Girl with a Fishing Net*, which had belonged to Rosenberg. The exchange took place under conditions that were less than ideal: The ERR sent a representative with the painting to Basel. Boedecker and Neupert met with him on April 7, 1943, at the train station in Basel. Boedecker had asked that the ERR also send a Cézanne watercolor, in the event that he did not want the Renoir. In any case, the Renoir was accepted, though again we have no idea how it got across the border. Neupert sold it to the Tanner Gallery in Zurich, which in turn sold it to a client. Neupert had assured Tanner that the paintings were from a private Swiss collection and that he had acquired them before the war. It was an important precaution, for the owner of the Tanner Gallery was also president of the Federation of Swiss Art Dealers, and therefore a representative of the respectability of the country's art market.

Switzerland was flooded with confiscated art. British investigators discovered in 1945 that the Kunstmuseum in Basel had purchased Dali's *The Coast*, a painting that had belonged to the Englishman Peter Watson before being confiscated by the ERR in 1941. The painting had just been purchased from the Gasser Gallery and brought into Switzerland by the Genevan publisher Albert Skira, who had himself bought it at the Renou and Colle Gallery in Paris. Skira had brought a number of paintings from France, claiming that they were "personal property." Most of them

were resold. We know from reading the memoirs of Germain Bazin that Albert Skira often went to Paris during the war. He also made frequent visits to the director of the Sourches warehouse, and to René Huyghes. These meetings between Huyghes, Bazin, and Skira took place in a private room in a restaurant called Lapérousse. Bazin recalled that "Lapérousse was overflowing with food.... Skira was trying to prepare some books with color reproductions for his bookstore. He couldn't raise our royalties because of the high costs involved, very clearly illustrated by the surveillance vehicle that was waiting in the street."

Many of the works that went to Switzerland have remained in the vaults of its citizens. Others can be found in Swiss museums— there for everyone to see, though still untouchable. Others are still missing.

PART IV

Revenants

12

The Found and the Lost

In France the recuperation of art began quite by accident, just two days after the Liberation of Paris. Paul Rosenberg's son Alexandre, a young lieutenant in Leclerc's Free French Second Armored Division that first entered into Paris, was confronted by a nearly miraculous stroke of luck. On August 27, 1944, he received an order to take over a train bound for Germany, which was at the marshaling yard at Aulnay-sous-Bois. General Leclerc's division had already captured the outskirts of Paris; the Germans were fighting as they retreated. According to information given by a railroad worker, the train was filled with art belonging to the French. Having commandeered the train, and opened all the doors of the cargo wagons, Rosenberg found, among hundreds of other works, paintings by Picasso, Braque, and Marie Laurencin that had belonged to his father.

They were what remained of what the Germans had hurriedly carted away in the final days of the Occupation, after four years of official train convoys.

In February 1944, faced with the advance of the Allied armies and the bombardments, Hitler ordered that the important paintings and other confiscated works stored in warehouses in the Reich be transferred to the Steinberg salt mines near Alt Aussee in Austria. Thousands of works were quickly packed up, and between February 1944 and March 1945, thirteen convoys of trucks filled with art drove from the ERR's six Reich depots to the underground shelters.

At the beginning of August 1944, with the German defeat looming in France, many soldiers and ERR officials were pressed into service at the front. Until then they had imperturbably continued to inventory works from the Rothschild, David-Weill, and Lévy-Benzion collections. Full documentation on every work had not been completed. The rest of the ERR staff abandoned the offices and Parisian warehouses in a hurry, well before the French Second Division and the U.S. army entered Paris.[1]

For the German embassy personnel there was no more time to send trains to Germany. The period of "every man for himself" had begun. A number of German officers had left with their division of the art spoils, in any way they could. Between July and August 1944, Ambassador Otto Abetz and the embassy staff moved out of their offices on the Rue de Lille. Abetz gave the order to take down the paintings decorating the walls and to prepare them for immediate removal to Germany. Wüster, the cultural attaché, had also taken down some of the better works before heading East himself. Among the paintings removed by various members of the diplomatic corps were pieces from the Rothschild collection. But they also included the very handsome *Portrait of Gabrielle Diot* (*see* insert A3), a pastel that Degas had done in 1890 for the daughter of an art dealer on the Rue Laffitte, and which had belonged to Paul Rosenberg. In fact, the embassy had thought that a number of the

pieces seized at Floirac were beautiful and good enough to hold on to. It had also decided to keep Renoir's *Breton Woman* and even a work by the Jewish painter Pissarro, *Woman at a Turn in the Road*. A large *Waterlilies* panel by Monet, Bonnard's *Interior with Flowers*, and Degas's *Two Dancers*, also from the Rosenberg collection, had also been to the taste of the Nazi diplomats, since they were sent to Berlin to decorate the Foreign Ministry office or to hang in von Ribbentrop's home.[2]

After the Germans' sudden departure, Abetz took refuge with the retreating Pétain, Laval, and other high officials of Vichy in the castle at Sigmaringen, near the Black Forest. Once the German defeat became official, not one of them wanted to take responsibility for the plundered works. A large number of them were transferred to the castle at Wildenstein in Germany, and *Portrait of Gabrielle Diot* may have been among them. Before the arrival of the Allies, Abetz had also stored 196 engravings from France with the curator of the museum at Sigmaringen, which is where the Allies rescued them.[3]

The Allies gave no quarter to Nazi leaders responsible for the war, its destruction and crimes, many of whom were also involved in art confiscation in France. Goering was captured on May 9, 1945, and put on trial in Nuremberg the next year. Two hours before his hanging, he committed suicide by swallowing cyanide capsules he had managed to smuggle into his cell. His ashes were thrown into the last incinerator that remained in the Dachau concentration camp. Alfred Rosenberg, the Nazi Party's ideologue and head of the ERR, and Joachim von Ribbentrop, Minister of Foreign Affairs, were also found guilty of war crimes and hanged on October 16, 1946. Baron Kurt von Behr, chief of the ERR in Paris, took refuge with his wife in his castle at Banz, near Bamberg. There, in this serene setting, they opened a bottle of champagne, a 1928 vintage, mixed in some cyanide, and drank it. They were found by American soldiers.[4]

Ambassador Otto Abetz was captured in Germany. Tried and found guilty by a French court in 1949, he was condemned to twenty years in prison, but freed in 1959.

The art historians Bruno Lohse and Gunther Schiedlausky, from the ERR in Paris, were also captured and interrogated in Germany. Von Behr's suicide was a godsend for them, because it permitted them to blame everything on him, and indeed they maintained they were merely following orders and that von Behr had been responsible for all the confiscations. The art dealer Gustav Rochlitz was captured in Germany and extradited to France, where he was tried, found guilty, and thrown into prison, having been stripped of all civil rights and all possessions.

Indeed, toward the end of the war, Rochlitz sent some twenty of his paintings to his home in Bavaria; the remainder he gave to friends. Fourteen of the paintings disappeared somewhere between Paris and Baden-Baden. Rochlitz maintained that the head of the shipping company he'd used had stolen them, and that they'd probably never left French soil. But since he had been forced to leave Paris a week before the city's liberation, he was unable to verify his assertions.

In April 1945, American soldiers opened one of the crates sent to Rochlitz's home and found it contained eight paintings. Four of the eight would resurface after the war. To this day, however, the other four have not been found. Rochlitz's postwar interrogators labeled him "a weak and cowardly man," a notorious liar, and above all a low-caliber opportunist. Nothing he said would stand up to scrutiny, they said. Indeed, many have suggested that his version of what happened to the paintings could easily have been a ruse, and that they always remained in his possession.

And more than fifty years after Rochlitz's interrogation, the facts came to confirm his interrogators' intuitions. Rochlitz was lying.

At a dinner party at the Catskills in August 1997, the grandson of Prentice Bloedel, a founder of the Canadian timber company MacMillan Bloedel Ltd., was looking at the illustrations of looted

paintings included in this book. He suddenly recognized a Matisse painting he knew well, since he had often seen it at his grandfather's—who had bought it in 1954—before it was donated to the Seattle Art Museum.

The painting was *Oriental Woman Seated on Floor* or *Odalisque* (*see* insert A6). On September 5, 1941, the Nazis had removed this Matisse from vault number seven, rented by Paul Rosenberg, at the National Bank for Commerce and Industry in Libourne, near Bordeaux. The Matisse had been stored among the 162 paintings Rosenberg left at the bank when he fled France for New York. *Oriental Woman* had been transported by the Nazis to the Jeu de Paume in Paris along with the other paintings.

On July 24, 1942, Rochlitz acquired this painting at the Jeu de Paume along with another Matisse and a *Crucifixion* by Gauguin in exchange for an oil on panel—*The Three Graces* from the French Renaissance School of Fontainebleau—for Goering. During his interrogations, Rochlitz declared that this Matisse had been lost on its way to Baden-Baden at the end of the war. But the fact is that *Oriental Woman* probably never left for Baden-Baden and instead was sold in Paris after being exchanged by Rochlitz.

In 1954 the Matisse was brought from France into the United States by Knoedler & Company, a renowned New York art dealer, who then sold it to Bloedel. Knoedler says it purchased the painting from the Drouant-David gallery in Paris.

When Prentice Bloedel's grandson recognized the painting, he told Elisabeth Rosenberg-Clark, a granddaughter of art dealer Paul Rosenberg. The Rosenbergs are now claiming *Oriental Woman Seated on Floor* from the Seattle Art Museum.

The painting's trail had been lost until it took shape again, thanks to the greater access of information to a wider audience. The difficulty of tracking the painting down was greatly magnified by the fact that the Matisse had been kept since the 1950s at the Bloedel's private home in the Pacific Northwest where only a selected few could see it.

As for the French who took part in the sale of confiscated works and the dealers who did business with the Germans, the situation is much more complex. The art market had flourished during the war and too many dealers were implicated. Those whose activities were most visible, such as Lefranc and Fabiani, were tried. But after a meeting of the Association of Art Dealers, it was decided by the members not to provide information to the new government or to the DGER, for fear of reprisal.[5] Many of them were themselves guilty of having dealt with the enemy and sold looted works.

The paintings from the Paul Rosenberg collection were victims of dispersal even though many never crossed the border. Indeed, some thirty of the works confiscated in Floirac remained in the annex of the German embassy until the end of 1941, while waiting to be used as exchange pieces. Among them was a very pretty drawing by Picasso called *Standing Nude*, as well as Braque's *Bather with Raised Arms* and *Plate of Oysters with a Napkin Ring*. Of course, given its own interdictions against "wild expressionists," embassy officials could scarcely hang them on the walls. The staff had simply been interested in trying to beat the ERR before it could flood the Paris market with "hundreds of expressionist paintings" that it had in its possession. Exchanged and scattered about on the market, the works therefore disappeared.

But when thousands of works pass through tens or hundreds of hands, their rediscovery becomes as probable their disappearance. Here's proof: At the end of 1970, the same Alexandre Rosenberg, the inheritor of his father's gallery in New York, received a letter from Frankfurt, informing him that Degas's pastel *Two Dancers*, which had been in his father's collection, could be found with two Swiss or German citizens who didn't want their identities known. These citizens maintained that Rosenberg had sold the pastel in Paris in the summer of 1940. They wanted to sell it back to Alexan-

dre. He told them that the work belonged to him because it had been confiscated from his father in Floirac. Realizing the complexity of international laws regarding property and the difficulty of bringing suit against these people, Rosenberg proposed giving up all rights to the work in exchange for a sum to be named. The putative owners were surprised by Rosenberg's reaction and accepted the proposition. The deal was settled.

Then one day Alexandre was going through a French catalog of an auction sale, "Floralies 1974," in his gallery in New York; works to be sold and exhibited at the Rameau Hotel in Versailles. Two hundred and six paintings from the nineteenth and twentieth centuries were going up for sale: Braques, Calders, Chagalls, and de Chiricos. What caught Alexandre's attention was lot 76, entitled *Table with Tobacco Pouch*, signed by Braque in the lower corner, and dated 1930. The catalog gave the provenance of the work as "the former Paul Rosenberg Collection." The painting was being sold by Madame de Chambrun, the daughter of Vichy Prime Minister Pierre Laval. But the painting had been confiscated by the embassy at Floirac and then exchanged in Paris.

Rosenberg hopped on a plane for Paris the following day, and on June 11, the day of the sale, he arrived at Versailles with the police to seize the painting. On the verge of a nervous breakdown, Madame de Chambrun handed it over. This was in fact the second time that Madame de Chambrun found herself in this situation. In the 1950s, the Schloss family discovered one of its confiscated paintings in her collection. One cannot trace exactly what happened to these paintings following the various confiscations between 1939 and 1945. But we know for sure that Otto Abetz, the German ambassador, was a political ally and close friend of Pierre Laval, and this is probably why these paintings ended up in Laval's daughter's art collection.[6]

In 1987, following Alexandre Rosenberg's death, his wife Elaine was leafing through the December issue of the British art magazine *Apollo* at the Frick Reference Library in New York. On page 25 she found a full-page color advertisement of an auction of old and mod-

ern paintings and drawings at the Mathias F. Hans Gallery in Hamburg. There were to be Rembrandts, Tiepolos, and works by Vallotton and Braque. But the centerpiece of the sale was reproduced in color on the page; it was Degas's *Portrait of Gabrielle Diot*. The advertisement indicated that the work had belonged to the Paul Rosenberg collection in Paris, but inexplicably, that's all it said. Troubling also was the fact that no color photo of this Degas had ever been made or published by the Paul Rosenberg Gallery or Jean Sutherland Boggs's 1962 catalogue raisonné of Degas. In the same year, the same painting had been offered to Parisian dealer Paul Brame, one of the best-known Degas experts in Paris; he refused it once he realized that it had been confiscated from Paul Rosenberg. Brame had immediately informed the French police. Having seen the gallery's archives and talked with a lawyer, Mrs. Rosenberg called Hamburg to declare that she was the owner of the work and demanded information about the seller. She explained that the painting had been taken from her father-in-law Paul Rosenberg during the war. Refusing to give the name of the seller, the gallery director said it would contact the consigner to let him know. When Mrs. Rosenberg called back several days later, she was told that the consigner had disappeared along with his painting. It had not been seen again until recently, when it is thought to have been sold in the United States.

The day after Paris was liberated, Paul Rosenberg began, from New York, to look for his stolen works. Starting in October 1944, through an exchange of letters with his brother Edmond, who had stayed in Paris during the war, he started to grasp what had happened. He first learned that the building on Rue de La Boétie had been occupied by an "Institute for the Study of the Jewish Question" and that when they had left, the staff had taken everything it could—wall coverings, curtains, carpets—for back pay they were owed. He also learned, to his enormous relief, that the stock in Tours had been spared confiscation thanks to the resourcefulness of Louis Le Gall. In the end, the chauffeur had paid the cost of storage out of his own

pocket. Le Gall had also kept a precious list of the paintings stored in Floirac in September 1940. Rosenberg learned that the few works he placed in Braque's safe at the bank in Libourne had been saved.

Mademoiselle Roisneau, his assistant at the Paris gallery, had invested the money her boss had left in paintings bought in Rosenberg's name. She was able to buy a Renoir. But she had to leave for the country, as the Germans had carried out a search of her apartment, sealed up her basement, and even threatened her. A series of letters from Edmond gave Paul further information: "The only thing that remained in the crates at the Rue de La Boétie was a large Matisse still life, a landscape and a nude by Picasso, and a large Marie Laurencin. . . . The concierge saved some works that were in storage in the basement. . . . All the photo albums, a cubic meter and half's worth, were saved."

Paul Rosenberg also learned that part of the the Floirac and Libourne paintings had been sent to Germany and that part of them had been sold on the Paris market. Seven Matisse works had been seen in Paris, including *Young Girl in Pink Skirt with Flowers on Table* and *Odalisque and Flowers*, which had been taken to Floirac and sold by Fabiani, while the *Sleeping Woman* had been sold by Renou and Colle to an unknown collector. *The Lunch* by Vuillard went on public sale in Paris on February 18, 1944. Through his brother's letters, Paul began to see the extent of the recycling of stolen art on the Paris market. Edmond recounted he had seen the Belgian dealer Raphaël Gérard about the Pissarro work, *Snow Scene*, belonging to Paul. Gérard had already sold it to a client but, terrified by all this questioning, he had told Edmond that he would do what he could to get the painting back. The worst thing Edmond could do, Gérard added, was to frighten the client by talking. Gérard finally confessed to Edmond that he had bought the painting from the German embassy. Edmond also learned that Braque, having found out that one of his paintings that was stolen from the Rosenbergs, *Mandolin on Table*, was being put on sale, had asked Louise Leiris to buy it to get it off the market.

Most of all Paul Rosenberg learned from his brother that the recently created CRA (Commission de Récupération Artistique) in France already had information about what had happened to some of his works. "According to their information," Edmond wrote him, "part of your collection, including Van Gogh's 'Man with Broken Ear' [sic] were in Switzerland." Rosenberg started preparing the long and complex claims files for the CRA. He learned from his contacts in Paris that Matisse's *Open Window* had also been seen in Switzerland.[7]

Rosenberg knew from that point on that his paintings were scattered throughout France, Germany, and Switzerland. From his gallery in New York, he prepared for his return and for his search. He began trying to return to Paris in 1944, but military priorities made it impossible and he wasn't able to get there until the summer of 1945.

Rosenberg's paintings are a few examples among thousands that the CRA attempted to go after. The Commission had been created only weeks after the liberation of Paris, and was headed by curator Albert Henraux. A *Catalog of French Property Stolen Between 1939–1945*, was put together, containing the names or reproductions of paintings, sculptures, art objects, and books, according to individual claims filed, beginning in the autumn of 1944. Among the Commission's greatest investigators was the curator Rose Valland, who played a major role. Her intimate knowledge of the German confiscations at the Jeu de Paume and her lists of inventories permitted the Commission to trace the paths of a considerable number of works. Hubert de Brie and Marcelle Minet, curator of the David David-Weill collection, were able to join in efforts to recuperate the works in Germany itself.

Faced with the systematic pillaging the Nazis had engaged in throughout Europe, the American and British Allies created services charged not only with the protection of monuments and artworks, but with their recuperation and restitution. The organization was called the MFA & A (Monuments, Fine Arts & Architecture). Its American side had composed very precise inventories that permit-

ted them to know who the victims of confiscations were, in France
and elsewhere. The British team was smaller, but had the advantage
of being run like a true intelligence service. The Soviets had a dif-
ferent view of things. Their perception was that reparation in kind
should replace what the German army had taken or destroyed. In
Germany and the eastern European countries occupied by the So-
viet army, few of the things owned or plundered by the Nazis were
returned to their owners.

The Western Allies, on the other hand, wanted to return the ac-
tual works to their dispossessed owners. They created a series of
warehouses in Germany where collections could be divided and in-
ventoried. It was what the ERR had done at the Jeu de Paume, only
in reverse. The center of the network was the "Collecting Point" in
Munich, installed in the Führerbau offices—Hitler's offices—and
in the Verwaltungsbau, the former headquarters of the Nazi Party.
During the war, these two buildings had also served as Nazi ware-
houses for hundreds of plundered works intended for the Linz mu-
seum. Part of the Rothschild collection and around 110 works from
the Schloss collection were stored there.

Brought by Corrèze to Paris, the 333 Schloss paintings had been
sent to three different locales: Works preempted by the Louvre
stayed in Paris, those taken by Germany went to Munich, and those
given as a commission to Lefranc (twenty-two in all) had been put
up on the Paris market. Lefranc sold his paintings to a Dutch dealer
by the name of Buittenweg. The modern art collection of Prosper-
Émile Weil had been sold to the very enterprising Raphaël Gérard.
Lefranc kept Toulouse-Lautrec's *Portrait of Romain Coolus* for
himself, selling it to the Louvre in March of 1944 for 35,000 francs.
At the end of the war Gérard, whom everyone accused of collabora-
tion, earned impunity by doing the same thing he had done for Paul
Rosenberg—locating art, in this case the works belonging to Pros-
per-Émile Weil that he had sold on the Paris market.

The Schloss paintings preempted or bought by the Louvre were
returned to the family in the years following the war. As thanks, the

Schlosses donated their Petrus Christus to the museum. As for the paintings that had ended up at the Führerbau in Germany, many were lost in April 1945, when the Allies entered Munich. According to Lieutenant Craig H. Smith, who was director of the "Collecting Point" and arrived there at the end of May of 1945, the Nazi depot warehouse had been pillaged by the city's inhabitants, German soldiers, and even American soldiers.[8] A number of these works stayed in the region, since in the months that followed two officers in the Yugoslavian army discovered some of them. These two soldiers decided to look for stolen works for themselves, both in Munich and in the surrounding regions. They met with pretty good results, for they also found a number of works from the David-Weill collection.[9]

In the end, the Schloss family recovered only about 149 of its 333 pieces; the rest was lost. In 1945, acting under their own names, officers of the American army had proposed selling four of the looted works to the family; naturally they refused but they never saw them again. In 1949, 1951, and 1954, Lucien and his brothers and sister decided to break up the collection and sell the recovered works at auction.

In the years that followed the war, a number of Schloss paintings turned up, either in Europe or the United States, in museums, galleries, or prestigious auction houses such as Sotheby's and Christie's. Such was the case with Frans Hals's *Portrait of Pastor Adrianus Tegularius* (*see* insert C7), which after a particularly tortuous international path, turned up in Paris forty-seven years after the war. Its subterranean itinerary shows just how negligent a great number of experts in the world of art have been toward stolen art since the war.

This portrait by Hals was bought for the Linz museum in 1943 and taken for storage to the Verwaltungsbau's basement in Munich. After the building had been pillaged, it disappeared. Then in 1952 Lucien Schloss received a letter from a Mr. A. R. Ball in New York, saying that he had been offered the Hals by a man in Frankfurt. Ball offered to act as an intermediary and asked whether he could make an offer. Not wanting to work with a dealer out of nowhere, Lucien

and his family placed an announcement in German newspapers, but they never received an answer. Fifteen years later, the portrait of this Protestant minister from the city of Haarlem surfaced in New York, at the Parke-Bernet auction house, where it had been put up for sale as "The Property of a Gentleman" and included in the sale of the estate of the late Italian Princess Labia on November 3, 1967. In the catalog, a very succinct historical description of the work ended with "Schloss Collection in Paris," but provided no date. Sold for $32,500 to the Norwegian collector Ludvik Braathen, the painting was put up for sale again in March 1972, at Christie's in London; again the historical description was sketchy, with no mention of the Nazi theft. In France, the Schloss heirs did not have the slightest suspicion that their painting was leading a second life on the international market. Then, in 1974, Seymour Slive, author of the catalogue raisonné of Hals's work, knowing that the work had resurfaced on the market, clearly explained that the work had been stolen from the Schloss collection by the Nazis and had disappeared, and emphasized that there was "a gap in its history" that "lasted until it appeared at the sale by Princess Labia and the others."

At the time of its next public appearance, in 1979, at Sotheby's in London, the Franz Hals would regain part of its history, thanks probably to Slive, and be described in the sales catalog as having belonged to the Schloss collection in Paris "until 1940/45, at which time it was stolen by the Nazis and reappeared at the time of its sale by the Princess Labia." The Sotheby's catalog even referred to the work as being listed in the very official *Catalog of French Property Stolen Between 1939–1945*, published by the French government after the war, and noted that the painting had been "declared stolen." Sotheby experts had apparently enlarged their field of research, though they had not gone so far as to halt the sale or get in contact with the Schloss heirs to learn more. And the painting was sold at the March 28 auction.

It stayed in private hands until, finally, in April 1989, Christie's in London put the work up for sale under lot number 26. This time

its status as a piece of stolen art mentioned in the 1979 Sotheby's catalog was missing altogether. The Christie's catalog said simply that the painting had been "in the Schloss Collection until the Second World War," without providing further details. One can wonder whether Christie's read the Sotheby's catalog. Newhouse Galleries Inc., an Old Masters dealer in New York, bought the *Portrait of Pastor Adrianus Tegularius* for $203,501. The director of the gallery, unaware that he was dealing with a painting with a litigious past, and thinking that it was the type of work that could find a buyer in Europe, took it to Paris to the 15th Biennale Internationale des Antiquaires at the Grand Palais, an important antique dealers show, held in September–October 1990. Hence, the looted work had gone full circle: having left Paris in 1943, the Frans Hals had finally come back to its place of origin. When Henri de Martini, one of the Schloss heirs, learned the news, he had the painting seized by the French police. The Newhouse Galleries, which had bought the work in good faith, made a claim to Christie's, which reimbursed Newhouse Galleries for the amount it paid. Since 1990, Christie's and the Schloss heirs have been engaged in a series of legal disputes over the seized painting, which are now pending appeal in France. The Frans Hals is a typical example of a stolen work that has been reintegrated into the normal market, once its origins have been progressively effaced or forgotten.[10]

Another work from the Schloss collection, Rembrandt's *Portrait of an Elderly Jew in a Fur Hat* (*see* insert C5), provides a similar example. The Schloss heirs claim the painting can be found today at the Carnegie Museum of Art in Pittsburgh. The museum maintains that the history and provenance of the painting have not been easy to ascertain. What happened to it, however, during three centuries following its creation are clear. The only doubt involves who painted the work, since it might have been painted by Rembrandt himself or another seventeenth-century Dutch painter.

Stolen in Corrèze and taken to Paris, to the headquarters of the General Commission on the Jewish Question, the painting is listed

among the twenty-two works bought by Buittenweg and sold in France or elsewhere. The painting came to the United States, very probably after the war, but no one knows how.

At that point, Charles J. Rosenbloom, an important Pittsburgh collector of Dutch and Flemish art, bought it. An immense number of European works were being put on sale in the United States. In 1946, Rosenbloom exhibited the work at the Carnegie Institute. In 1975, he bequeathed the work to the museum. Sol J. Chaneles, a criminologist working for the Schloss family, discovered the work, but neither the museum nor Rosenbloom's heirs were able to provide him with credible information about its provenance prior to March 1946. The proof that Chaneles and the Schloss family have been able to provide is very solid. First, there is the confiscation of the inventory of the twenty-two pieces done for Lefranc by R. Cl. Catroux, a collaborationist and art expert who was the brother of General Georges Catroux, a French Resistance hero. Then, there is the *Catalog of French Property Stolen Between 1939–1945*, where one painting is listed as missing. And, finally, the family photos that prove it is the same painting.

For the last few years, *Portrait of an Elderly Jew in a Fur Hat* has been taken off the walls of the Carnegie museum and is no longer accessible to the public, even in reproduction.[11] Louise Lippincott, the Carnegie's current curator of Fine Arts, stated that the painting is not visible anymore "because we don't know who it is by. We think it's by a seventeenth-century unknown Dutch painter." While refusing to hand over any written information or statement on the Schloss claim, Lippincott added that "our painting and the Schloss painting are different." Still, the family in Paris is convinced this is the painting looted from them by the Nazis.

As we've seen, the fate of the Rothschilds' paintings transferred to Germany was less tortuous, no doubt due to the fact that these col-

lections had been highly coveted and were well inventoried, cataloged, packed, and stored, having been so coveted. They were therefore recovered almost intact at the end of the war, at the ERR depot in Neuschwanstein in the American zone and in the Alt Aussee salt mines. They were quickly returned to France. Vermeer's *The Astronomer* and all the other looted masterpieces from the collections were given back to the family. Still, there were a few losses. Some paintings from Baron Robert's collection, including several works by Braque, Derain, and Zak, never made it back. They had been confiscated at the La Versine castle and sent to Germany. Other paintings and books from the collection of Alexandrine de Rothschild, Maurice's sister, had been stored in the castle at Nikolsburg in the Sudetenland. At the end of the war, therefore, these works were held in the Soviet zone. Ironically, Henri's collection of Chardins sent to England for safekeeping perished under German Luftwaffe bombing of the city of Bath.

As for those Rothschild works that had remained in France, in the Louvre's depots for the most part, they were returned in their entirety. The château at Ferrières, Édouard de Rothschild's property, which had served as a German garrison, didn't suffer too badly. To show their gratitude to the Louvre, the family of Robert de Rothschild donated Gainsborough's *Lady Alston* and a twelfth-century ivory statue.[12]

The sons of Josse Bernheim, Jean and Henri, who had changed their name to Dauberville, their nom de guerre, recovered a part of their father's collection. Despite the series of occupants of Rue Debordes-Valmore, and the confiscation of their collection and the gallery's stock, they tracked down a good many of the works. Some they found in Germany, with the help of the Commission; some they found among their own neighbors.

They had begun their efforts while living in Switzerland during

the war. They had learned that after it had been confiscated, a dealer had offered Bonnard's *Venus of Cyrène*, which had hung in their home on the Rue Debordes-Valmore, to the museum in Basel. When they attempted to get it back, they were forced to back down or face expulsion from the country. Once back in France, the family had again tried to recover the Bonnard, but the museum maintained that according to Swiss law they had ownership. The painting was never returned. It can still be found hanging in the Kunstmuseum in Basel. Recently the museum has stated this Bonnard has never been in their locale, but the Dauberville family claims it saw it exhibited there as recently as 1995.

The Bernheim-Jeune heirs also tried to recover their old gallery on the Rue Faubourg Saint-Honoré. M. Borionne had rented it to a number of clients. Getting it back took many years and more than sixty civil suits. Borionne had cleaned the place out and hidden five or six thousand precious archival photos from the gallery, which he used as blackmail. He would destroy them, he said, if the brothers reported his activities during the Occupation. Finally Borionne won and the photos were safely returned to the gallery.

Most of all, the Dauberville brothers investigated the Rastignac fire and found another version of events. Jacques Lauwick was categorical in his insistence that the works really had burned. The Daubervilles hired a private detective, who found new clues during the course of an investigation in the Périgueux region. On the same day as the fire, a worker had seen the Germans load paintings wrapped in brown paper into a truck. The description of their wrapping matched how they had arrived at the château in the first place. Another witness, a very young girl, had written in her diary that she had seen German soldiers loading rolled-up pieces of cloth into a truck. Curious, she had asked the soldiers what the rolls were and had been told that they were paintings. In March 1944, a theft of paintings followed by transport into Germany by train was still a plausible hypothesis. Whatever the case, Renoir's *The Moss Roses* and Van Gogh's *Flower Vase Against Yellow Background* have never been found.[13]

At the liberation, David David-Weill reopened the doors of his house in Neuilly. There was little left in it. The Germans had taken away 80 percent of the antiques, paintings, and sculptures, as well as the library that he had left behind. Photos of the collection and correspondence had also disappeared. The ERR had continued taking objects until January 1944, probably under the direction of the "M-Aktion," to furnish offices in Germany and in the territories to the east.

The one hundred thirty crates left in the care of the national museums at the Château Sources, and those seized at Mareil-Le-Guyon, had been carefully cared for in the ERR's warehouses in Germany. Marcelle Minet became part of the recovery efforts and was named to the French delegation at the central warehouse, the "Collection Point" in Munich in the U.S.–occupied zone. This enabled her to locate and quickly return the different collections of David-Weill.

There were, nevertheless, many losses, in particular among the pieces David-Weill had left in his home in Neuilly: at least fifty paintings, including Bonnard's *La Place de Clichy*, *Woman in the Tub*, and *The Beach*; a work by Vuillard; Utrillo's *Ruins*; a landscape by Maillol; some works by Roussel; and two Vallottons. A series of six sketches by Fragonard entitled *Warrior Stabbing a Man in His Bed* (*see* insert C1), and Isabey's *Portrait of Châteaubriand at 43* had been stolen on August 10, 1943, at Neuilly. Dozens of eighteenth- and nineteenth-century drawings, as well as chairs, tables, statues, frames, porcelain figurines, and clocks had also disappeared. Of David-Weill's library only the filing cabinets were left.

In fact, the ERR had sent part of the works—including the six sketches by Fragonard, the portrait of Isabey, and some of the books—to its warehouse in Nikolsburg in the Sudetenland, in what is today the Czech Republic. This, of course, was in the Soviet-occupied zone.[14]

In the Neuilly house all that remained was one solitary statue,

which had been part of a pair. Stunned by the oddness of this, David David-Weill asked an expert why this was the case. The expert replied that, of the two, the Germans had left behind the copy.[15]

☐

The apartment belonging to David-Weill's son, Pierre, the one decorated by André Masson, Alberto Giacometti, Lipchitz, and Lurçat, had been completely plundered. The radiator covers had been pulled off and probably sold, a portrait of Pierre's wife by Balthus had disappeared, as well as several of the tapestries by Lurçat. Only the andirons designed by Lipchitz had been left behind. The most grievous loss were the two murals that Masson had done, the green *Animals Devouring Each Other* and the yellow *Family in Metamorphosis*, which had been set at perpendicular angles to each other in the apartment's dining room and smoking room (*see* inserts C2, C3). Pierre David-Weill never recovered the panels. In fact, having lost nearly all of his modern works, he stopped collecting modern paintings altogether after the war. His new postwar collection consisted almost exclusively of sixteenth-century works. The green painting was almost certainly destroyed. But the yellow work had only disappeared. And the history of this work suggests that looted art eventually resurfaces. Indeed, after a long subterranean life, *Family in Metamorphosis* turned up at an exhibition at the Brusberg Gallery in West Berlin in 1985. In the catalog's historical description of the work, there is a gap between 1940, the last year Pierre David-Weill was in Paris, and the exhibition's opening in 1985. Before being lent by the Paolo Sprovieri Gallery in Rome to the Brusberg, the work had been in a private Italian collection.

After this rebirth, *Family* was then exhibited in the summer of that same year at the Sprovieri Gallery in Rome. In 1985, it came back to France for an exhibit at the Fine Arts Museum in Nîmes. Then on November 11, 1988, it was put up for sale by Sotheby's in New York. As we've seen was the case with other works, the re-

searchers at even the most prestigious auction houses have not always found out everything they could about the recent history of the works up for sale. Some of this information is readily available. Masson's preparatory sketches for both these paintings he called *Animals Devouring Each Other* can be found at the Museum of Modern Art in New York. But the catalog listed just the exhibition in Berlin in 1985 as the only reference for the panel. Nothing was given either before or after it.

The history of *Family* was never verified by its postwar buyers and sellers. A man named Odermatt, a gallery owner in Canada, bought the work at Sotheby's. And in the summer of 1995, the Centro de Arte Contemporaneo Reina Sofia in Madrid, Spain's museum of modern art, obtained the work from Odermatt as part of an effort to enlarge its holdings of modern art. The Centro restored the painting and is currently exhibiting it. Neither the buyers nor the sellers exercised sufficient curiosity about the real origins of this painting.

The illustration of Pierre David-Weill's apartment in this book shows that the painting was attached to the walls in the smoking room. It disappeared, having been confiscated by the Germans during the war, then reappeared in Berlin after an absence of forty-five years, then was exhibited in Italy and France, sold in the United States, bought by a Canadian, taken to Canada, then bought again and transported to Spain, where it can be found today.[16] Other important works have also surfaced decades after and far from the place where they were confiscated.

Alphonse Kann's confiscated collection suffered serious losses during the war. Kann, unfortunately, did not make an inventory of his vast collection and in 1938 fled to London, where he remained throughout the war. He died in 1948 without ever returning to Paris. Some one hundred paintings and drawings disappeared as did some thirty tapestries and a few illuminated manuscripts. Among the missing paintings are works by Degas, Manet, Bonnard, and an important 1917 Matisse, *The Two Sisters*, a portion of which can be

Warrior Stabbing a Man in His Bed *(whereabouts unknown)*
JEAN-HONORÉ FRAGONARD
Six sketches. Pen and wash.
David David-Weill Collection
(Photo courtesy David-Weill)

Salon, home of Pierre David-Weill, Avenue Émile-Accolas, Paris, late 1920's; tapestries by ANDRÉ LURÇAT, andirons by JACQUES LIPCHITZ.

Smoking room, home of Pierre David-Weill, Avenue Émile-Accolas, Paris;
on the back wall: **The Family in Metamorphosis**
ANDRÉ MASSON, (1.4 × 4.5 m.), 1929, © SPADEM 1995.

The Schloss Collection before the war: the long gallery
Adolphe Schloss residence
38, avenue Henri-Martin, Paris
(Photo courtesy A. Vernay)

Portrait of an Elderly Jew with a Fur Hat
First attributed to Rembrandt van Rijn, then to an unknown
seventeenth–century Dutch painter (21 × 17 cm.)
Schloss Collection
(Photo courtesy A. Vernay)

The Schloss Collection before the war: salon overlooking the gallery.
Adolphe Schloss residence
38, avenue Henri–Martin, Paris
(Photo courtesy A. Vernay)

The Schloss Collection before the war: salon
Adolphe Schloss residence
38, avenue Henri–Martin, Paris
(Photo courtesy A. Vernay)

Portrait of Pastor Adrianus Tegularius
FRANS HALS (28.5 × 23.5 cm.), 1655–60
Schloss Collection
(Photo courtesy A. Vernay)

Landscape with Smokestacks
EDGAR DEGAS (28 × 40 cm.), pastel over monotype, 1890
(Photo private collection)

Friedrich (Fritz) Gutmann
and his son Bernard in
Holland, in the early
1920's.
(Photo private collection)

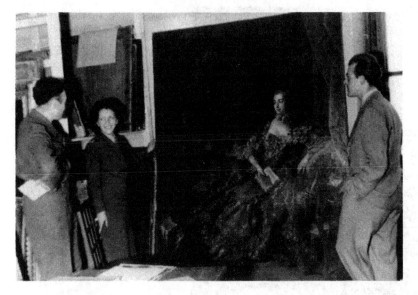

Above: Hubert de Brie, Marcelle Minet, and H. von Wilfinger at the time of the recovery of **Portrait of the Marquise de Pompadour** by BOUCHER, Central Collecting Point, Munich, 1945.

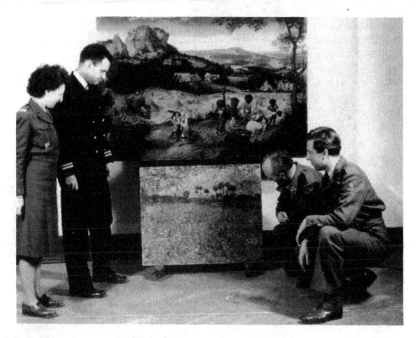

Marcelle Minet, U.S. Lieutenant Craig H. Smyth, head of the Central Collecting Point, M. de Risom, and Alfons Vorenkamp at the time of the recovery of **The Hay Harvest** by BRUEGEL from the Lobkowitz Collection in Prague and a VAN GOGH landscape, from the collection of Alexandrine de Rothschild at the Central Collecting Point, Munich, 1945.

Madame Camus at the Piano
EDGAR DEGAS, oil on canvas
(139 × 94 cm.), 1869
(Photo private Collection)

Reichsmarschall Hermann Goering, during one of his visits to the Jeu de Paume during the German Occupation of France. Here he's admiring a confiscated painting. In the background, an assistant is pouring champagne.
(Musée D'Orsay, Galeries Jeu de Paume)

Head of a Woman (R2P)
PABLO PICASSO (65 × 54 cm.), 1921
This unclaimed painting can be found today at the Rennes Fine Arts Museum, Rennes, France.
Museé National d'Art Moderne
Centre Georges Pompidou, Paris, and © 1997 Estate of Pablo Picasso/Artists Rights Society (ARS), New York

The "Room of Martyrs" at the Jeu de Paume (circa 1942), where the confis-
cated "degenerate art" was stored. At the back is a Picasso; on the right, two
Légers: a 1920's **Odalisque** looted from the Alphonse Kann Collection, and
Woman in Red and Green painted in 1914 and belonging to Leónce Rosen-
berg (see full painting on next page).
(©*Musée D'Orsay, Galeries Jeu de Paume*)

Woman in Red and Green (R2P)

FERNAND LÉGER (100 × 81 cm.), 1914

This unclaimed painting can be found today at the National Museum of Modern Art (MNAM) at the Georges Pompidou National Center for Art and Culture, Paris. It was looted during the war by the ERR from Léonce Rosenberg, the French art dealer.

Museé National d'Art Moderne

Centre Georges Pompidou, Paris, and © 1997 Artists Rights Society (ARS), New York/ADAGP, Paris

The Forest, or Forest Scene with Two Roman Soldiers (MNR 894)
FRANÇOIS BOUCHER (131 × 163 cm.), 1740
Louvre Museum, Paris
(Photo courtesy Louvre Museum)

The Cliffs of Étretat, after a Storm (MNR 561)
GUSTAVE COURBET (133 × 162 cm.), 1869
Musée d'Orsay, Paris
(Photo courtesy Musée d'Orsay)

Landscape (R1P)
ALBERT GLEIZES (146 × 115 cm.), 1911
This unclaimed painting can be found today at the Georges Pompidou National Center for Art and Culture, Paris. It was looted during the war by the ERR from the collection of Alphonse Kann.
Musée National d'Art Moderne
Centre Georges Pompidou, Paris, and © 1997 Artists Rights Society (ARS), New York/ADAGP, Paris

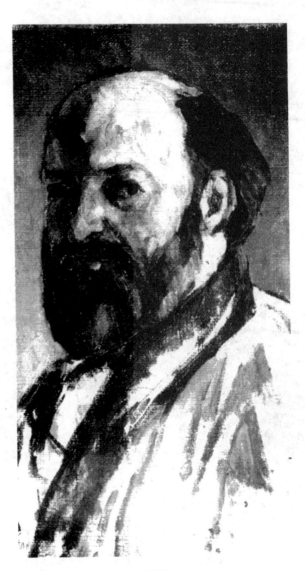

Self-Portrait (MNR 228)
Paul Cézanne (25.5 × 14.5 cm.), 1877–80
Musée d'Orsay, Paris
(Photo courtesy Musée d'Orsay)

barely seen in the upper left-hand corner of a photo of a storage room at the Jeu de Paume taken by the Nazis (*see* insert C12).

Also recently found is a very important painting by Braque, formerly owned by Kann, at the Musée National d'Art Moderne (MNAM) in the Pompidou Center in Paris. The path taken by this masterpiece is another example of the surreptitious ways by which very important looted works enter back into the art world—through a chain of international transactions that begins with the shadiest wartime wheelers and dealers and ending at highly respected collections and important museums—leaving few signals behind them concerning their real plundered origins.

The painting is Braque's 1914 *Guitar Player* (130 X 73 cm.), a Cubist masterpiece central to the MNAM's collection of modern artworks.

Alphonse Kann bought it in 1924 from art dealer Daniel-Henry Kahnweiler and owned the painting until it was looted by the Germans in 1940 from his townhouse west of Paris. The painting was taken to the Jeu de Paume and listed in the Nazi looting inventory of the Kann collection as item KA 1062, where *KA* stands for "Kann Alphonse." Its description reads: "*Stillleben mit Gitarre*" ("Still Life with Guitar"). Next to the description the letters *H.G.*, which stand for Hermann Goering, have been stamped. This means the painting was being reappropriated by Reichsmarschall Goering for a personal exchange. The ubiquitous art dealer Gustav Rochlitz is at the heart of this transaction. On 9 February, 1942, he gets the Braque, another Kann painting—Matisse's *Yellow Curtain*, today at the MoMA—and five other works in exchange for an *Adoration of the Magi* by an unknown early German painter. During his interrogation by the U.S. Army after the war, Rochlitz confessed to selling the painting in Paris to Paul Petrides, an unscrupulous French art dealer. The *Guitar Player* then ended up in the Paris collection of Andre Lefevre, a well-known and respected collector of Braque and Juan Gris. In November 1965, after Lefevre's death, the collection was auctioned off and the Braque bought by the German-American

art dealer and collector Heinz Berggruen, whose personal collection is housed today in the recently inaugurated Berggruen Collection in Berlin. A few years later, in 1981, MNAM bought the painting from Berggruen for 9 million French francs (about $2 million then). The Kann family claim in 1997 was kept confidential until January 1998, when it was made public and surprised the international art world. The claim is still pending.

Another, intriguing international story concerns eight illuminated manuscripts in the Kann collection identified by the Nazis as items "KA 879" through "KA 886." They consisted of five late fifteenth-century and early sixteenth-century *Flemish Book of Hours*, two sixteenth-century Italian prayer books, and one Persian manuscript. Many of the manuscripts' illuminations are described in detail in the Nazi inventory.

The eight manuscripts were never returned after the war, unbeknownst to Alphonse Kann's heirs until recently. In 1949—one year after Alphonse Kann's death—three of the eight manuscripts were exhibited at the National Library in Paris as important examples of unclaimed Nazi loot. Some time after, Georges Wildenstein, owner of the Wildenstein Galleries in Paris, London, and New York, staked a claim for the three manuscripts that had been exhibited at the National Library. Even though curators at the National Library were, then, apparently unaware of the existence of a detailed Nazi looting inventory of the Kann collection, they nevertheless disagreed with Wildenstein's abrupt claim and wrote an internal report questioning Wildenstein's proof of ownership. Through a series of forceful letters, Wildenstein insisted, and finally obtained at least three of the eight manuscripts in 1952.

Learning that many artworks—including the manuscripts— were still missing from the looted collection after the publication of this book, the heirs of Alphonse Kann resumed their search.

Wildenstein & Company and the Wildenstein Foundation still exist today in New York and London and are run by Georges's son and grandsons, Daniel, Guy, and Alec.

Between November 1996 and January 1997, Francis Warin, a grandnephew of Alphonse Kann, wrote three letters to the Wildenstein Foundation in Paris laying claim to all eight of the manuscripts. Successive research and information coming from the French Government and the National Library had led to the conclusion that the eight manuscripts looted from Alphonse Kann's townhouse were still, forty-five years later, in the Wildensteins' hands.

The Wildensteins rejected the claims. Guy Wildenstein replied to Warin's first letter explaining that his grandfather, Georges, had bought the disputed manuscripts directly from Alphonse Kann before the Second World War. He added that the manuscripts had been stolen by the Germans from the Wildenstein Gallery in Paris and returned to his grandfather after the war. The reply to the other two letters created some confusion in the minds of the Kann heirs. The Foundation's Paris lawyer stated this time that three of the manuscripts had, in fact, been bought in 1909 from Edouard Kann, a distant cousin of Alphonse Kann. The letter reiterated that: "These documents are the exclusive property of the Wildenstein family and were returned to them after being looted."

The confidential discussions between the two parties were at a deadlock. A few months went by and, suddenly, in late April, James H. Marrow, a professor of art history and an expert on Flemish illuminated manuscripts at Princeton University, called Francis Warin in Paris.

Marrow told Warin why he was calling. In February—a month after Warin's last letter to the Wildensteins—Sam Fogg, a British rare books and manuscripts dealer, had been shown a few manuscripts at Wildenstein & Company on East 64th Street in New York and asked Marrow to examine and evaluate them.

On his first visit, Marrow was introduced to Daniel Wildenstein, who knew the purpose of his visit. During two visits to the gallery in March, Marrow prepared a written description of the most important manuscript in the lot, a very rare and valuable late fifteenth-century *Book of Hours*—or prayer book—known as the

"Hours of Jean de Carpentin" with illuminations by an anonymous artist known as the Master of the Dresden Prayer Book. The manuscript was indeed rare, very beautiful, and had not been seen in decades, which made it even more valuable.

Marrow examined seven other manuscripts and took color slides of them. He noticed each of the manuscripts he examined had "KA" plus three-digit numbers going from 879 to 886 marked in red pencil. He did not know exactly what they meant.

When he asked the Wildenstein gallery for proof of title and provenance, Marrow was told the manuscripts came from the Kann collection and had belonged to the Wildensteins for a very long time. The gallery could not, however, provide any bill of sale or a precise date for the transaction.

Marrow reported back to Sam Fogg, insisting on the gap in the provenance. Nevertheless, Fogg agreed to go ahead with the transaction provided the Wildensteins include a clause in the purchase contract to indemnify him against litigation about the manuscripts' real ownership. The Wildensteins refused and Fogg did not go through with the deal.

Intrigued by the incomplete provenances of the manuscripts he had examined, and not aware of the claims sent by Warin to Wildenstein, Marrow talked to Bodo Brinkmann, a curator at the Staedel Museum in Frankfurt, who is writing a book on The Master of the Dresden Prayer Book.

Brinkmann soon found the missing elements: the cards for all eight documents prepared by the United States Forces Central Collecting Point in Munich. The Collecting Point had been in charge, after the war, of gathering and returning all Nazi-looted art. Each card mentioned the KA number from the Nazi looting inventory; each identified the same presumed owner: the Kann collection. The manuscripts left the Munich Collecting Point for Paris on October 30, 1946.

Marrow looked then to warn the heirs of Alphonse Kann and found Warin who, in turn, informed him about the recent claims.

Indeed, having kept the precious Kann manuscripts for more than forty-five years, the Wildensteins now wanted to sell them, a few months after having been claimed by the Kann heirs. The Kanns are preparing a lawsuit.

When asked why the claimed manuscripts were now being offered for sale, Daniel Wildenstein said it was a coincidence. He gave still another version of the purchase wherein his grandfather, Nathan, had bought them from Edouard Kann between 1903 and 1914. According to Daniel, they had been looted by the Nazis from a safe in the Bank of France. He added: "I don't understand this claim. They claim it fifty year later? I tell you, if tomorrow someone steals a picture from me, I go and make a declaration to the police that it is stolen. But after thirty years, the man who stole it owns it."

The collection owned by the Gutmanns, Dutch nationals who consigned some of their paintings, sculptures, and art objects to an art firm in Paris, is another case in point. The fate of their works—whether kept in their residence in Holland or stored away in France—has been inextricably linked until today to the tragic destiny of their owners.

In Holland, "Fritz" Gutmann had been forced, at the beginning of the war, to sell not only part of the silverware and bronzes of his family collection to the Nazis but also several of his paintings, among them the *Portrait of a Young Man* by Botticelli. He managed, though, to keep several important pieces in his house out of Goering's reach.

The works sent by Gutmann to France were confiscated, partly, at an art firm on the Place Vendôme and, then, at Wacker-Bondy's, a forwarding agent on Boulevard Raspail, by Bruno Lohse, deputy director of the ERR. But, German art dealer Karl Haberstock had been previously to Boulevard Raspail and had already carried away some eight paintings.

Of those looted by the ERR and inventoried under the initials MUIR, some were taken to the ERR's central depots in Germany. But the two Degas—*Landscape with Smokestacks* and *Woman*

Drying Herself—and Renoir's *Apple Tree in Bloom*, were sold or exchanged by the Nazis in the European art market. And the small portrait by Dosso Dossi was chosen by Goering for his private collection.

With their son Bernard in England and their daughter Lili in Italy, Fritz and Louise Gutmann opted for staying in Holland during the war, trusting their luck. Like many unsuspecting Europeans at the time, they believed no harm would come to them. Gutmann thought that his eminent high-level political and financial connections and his Italian brother-in-law—a former ambassador to Berlin—would suffice to protect him.

Indeed, in the spring of 1942, the Italian ambassador to Germany wrote to SS Reichsführer Heinrich Himmler, head of the German police, inquiring about the Gutmann's well-being in Holland. Himmler's reassuringly bland answer came back on June 1942:

> Dear Excellency,
> Following your letter of 31.3.42, I notify you that no measures
> have been carried out against the Jew and Dutch citizen
> Gutmann, who resides in Hemstede near The Hague.
> According to your wishes, I have ordered my office at The Hague
> to leave Gutmann in his house and to except him and his wife
> from any kind of security police measures. With my special high
> esteem, I remain yours,
>
> H. Himmler

A few months later, the Italian consulate at The Hague also made sure Himmler's orders were being followed. Not only did Goering and other Germans in occupied Holland covet the rest of the Gutmann family collection but, also, Hitler's "Final Solution" project was being inexorably deployed. And, one day in the spring of 1943, a German officer reached, unexpectedly, the Gutmann's house to announce to the couple they were being granted safe passage and would leave by train to Florence, where they would meet

their daughter Lili. The SS officer handed them first-class Pullman car tickets. The couple dressed up in their best and took in their wardrobe, their coats and their family souvenirs along with their luggage. Their long train trip to Italy would take them, first, to Berlin.

Their daughter Lili waited for them at the station in Florence, but the Gutmanns did not show up. Thinking that her parents had missed the train or that there had been a delay or some misunderstanding concerning the schedule, for days Lili went regularly back to the station to meet each train that pulled in. But no one came.

In fact, at their stop in Berlin the Gutmanns were taken off the train. The couple was then sent on another train going southeast to Thereisenstadt, a concentration camp thirty-five miles away from Prague, and a transit station on the way to the extermination camps farther east.

When Lili learned her parents were at Thereisenstadt, she headed for the Ministry of Foreign Affairs in Rome, where she hoped her contacts would help her get her parents out of the camp. But, as it almost always happened then, once the Nazi extermination machinery had started furiously persuing someone it was almost impossible to stop the process. Lili's efforts turned out to be fruitless.

The Gutmanns survived all through the winter at the camp, but, then, in April 1944, Fritz Gutmann was found beaten to death. Gutmann had refused to sign a document "legally" ceding his assets and art collection to the Reich. In late June or early July 1944, Louise Gutmann was transferred from Thereisenstadt to Auschwitz, where she died in the gas chambers some fourteen days later. With the death of the Gutmanns the Nazis were free to confiscate and take to Germany what was left of their collection.

After the war, Bernard and Lili Gutmann took years to recover what had been dispersed by the Nazis and reconstruct the route of their looted parent's possessions. Their house in Holland had been emptied by the Germans. Endless interminable claim procedures in

Holland, Germany, and France took up much of Bernard's time. Through the years, the Gutmann children contacted art historians, art dealers, and Interpol, and kept a watch over art sales to try to discover the whereabouts of the collection that had belonged to their parents. Between 1946 and 1958 the paintings and other artworks started slowly reappearing. In 1964 they wrote to the Swiss Government intent on finding any assets left in Swiss banks by Fritz and Louise Gutmann. The following year the Swiss Government replied saying it would take a long time before it could provide any answer.

Many works from the collection seemed to have completely disappeared, among them, the two Degas pastels, the Renoir, the Dosso Dossi, all lost in France, and the Botticelli, lost in Holland. Unable to track them down in Western Europe, the Gutmann children were convinced these paintings were held somewhere in Eastern Europe or in the former Soviet Union.

Like all looted families, they obtained from the Federal Republic of Germany more than twenty years after the beginning of the Second World War, a very small compensation that was based on half of the artworks' market value in 1940. But, like many looted families, what Bernard and Louise Gutmann veritably wanted was to find and retrieve the paintings stolen from their parents.

Bernard Goodman—he had Anglicized his last name—searched continuously but rarely spoke about it to his family. When he died in 1994, his two sons, Simon and Nick Goodman, along with their aunt Lili, took up the search for the missing paintings. With the 1995 exhibition at the Hermitage Museum in Saint Petersburg of paintings seized by the Soviet army after the German defeat, Lili Gutmann's hopes of finding her parent's paintings increased. But a Russian curator Lili had seen was unable to trace them in the former Soviet Union.

Bernard's two sons, who live in Los Angeles, then contacted Willi Korte, a German lawyer who specializes in World War II loot. Soon after, a friend of Nick Goodman found the lost trace of the

Apple Tree in Bloom by Renoir. The two brothers and their aunt realized that, after many years of looking eastward, the three Impressionist paintings might just be in the United States.

The looted Renoir appeared, indeed, in an April 17, 1969, Parke-Bernet public auction sale catalog in New York. That day a few hundred lots from various owners were being auctioned as "Important Modern and Impressionist Paintings." The Renoir was lot no. 105 and presented as the property of the estate of the late Madame Lucienne Fribourg and of The Fribourg Foundation. It was sold for $85,000.

But The Fribourg Foundation in New York told the family it had no relevant information concerning the ownership of the Renoir they sold. And, when asked again by this writer, the Foundation refused to comment, stating that it is a privately held company that does not give out information to journalists. Moreover, Sotheby's in New York—who merged with Parke-Bernet—has systematically refused to disclose the name of the person who purchased Renoir's *Apple Tree in Bloom*. The Goodmans have asked Sotheby's, for over a year, to disclose the name of the owner, promising to keep this information confidential, but to no avail.

Confident that they were on the right track, the two Goodman sons continued their search for the other missing paintings.

A Degas traveling exhibition, *Degas Landscapes*, had been organized in 1994 at the Metropolitan Museum of Art and the Houston Museum of Fine Arts. But the Goodmans had no knowledge of it. And, in 1995, Simon Goodman, while consulting a book—written by British art historian Richard Kendall to coincide with the two American exhibits—found the Degas monotype and pastel *Landscape with Smokestacks* that belonged to his grandparents. The missing picture looted in Paris was shown in plate number 130. It identified Mr. and Mrs. Daniel Searle as the owners who had loaned it.

Lili and her nephews were delighted at the news. Searle was not. Mr. Daniel Searle, a former chairman of G. D. Searle, a major

pharmaceutical company, is also a trustee of the Art Institute of Chicago. The Goodmans soon started writing to Searle's attorneys and learned, through the provenance of the looted Degas, its very interesting history.

In 1987, on the advice and expertise of a curator at the museum, Searle had acquired the Degas through Margo Pollins Schab, a New York art agent, for $850,000. They also found out that Pollins Schab had purchased it in 1987 from Emile Wolf, a New Yorker. Wolf had owned the Degas for many years and had loaned it to exhibitions twice: in 1965, to the Finch College Museum in New York, and, in 1968, to Harvard University's Fogg Museum of Art. He had bought it in 1951 from art collector Hans Frankhauser, a Swiss textile merchant from Basel. And Frankhauser had, in fact, purchased *Landscape with Smokestacks* at an unknown date from another art dealer, Hans Wendland. And here we have found the proof we needed. Frankhauser was Wendland's brother-in-law who, after the war, paid for his legal fees in defense of charges of looting art.

For Wendland, as we have seen elsewhere in this book, was the active mastermind of the looted art smuggling ring between France and Switzerland. He worked closely with Bruno Lohse of the ERR, was an assiduous visitor to the Jeu de Paume, and a partner of Theodor Fischer, the Lucerne art dealer. Moreover, it was Wendland who had first suggested to Goering and Hofer using the German diplomatic pouch to get looted art across the border in order to avoid Swiss customs and other obstacles. He was also, according to a British intelligence report, a friend of Mme. Wacker-Bondy, the forwarding agent on Boulevard Raspail, where the Goodman's Degas was stored and looted. Wendland, according to the same report, also rented a room in Mme. Wacker-Bondy's store, where he kept many paintings.

Backed by this evidence and by a year of correspondence with Searle's lawyers that have yielded no results, the Goodmans have filed suit. They will probably recover their lost Degas. They will, sooner or later, also find out who is the current owner in the United

States of their Renoir and whether other family paintings, like their Degas pastel *Woman Drying Herself* survived Nazi looting. They will also track down the whereabouts of their Botticelli *Portrait of a Young Man*, which disappeared in Holland during the war but is probably in the United States.

The missing artworks we have treated in this chapter are part of the lost museum that the Nazis and the Second World War scattered about and destroyed. By tracking down, finding, and, finally, recovering them, these families retrieve a part of the soul of the past. That might help them assuage the bleak part of that past that has haunted them for so many years. They are also exercising an elementary right to justice, which is the least that could happen to them.

Other looted artworks did not travel much; they left Paris during the war and have remained through all these years in Switzerland, a relatively inaccessible country.

13

A Short Swiss Epilogue: Purchased Skeletons in the Kunstkammern

Starting in 1945, the three victorious Western allies—the United States, Great Britain, and France—quickly attempted to pursue those Nazis who managed to find refuge in Switzerland. To stifle any attempt at Nazi resistance, or revival, they also tried to obtain detailed information about German activities there—hidden goods, financial holdings, and commercial transactions—and to bring to light the ties that existed between Swiss citizens and the Third Reich.

Switzerland took advantage of its neutrality during the war to conduct profitable business with the Reich and the Axis countries, as well as with the Allies, during the war. It therefore found itself in a

very peculiar position when the war was over, comparable only to that of Sweden. Having not been a belligerent, Switzerland was neither an occupier nor occupied, and as a result the Allies had no real way of monitoring the country's internal affairs. That fact more than any other affected the postwar period, for as regards stolen art it gave Switzerland maneuvering room that it continues to enjoy to this day. It managed to hold itself apart from the rest of Europe and to impose its own pace, and sometimes even its will, upon the Allies.

The Swiss government promised to assist the Allies in their investigations, but very soon they ran straight up against administrative stalling and legal barriers. The country's bureaucracy did a great deal to protect its citizens, businesses, banks, and secrets from prying eyes. Swiss banking secrecy had been instituted in the 1930s, when dictatorships were growing in Europe and with them people wishing to make anonymous deposits. Swiss bank secrecy and discretion became even more pronounced during the war and created a number of bad habits.

We've already had a look at the Swiss art market. The British consul in Zurich and the American and British delegations in Bern had followed the comings and goings of Swiss dealers all through the war. They were aware in particular of the activities of Theodor Fischer, of the gallery bearing his name, and of Hans Wendland—both active partners of Gustav Rochlitz, the dynamic dealer of the Jeu de Paume. All three, as we've seen, were busy exchanging and selling plundered French art in Switzerland, and at enormous profit. The Allies suspected that other dealers, particularly those working out of the country's German-speaking cantons, the offhanded manner of several collectors, and the government's protections and laissez-faire attitude had encouraged these troubled transactions.

In short, the Swiss bureaucracy stifled postwar investigation with passivity and avoidance. In March 1945, Swiss authorities announced that they were willing to compile an inventory of all German assets in Switzerland, but then they denied access to

investigators. The Allies complained about this stonewalling. They already suspected that Swiss authorities had done nothing to prevent the sale or concealment of stolen art. In August of that same year, faced with continuing pressure from the Allies, the government declared that there was no need to create special legislation to recuperate confiscated property; Swiss laws covering stolen goods, it argued, were sufficient to help foreigners reclaim their property.

The Allies made it known that the annulment of fraudulent commercial transactions needed to be made automatic, just like elsewhere in Europe. The current situation was unacceptable, they argued, because, according to Swiss law, an owner deprived of his property can only claim his paintings from a buyer who has supposedly purchased them in good faith, within a period of five years following the work's disappearance. Given that most of the Nazi confiscations in Western Europe took place in 1940, most claims made in 1945 would be thrown out of the Swiss courts.

The Allies were also critical of the fact that each foreign claimant was forced to go to trial, individually, against each buyer, to retrieve what was his as if the art taken from him had simply been a matter of ordinary robbery, not a result of war. Moreover, they considered it outrageous that, again according to Swiss laws, looted owners were not only forced to pay their own legal costs but to reimburse any current possessor for the cost of the stolen paintings.

This cavalier attitude on the part of Switzerland not only meant endless travails for those seeking to reclaim their work, but also was a way of making the exceptional wartime crime committed by the Germans seem commonplace. Given the extent of the Nazis' looting, the Allies therefore demanded that a Swiss federal committee or special tribunal—similar to the recuperation committees created throughout the rest of Europe, including Sweden—be given global responsibility to investigate, collect, and automatically restore all recovered works of art to their former owners.

Dissatisfied with the Swiss government's general attitude, the Allies decided at the end of September 1945 to send to Switzerland

a specialist, an energetic connoisseur, someone capable not only of initiating discussions with Swiss authorities, but of leading a thorough investigation into impounded works of art and into the world of dealers and collectors. The specialist in question was Squadron Leader Douglas Cooper. Having already compiled the highly useful Schenker Papers in Paris, and having recently returned from a tour of the Nazi art storehouses in Austria, he was sent to Switzerland to compile a report.

Cooper's detailed investigation would provide the missing details and supply revelations as stunning as those found in Paris.[1] Within several weeks, Cooper succeeded in compiling a detailed list of seventy-five confiscated works of art that were to be found in Switzerland. Hundreds of others were found later on, but Cooper's were the finest. These seventy-five works had been part of eight collections belonging to British, French, and Dutch citizens. He picked up on the trail of the magnificent paintings from the collections of Alphonse Kann, Lévy de Benzion, and Paul Rosenberg, collections that we've followed since their being stored at the Jeu de Paume. These were the paintings Goering (or Hofer, the director of his collection) had chosen to use in exchanges. The investigation revealed that many Swiss citizens were implicated and that there had been enormous activity on the art market. There were at least nineteen Swiss citizens in possession of these seventy-five stolen paintings—dealers as well as collectors.

The biggest players were, of course, Fischer—who was in possession of at least thirty-eight pieces of stolen art—and the dealer Hans Wendland, the mastermind of the Swiss network. Before the war, Fischer had been a dealer in Old Masters and antiques, but, after his enriching collaboration with the German confiscators, he had become an "expert" in nineteenth-century and modern paintings, the works "refused" by the Nazis.

Cooper discovered that at a minimum sixteen Swiss dealers (a sizable number given the size of the country) were suspected of involvement in the traffic in stolen art. He further believed that

hundreds of confiscated works had crossed into Switzerland unnoticed. Cooper suspected that some of the works were placed in anonymous safes in the vaults of Swiss banks. Confronted with these revelations, the Allies insisted that the stolen works indicated in the report be put in the care of Swiss authorities and that the commercial activities of the dealers named be suspended until the matter of the origins of the paintings they had been holding since 1940 could be cleared up. All that the Swiss agreed to do was gather together a portion of the paintings in question and place them in storage in the Bern Museum. But the licenses of the dealers were not suspended.

The biggest news revealed by Cooper's report, nevertheless, was that the largest Swiss buyer of art confiscated by the Nazis was the armaments maker Emil G. Bührle. One might assume that his name appears in the report because of carelessness on his part. He was a passionate collector of art, and in his eagerness to acquire art he might by mistake have bought a stolen work. But a closer look at the facts makes it difficult to give the benefit of any doubt to this industrialist so well advised on business matters.

Not only was the Zurich industrialist one of Switzerland's most important art collectors; he was also a generous benefactor to the Zurich Kunsthaus. Born in Germany, Bührle had established himself in Switzerland in the 1920s, and made a fortune from his machine-tool company, Oerlikon Bührle and Company. Early in the game Bührle had come up with prototypes of air defense and anti-tank weapons that became highly prized by Europe's militaries. Profiting from Swiss neutrality, Bührle did business with the Third Reich and the Wehrmacht during the entirety of the war. The business allowed him to greatly increase his wealth and to find himself welcome among Nazi high officials. It was during the 1930s—the period of the arms build-up in Germany—and the 1940s that he created the basis of his art collection.

According to Cooper's report, in a short period of time Bührle had purchased thirteen stolen paintings, principally from the

gallery of Theodor Fischer in Lucerne. What is interesting from our perspective is that many of these paintings can still be found in the excellent collection of the Bührle Foundation in Zurich.

Bührle's purchases perfectly illustrate, down to the smallest details, the ambiguities inherent in the Swiss postwar attitude. The purchases included several world-class paintings, each one a veritable crown jewel for his personal collection: the large oil portrait *Madame Camus at the Piano*, painted by the young Degas; an oil sketch, *Dancers in the Foyer*, also by Degas; and a pastel of a nude woman, called *The Dressing Table*, or *La Toilette*, by Manet. All three had come from Alphonse Kann's looted collection. Among Bührle's other acquisitions are *Banks of the Seine* (or *Summer at Bougival*) by Sisley and Corot's *Sitting Monk, Reading*—one of a number of canvases Corot did of monks; both coming from the Lévy de Benzion family's looted collection. And of course there were several exceptional works from the collection and the Paris stockroom of Paul Rosenberg, among them a well-known Corot, *Girl in Red Bodice* (also known as *A Girl Reading*); a drawing of two nudes by Degas and one of his horse-race paintings, *The Jockeys*, or *Before the Start*; one of Manet's last works, *Flowers in a Vase*, or *Roses and Tulips in a Vase*; and finally a Pissarro, *Rouen Harbor, after a Rainstorm*.

The least we can say is that Bührle had indeed acquired some of the best pieces of nineteenth-century art that had been looted in Paris, and that he possessed a fine and well-developed taste. But he could not have been unaware of the French collectors who owned these works and the shady origins of the paintings he was buying. Besides, he knew very well who he was buying them from. It was common knowledge in Switzerland during the war that Fischer and Wendland had close ties with the Nazis in matters concerning art. In June 1939, the Fischer Gallery in Lucerne organized for the Nazis their first auction of "degenerate art" from German public museums, and had continued to negotiate other sales on their behalf.

During his investigation, Cooper went to see Emil Bührle in Zurich. He wanted to know more about the relations between the

industrialist and the dealers suspected of trafficking in plundered art. Bührle used the occasion to give his side of the story to the young British officer. While insisting he was not aware of Fischer and Wendland's activities—an assertion that is very hard to be-lieve—the powerful industrialist also furnished, despite himself, an outline of his dubious art-dealing company during the war.

Bührle explained to Cooper that he had indeed had fruitful business dealings with Fischer. In 1941, they had auctioned off in half-share a certain German collection. Fischer therefore owed him a considerable amount of money. Bührle said he went to Lucerne several times to visit Fischer and to buy the French works the dealer offered him. He suspected nothing of their origin, he added; Fischer had assured him that the paintings had come from German museums. Bührle went on to say that one of his art advisers told him that Fischer was lying and that the works were confiscations. He went to see his lawyer, who explained that, according to Swiss law, if the paintings turned out to be stolen, but he, Bührle, had bought them in good faith, all he would need to do is return them to Fischer and get reimbursed. Guided by his business instincts, and cynically waiting to see whether the paintings' former owners eventually came forward to claim their property, Bührle realized that under Swiss law he had nothing to lose and continued to buy works from Fischer.

Bührle described buying the paintings in Paris that we dis-cussed in an earlier chapter. He recounted how, in September 1941, during a business trip to France (a trip that would have been impos-sible without an official safe-conduct visa issued by the Germans), he met Charles Montag, a Swiss citizen living in Paris. Before the war Montag had been Winston Churchill's drawing instructor. But during the war he had helped liquidate artwork impounded from the Bernheim-Jeune Gallery and had dealt stolen art in Paris. Mon-tag led Bührle to the Dequoy and Company Gallery (formerly the Wildenstein Gallery), located on Faubourg St. Honoré. There the Swiss collector chose and bought five paintings, including a David

and two Renoirs, about whose origins Bührle maintained that at the time he knew nothing. Then—again according to Bührle—while the three individuals were in the gallery, the dealer Hans Wendland happened to stop by. Montag and Dequoy introduced them. But Bührle maintained to Cooper that up to that point he had not known Wendland, another German national living in Switzerland.

It also seems difficult to see how this crafty businessman happened to be in this particular Parisian gallery that worked closely with the Nazis without being aware of what they did for a living.

Bührle continued his story by saying that he'd been forced to leave behind the paintings he'd bought in Paris when he returned to Switzerland. One day, he told Cooper, Wendland turned up at his house in Zurich and proposed that Bührle buy other paintings from Fischer. During their conversation, Bührle happened to mention the paintings he'd left behind in Paris. Wendland said he knew of a way of getting them into Switzerland. Lo and behold, one day (when he was out of town, and not expecting them, Bührle maintained) an unknown person dropped off two of the paintings at his home. Bührle said he did not know the identity of the man who delivered them. Cooper, who listened attentively to what Bührle was recounting, had already learned the identity of this unknown man through other channels. It was none other than Walter Andreas Hofer, the director of Goering's collection, who had been in charge of transporting these paintings in November 1941. Given that it was Hofer, it becomes difficult to believe Bührle's assertions that he had not expected the arrival of his paintings, nor that he did not know the identity of the anonymous deliveryman that brought them.

At the end of the long conversation, Cooper informed Bührle that the Allies had already collected all the evidence they needed about the stolen paintings he had bought. He added that it would soon be passed along to the Swiss government. He suggested to Bührle that it would be a gesture of good will on his part if he placed the paintings in the government's care. The elegant, art-loving

industrialist agreed with Cooper. He would, he said, take care of the matter the following week.

Several days later, given Bührle's apparent change in attitude, Cooper made a formal request to the Swiss government to have the industrialist's name removed from the list of suspects slated for interrogation. This turned out to be a mistake. Bührle did not make the paintings available to investigators, arguing that he had bought them in absolute good faith. Cooper should have expected this, but he was unaware that earlier Bührle had already begun procedures that would allow him to keep the paintings. Several weeks prior to Cooper's visit to Bührle, Paul Rosenberg had come to Switzerland. Right from the moment of his first visit with Bührle, the experienced and canny art dealer knew whom he was up against. Exasperated with the military priorities in postwar France that had kept him from being able to leave New York before the summer of 1945, and then by the slowness with which the Swiss were releasing information, Rosenberg had decided to take matters into his own hands—bringing along his archival photos and his own inventory.

Rosenberg renewed his personal prewar contacts and made the rounds of the Zurich art dealers. He refused to visit Fischer in Lucerne but did talk with Wendland, whom he described as "exceptionally intelligent and wily." In the Neupert Gallery in Zurich he was offered Matisse's *Woman in Yellow Chair*, which had been stolen from him at Libourne. The asking price was 8,000 Swiss francs. It came with a guarantee that the work had come from a private Swiss collection. In the same gallery, Rosenberg saw photos of French Impressionist works that he had seen in France before the war. He knew this gallery did not specialize in French paintings before the war, and immediately suspected that the dealer was actively trafficking in art looted by the Nazis.

He also learned that *Self-Portrait with Severed Ear*, one of Van Gogh's famous self-portraits, plus four other Cézannes, all coming from looted French collections, were being stored in a bank vault at the Société des Banques Suisses in Zurich.

At the Aktuaryus Gallery he learned that his *Odalisque on Blue Background* by Matisse, confiscated at Libourne, had been sold to Bührle. He saw firsthand that the Swiss industrialist had benefited from the skewed prices that were a result of the aesthetic tastes of the Nazis—and of the extent of their confiscation. Rosenberg had paid 20,000 Swiss francs for the painting before the war; Bührle paid only 14,000 Swiss francs for it in 1942.

But the climactic moment of this trip occurred when Rosenberg went to visit Bührle at his home. Rosenberg reported that Bührle was very surprised to see him, since Bührle had been told he was dead. Furious, Rosenberg warned the Swiss collector that he would be deceiving himself if he thought that Rosenberg would have anything to do with him or that he would even consider that Bührle buy back the paintings stolen from him. He told Bührle that he should have asked where these paintings he was buying were from; all of them carried the mark "Rosenberg Bordeaux" on the back, put there by the Nazis. Rosenberg added that no confusion about their origins could have been possible, since many of the confiscated works Bührle had bought had been amply reproduced in catalogs bearing Rosenberg's name.

Bührle replied by telling Rosenberg that he was willing to return the paintings to Fischer, were Fischer prepared to pay him back what he had paid for them. Rosenberg was thrilled by the news.

Rosenberg knew very well that by visiting Bührle and by declaring that he had no intention of negotiating with him about the restitution of his property, he had "set the cat among the pigeons." But given Rosenberg's intransigence "on principle," he knew Bührle, Fischer, and Wendland would attempt to negotiate with him. Several days later, they sent an intermediary to offer a proposition. Rosenberg refused. He was sure that the government would push the three confederates to settle their differences out of court. Several days after that, the intermediary went to see Rosenberg again and proposed that 80 percent of the paintings be returned, meaning

they had a deal if Rosenberg agreed to part with 20 percent. This would spare everyone a protracted legal process. Rosenberg categorically refused again. He would not budge. Instead, he wanted the negotiations to be handled government-to-government.

The Swiss government, meanwhile, did not make anything easy, and to recover his paintings Rosenberg was forced to sue Fischer, Bührle, and others, all of whom insisted on the letter of Swiss laws and hid behind the vague concept of "good-faith" purchase. From New York, Rosenberg followed the trial's lengthy period of preparation with his customary tenacity. It finally got under way in June of 1948.

In court, Fischer, Bührle et al.'s lawyer did not dispute that Rosenberg had indeed once been the owner of the paintings. But with admirable cool he also argued that the manner in which Rosenberg had been dispossessed of the works was not illegal. In other words, he placed in doubt the very fact of their having been looted in the first place. Rosenberg, he posited, had acted in defiance of the Occupation Force's decrees by hiding the paintings in Floirac and Libourne. These decrees forbade the concealment of artworks. By disobeying them, Rosenberg had automatically forfeited all rights to these paintings and therefore could not sue for their restitution. Moreover, the lawyer argued that the Vichy law of July 1940 that deprived fleeing French citizens of their citizenship had been the valid law of the land. Given that Fischer, Bührle, and the others had purchased Rosenberg's works in Switzerland at the moment when according to the German occupiers and to Vichy he was no longer the rightful owner, they had not bought these confiscated works illegally.

This ignominious argument did not convince the Swiss judges. In the end, Rosenberg won and he was able to get his paintings back. But Bührle, ever the avid collector, convinced Rosenberg to let him buy back the same paintings he had already bought and lost in court. In the end, therefore, Bührle retained possession of the works, which can be seen today at his foundation; he finally got

what he wanted. We have already seen, however, that Bührle had bought many other confiscated works.

Does the current catalog of the art collection of the Emil G. Bührle Foundation indicate the true origins of the paintings it contains? To find the answer we need only take the three Kann paintings as examples. I have already traced their progress from Paris to Zurich; there is enough information to reconstruct the story of how they got there. We know that the Nazis took Alphonse Kann's collection from his private residence near Paris. We also know that it was Bruno Lohse, von Behr's assistant at the ERR and Goering's go-between, who compiled the inventory of some 1,202 Kann works that went to the Jeu de Paume. The ERR designated these works as "ka" (Kann, Alphonse). Cooper found some of Kann's paintings in Bührle's collection, including *Madame Camus at the Piano* (*see* insert C 10), which carries the notation "ka 989," as well as *Dancers in the Foyer*—or "ka 15"—and *The Dressing Table*, designated as "ka 20." The methodical and meticulous inventories compiled by the ERR are still very often the best points of departure for tracking down the itineraries of confiscated art. In addition to the Nazi inventory, we have already discussed the paintings stored at the Jeu de Paume and used in exchanges, as well as their importation into Switzerland, whether through legal means or via German diplomatic pouch. Finally, there is Squadron Leader Cooper's invaluable report, which provides further confirmation that the paintings undoubtedly found their way into Switzerland.

The Bührle Foundation in Zurich today publishes an official and very carefully prepared catalog of the 321 works in its collection. The paintings from Kann's collection are part of it; their real history is not.

For example, entry number 43, *Madame Camus at the Piano*, indicates only that it was acquired in 1951 from a "private French owner." One would have no idea it was the same painting whose background we now know. There is no question, however, that it is the same painting: the one listed as number 207 in the catalogue

raisonné done by Lemoisne, and reproduced as plate 65 in *Portraits by Degas* by Jean Sutherland Boggs.

Taken aback by the differences between our story and that told by the Bührle Foundation, I consulted yet another official source: the catalog for an exhibition called *The Passionate Eye: Impressionist and Other Master Paintings from the Collection of Emil G. Bührle, Zurich*. This important exhibition consisted of eighty-five of the collection's finest works, selected to celebrate the centenary of Bührle's birth. It traveled throughout the world between 1990 and 1991. It was organized by and first exhibited between May and July of 1990, at the National Art Gallery in Washington, and from there went to the Montreal Museum of Fine Arts and the Yokohama Museum of Art, and finally ending up at the Royal Academy of Arts in London.

This catalog, so fulsome about Bührle's life and "voracious" appetite for art, pictures him surrounded by his favorite paintings. On the wall behind him hangs *Madame Camus at the Piano*. The catalog also says that this exemplary businessman and aesthete had modeled his foundation on the Frick Gallery in New York and the Barnes Collection in Pennsylvania—both of which are housed, like Bührle's, in the former residences of their founders.

The catalog provides new details about the Degas, but these details do not square with what I know. For example, the catalog informs us that Alphonse Kann was the owner of the painting "by 1924" and "until at least 1937." This seems strange, given the fact that *Madame Camus* was listed in the inventory that the ERR compiled in 1940–41 as belonging to the Kann collection. The exhibit catalog adds what the Foundation's catalog had already informed us: that Bührle had purchased *Madame Camus at the Piano* from a "private French collection" in 1951.

This is troubling information, because not only does the Bührle Foundation insinuate that Kann had perhaps not been the owner of the painting during the war period, but, what's more, that Bührle had bought it in 1951. Given that Kann died in 1948, Bührle would

have bought it from a "private French collection"—but three years after the French collector's death.

Nonetheless, the various bits of available information point to my version of the facts: that Alphonse Kann had indeed been the owner of the painting at the time of its confiscation by the Nazis. This seems to be the case, even without having to count on Cooper's assertion that it had been sold to Bührle by Fischer and/or Wendland during the war—well before 1951, in other words. We might also remember that when Cooper went to visit Bührle to question him about the paintings, the industrialist never denied having bought them, or that they were currently in his possession. All Bührle had said was that he had not known about their origins.

Not satisfied with the muddied background offered by the Foundation's catalog, I contacted the Zurich headquarters of the Bührle Foundation directly. I asked the Foundation's document service whether they would provide me with some information about *Madame Camus at the Piano*. My hope was that we could finally clear up the matter.

I was informed that according to the unpublished internal files at the Foundation, the painting, along with two others from the Alphonse Kann collection, had been bought in 1951 from a "private French collection." But I already had been given that somewhat surprising information through the catalog. Then, after a closer inspection of the files, the archivist told me she noticed there was a kind of contradiction between that and what was written further down in the same files. First of all, the files mentioned this strange purchase date of 1951. Then, the archivist added, they said that the paintings had been bought "through the Fischer Gallery in 1942."

The history of these paintings is indeed as I had reconstructed it. Alphonse Kann had been the owner from whom they were stolen.

The difference between my facts and the erroneous ones

contained in the two Bührle catalogs is probably due to the fact that those who filled those files at the Foundation have since forgotten the true provenance of these paintings: the way in which Emil Bührle had acquired them in the first place.

To learn whether the same problem affected other confiscated works to be found in the Foundation's collection, I asked the document service for information about the Degas work *The Jockeys*, one of the paintings impounded from Paul Rosenberg's collection. We know that after the trial Bührle acquired the works from Rosenberg himself after the end of the war. According to the foundation's document service, there were also some contradictions; the file just mentions Rosenberg's sale of the work to Bührle in 1950. The details about the confiscated painting's true course have also been omitted.

Is it possible then that Bührle had come to a financial agreement with Kann's heirs, after the French collector's death in 1948? I contacted André Moquet, legal counsel to the heirs in France. Moquet confirmed that the heirs recently learned that Kann's executors in both France and England came to an agreement in the early 1950s concerning the Kann paintings now found in Bührle's collection.

In fact, as often happens with many heirs to looted art, most of the Kann heirs were not always aware of the background and history of their collection, not until it was reconstructed for this book.

Thus the Emil G. Bührle Foundation's collection contains paintings that were confiscated during the war, paintings whose story is not fully told in its catalogs. The Foundation's collection is a good example of how Swiss collectors and dealers profited from their country's neutrality, and from the war itself. It is also unfortunately the case that Swiss banks and financial institutions also profited from the savings of people fleeing Nazism, as well as from the enormous cash and gold transactions with the Third Reich.

Just as a gap or involuntary historical omission appears in the Bührle Foundation's catalog, so too Switzerland as a whole has either forgotten, or chosen not to remember, the role it played during

the war. Still today, it feels unaffected by actions taken then. And if Switzerland owned up to these actions, it would surely discover—as I did at the Bührle Foundation—too many skeletons—sometimes purchased twice—in the Kunstkammern, too many shadowy places, and too many unresolved questions in its past.

14

Something New
on the Eastern Front

In 1950, in Paris, Madame Katiana Ossorguine, née Bakunin, happened to be reading the annual report of the Lenin Library in Moscow. Among the many news items figuring in the report was one in which the Russian curator complains about the lack of available personnel at the Lenin Library. The curator says that from his point of view everyone is too busy organizing and cataloging the books from the Turgenev Library.[1] Created by Russian immigrants in France, the library, located before the war on Rue de la Boucherie in Paris's 6th Arrondissement, boasted more than 100,000 volumes and contained the original editions of the works of Hertzel, complete collections of nineteenth-century Russian his-

torical journals, archives, novel and literary manuscripts. Founded by Russian immigrants to France, the library was a veritable memorial to Russians living in exile and to political opposition over two centuries, from the times of the czars to Stalin's regime.

Madame Ossorguine, the grandniece of the Russian anarchist revolutionary Mikhaïl Bakounine, began working at the library in 1929. In 1940, as a Russian refugee and left-wing opponent to Stalin, and therefore threatened by the Nazis, she had to leave Paris and hide in the countryside with her husband, the writer Michel Ossorguine. When she returned, she discovered that the Turgenev Library, as well as her husband's library, had been confiscated. According to her neighbors, the ERR had taken everything right after the arrival of the German army in Paris. Eight German soldiers and a civilian who spoke Russian first went into her house at 11, square Port-Royal and carted away two or three thousand books from her husband's own personal library collection. Much property belonging to Russian left-wing emigrants, ex-Socialist revolutionaries, and exiled Mensheviks met with the same fate.

Then in October 1940, ERR operatives had appeared at the Turgenev Library, asked for the keys from the librarian, and let themselves in. The hundred thousand volumes they took were loaded onto wagons at the Gare de l'Est and sent to Berlin, from where, apparently, they went on to Ratibor (the Polish city of Raciborz, near Cracow), where the Nazis planned to found a "Center for Slavic Studies" akin to their center for Jewish studies.

After the war, Madame Ossorguine and other loyal library employees tried to resume their work and to reconstitute the plundered library. They had started to work with the CRA, which had already successfully recovered a number of other libraries. But in this instance the Commission was powerless. The American, British, and Soviet armies officially reported finding no traces of the Turgenev Library. Madame Ossorguine and her colleagues were forced to accept the painful idea that the collection had been either destroyed or dispersed for good.

Then, around 1950, came that report from the Lenin Library. The news came as an enormous surprise, for it meant that the Turgenev Library had been seized by the Red Army and that the Soviets had lied. Madame Ossorguine, now a widow, hoped that she might recover her late husband's library. But there was little she could do, given that the cold war was now on. Given their tradition of paranoid secretiveness, the Soviets would hardly be willing to part with information as they had done up to now.

In the years that followed, witnesses told her that you could find at the Lenin Library in Moscow books stamped with the seal of the Turgenev Library. Not until 1968, during a trip to the Soviet Union, could Katiana Ossorguine consult a bibliography of works that had belonged to her husband. In 1970, she even got access to a two-volume inventory from the State Library and found listed there the Turgenev Library's archives. She was nearly at the end of her search, but it took until the end of the 1980s and the advent of glasnost to even consider the chances of obtaining a true inventory of the French cultural artifacts found in Eastern Europe and the Soviet Union. Such an inventory still does not exist, or if it exists, it has not been made public.

François Rognon and Philippe Morbach, librarian and director, respectively, of the Museum of the Freemasons' Grande Loge de France in Paris, reported to me in a recent interview that whole warehouses of books, including some from the Masonic libraries the ERR had seized in France, have been found in Eastern Europe—in the German town of Würzburg, at the University of Poznan in Poland (where some 80,000 books and 40 paintings are to be found), and in KGB warehouses in Russia.

Klaus Goldmann, director of the Museum of Prehistory in Berlin and an expert in Soviet wartime confiscation, affirms that during recent negotiations between the Germans and the Russians concerning the restoration of certain works taken during the Second World War, the German commission had provided the Russians with a list of 2 million books that the Germans believed the

Red Army had seized in Germany. Surprised, the Russian commission replied by providing its own list of books seized in Germany and found in Russia. Their list contained 12 million volumes. This difference of 10 million unaccounted books, Goldmann believes, surely includes whole libraries confiscated in France and elsewhere in Western Europe.

The French government was, until recently, negotiating these lists and restitutions on a global level, beyond just the Turgenev Library. These negotiations included not only books but papers, such as those of French composer Darius Milhaud, and most especially paintings.

The Duma, or Russian Parliament, recently legislated on all the cultural war booty the Red Army had carried along to Soviet territory after the war. Parliament decided to consider this booty as war reparations and to declare it state property. Russian President Yeltsin disagreed and applied his veto to the Parliament's move. Today, all international negotiations are at a standstill.

Éric Conan, Jean-Marc Gonin, and Yves Stavridès, journalists with the French weekly *L'Express*, were among the first to report on what was being held in the East. In 1990, one year after the fall of the Berlin Wall, they discovered the existence of twenty-eight paintings taken to Germany from France at the end of the war, which were now being stored in warehouses belonging to the National Gallery in East Berlin.

Then in August 1995, Conan and Stavridès revealed that the eighteenth-century painter François Desportes's *Still Life*, which had belonged to a French citizen, could be found at the Pushkin Museum in Moscow, among hundreds of other paintings seized by the Red Army in Germany. The painting figures in the *Catalog of French Property Stolen Between 1939–1945* right next to the name "Paul de Cayeux de Sénarpont," which was the pseudonym of the Parisian dealer Paul Cailleux, whose activities I have discussed. With what the Schenker Papers show us, it seems probable that this is the same painting by François Desportes that was sold by

Cailleux for 60,000 francs to the Dusseldorf Museum on July 16, 1941. Cailleux not only sold it to the German museum but, once the war was over, he even claimed it as looted art.

According to all appearances, some of the paintings either sold or confiscated in France during the war are on territory once part of the Soviet Union, or in Eastern Europe. One of the ERR's warehouses, Nikolsburg Castle, in the Sudetenland in the Czech Republic, was in the Soviet-occupied zone at the end of the war, and as we saw it, housed many works from the Paul Rosenberg, Alphonse Kann, Rothschild, and David-Weill collections. From the Rosenberg collection were three drawings by Delacroix, including *Portrait of Mr. Henri Hugues* and *Sultan of Morocco*, both stolen at Libourne; Courbet's study of choirboys for *The Burial at Ornans*; Picasso's *Masked Pierrot* and *Fruit Basket on Table*; Berthe Morisot's *The Haymaker*; two works by Bonnard, *Woman Sitting in Interior* and *Summer Morning*; Braque's *Still Life with Grapes*; and, finally, Vuillard's *Interior with Woman*. The paintings were transferred to Nikolsburg in November 1943 and August 1944.

A large portion of the paintings pillaged in August 1943 from David David-Weill's Neuilly residence, including Fragonard's sketches and Isabey's *Portrait of Châteaubriand at 43*, were, as we've seen, taken to the castle in the Sudetenland. This was one of the least important of the ERR's warehouses, as well as the last one to be opened. When the Red Army arrived, part of the structure burned down in the fighting. In the 1950s and 1960s, when the RFA put together its files for the claiming owners of the confiscated paintings, the Soviet and Czech governments' official response was that Nikolsburg Castle had burned down completely in April 1945.

In 1961, however, a French commission was able to get access to the castle and to talk to eyewitnesses.[2] It concluded that fire could not have consumed the entire castle, nor all of the works being stored there. The committee then learned that before the end of the war, the Nazis had sent some of the art stored there into Austria, but had not had time to compile a complete list of the works being

transferred. These two late discoveries, which to my knowledge have not been followed up, should alter our perspective on the problem. First, it is very possible that some of the works were found by the Red Army and today can be found in Russia or in the Czech Republic. It is also very possible that the works the Nazis sent from Nikolsburg to Austria that were not on the transport lists were either stolen or else claimed by governments or persons other than their original owners. The Austrian government jealously guarded for more than forty years some three thousand unclaimed works in the Mauerbach monastery since the end of the war, refusing all public access and resisting even addressing the issue. It is therefore possible that some works confiscated in France, sent to Nikolsburg, then to Austria and never reclaimed were among them.

The works at Mauerbach were auctioned off by the Austrian government in October 1996. Most of the proceeds from the successful sale, prepared by Christie's, were handed over to Jewish organizations and other victims of Nazism. The two-day sale was well publicized and struck international opinion as a reasonable solution. But what is less well known is that ten years ago Christie's had performed an inventory of these pieces. And that, for ten years, no one thought it was their duty to do serious research on the ownership of these artworks—when probably many looted owners were still alive.

Other new discoveries in the East point to the same kind of surprises and neglect. Alain de Rothschild's driver's license and his brother Élie's school notes were discovered in a Moscow archive. These objects, uninteresting in and of themselves, were very likely seized from Baron Robert's Avenue de Marigny residence at the beginning of the war. They must have been transferred by the ERR to Germany and placed in a warehouse that later fell under Soviet control. It's not difficult to imagine the same thing happening to works of art.

Moreover, 159 documents, including files, account books, catalogs for exhibitions of works by Cézanne and Renoir, a catalog for

The Purgatory of the MNRs

Hanging on the walls at the Musée National d'Art Moderne (MNAM), located in the Pompidou Center in Paris, is a superb painting by Fernand Léger entitled *Woman in Red and Green* (*see* insert C13). Léger painted it in 1914, and it is one of a number of Cubist compositions characteristic of those years in which this painter of the contrast of forms was starting to move away from abstract work. The painting shows the face, nose, and silhouette of a woman, all easily recognizable, while her body gives the appearance of a figure wearing armor. In the lower left of the painting one can clearly see the outline of a stairway.

This well-known painting (number 91 of volume 1 of the catalogue raisonné of Léger's work, 1903–19), which figured in at least twenty exhibitions in London, Brussels, Vienna, and Tokyo, has a

short but remarkable episode in its history that bears very closely upon art confiscation, an episode well worth a closer look.

No mark or outward sign distinguishes *Woman in Red and Green* from many of the other paintings hanging in MNAM, except the classification code "R 2 P." This code seems innocent enough, and few art professionals would know what it means. According to the internal classification system used at the Pompidou, "R" refers to "récupération," and the number 2 indicates the chronological order in which the painting arrived at the museum. "P" means "painting," just as "D" would indicate a drawing and "S" a sculpture.

In fact, what "R 2 P" means is that *Woman in Red and Green* was recovered after the war and that it had been one of the thousands of French works looted by the Nazis. The code also means that it was the second plundered work of art to be temporarily given to this museum, where it has been housed since 1949. What is even more surprising is that the code means that *Woman in Red and Green* belongs neither to the museum nor to the French government. Nor was it donated to the museum by a private individual. Who owns it? Why has it spent nearly half a century in a national museum?

Strange as it might seem, the painting has been on a "provisional" stay at the museum for over fifty years, waiting for its true owner to reclaim it. According to MNAM curators, it has not been possible for all these years to unravel the mystery of the work or to find its legitimate owner. The question is, how hard have they tried?

Woman in Red and Green is one of an estimated two thousand unclaimed works of art (which include paintings, drawings, sculptures, art objects, rare books, and manuscripts) under the protection of France's national museums. Among them are nearly one thousand paintings, including known works by major twentieth-century artists such as Picasso, Matisse, Vlaminck, Derain, Ernst, Picabia; nineteenth-century artists such as Cézanne, Degas, Manet, Courbet, Delacroix, and Ingres; and eighteenth-century artists such as Boucher and Chardin. Then there are the hundreds of drawings,

sculptures, and other pieces, many of them very well known, spread out among France's most prestigious public museums, libraries, and government institutions.

According to my estimate—since a complete inventory of unclaimed recovered works has never been ordered by either the head of the national museums or the Ministry of Culture—at least 500 of these works can be found in the Louvre, at least 110 at the Musée d'Orsay, 38 at the Pompidou Center, 13 at the Rodin Museum, and the rest either in storage or in museums elsewhere in France. Given that the public knows nothing about their provenance, these works have become the de facto possessions of these museums. Several are even used to decorate official residences and government offices in Paris, where they are inaccessible to the public. Thus the unclaimed bust of a young woman said to be Madame de Pompadour and attributed to the eighteenth-century sculptor Jean-Baptiste Pigalle can be found in the Pompadour Room of the president at Elysée Palace, while an unclaimed cast bronze of Rodin's *The Kiss* graces the Hôtel de Matignon, the official residence of the prime minister. The museums loaned an unclaimed work by Utrillo, *Rue de Mont-Cenis*, to the offices of an executive of the Crédit Lyonnais bank. Because these works are not publicly accessible, of course, it is more difficult for dispossessed owners or their heirs to claim them.

In the fifty years that have passed since the end of the Second World War, all these works of art have been in a kind of purgatory, and the museums' curators have made no huge effort to arrive at a resolution of this embarrassing situation.

Hubert Landais, the head of the Administration of French national museums from 1977 to 1987, is open about the fact that no serious attempt has been undertaken: "It is a very bizarre story. We never attempted to look for the owners. I realize how surprising that must seem. The weak point in the justification offered by museum administrators is that no one in the last fifty years has taken the initiative."

These thousands of unclaimed works of art are known by

the generic name of MNRs (standing for "Museés Nationaux Récupération"). They have been placed under the guardianship of France's public museums. Each museum, in turn, created its own internal classification, such as we saw with *Woman in Red and Green* at the Pompidou Center. This, of course, makes gathering information about these MNRs even more difficult.

What investigators discover is that they are faced with an entirely new and completely stupefying situation, one in which the nature of the problem regarding stolen art is turned upside down. Obviously it is more difficult to look for and to locate lost paintings than it is to look for owners or inheritors. Yet here we have the works, right before our eyes, and it is the owners who are seemingly impossible to locate.

In the postwar years, the Allies and various Western restitution organizations accomplished the enormous task that they were assigned. They researched thousands of works confiscated by the Nazis during the war and returned them to their owners—not just paintings, but sculpture, art objects, furniture, and books. It cannot be denied that in France, Albert Henraux, the president of the CRA, Rose Valland, the Resistance curator who had managed to deceive the ERR during the war, and many others have done exemplary work recovering and restoring a considerable number of works. According to figures from the Ministry of Culture, more than 61,000 works have been found and returned to France. More than 45,000 of them—80 percent of the total, roughly—have been returned to their former owners. Naturally, these figures exceed the 21,903 works noted in the ERR's aforementioned final report of July 1944. But the ministry's number includes all forms of looting and purchasing on French soil, not simply the official and systematic confiscation organized by the ERR in the Occupied Zone.

The seven volumes that make up the *Catalog of French Property Stolen Between 1939–1945* bring together most of the major claims about all types of stolen artworks. Between June and August 1946 the first exhibition of *Masterpieces from French Collections Found in*

Germany by the Commission for Artistic Recuperation and Allied Organizations opened at the Orangerie Museum. The exhibition had obvious symbolic value for the new French government; it was in this little museum that Hitler's favorite sculptor, Arno Breker, had had a popular exhibition in 1942, right in the middle of the Occupation. Breker's show had attracted Parisian society, beginning with Jean Cocteau, who praised the mediocre Breker's work. With more than poetic justice, the new uses of the two small neighboring museums, the Jeu de Paume and the Orangerie, were undoing what the Germans had done during the Occupation.

At this exhibition of recovered art, people could admire 283 confiscated paintings, drawings, sculptures, ceramics, enamels, watches, furniture, tapestries, and books; they could also gauge the extent, previously unimaginable, of the Nazis' plundering. In the museum's last room, a large map pointed out the major Nazi warehouses in Germany in which the works had been found.

The most important pieces were from the collections of the Rothschild and David-Weill families; they had been the ones intended for Hitler's Linz museum. Here were Vermeer's *Astronomer*, Memling's *Virgin and Child*, Frans Hals's *Portrait of Isabella Coymans*, the two portraits of the Soria children by Goya, *Portrait of the Marquise de Pompadour* by Boucher (*see* insert C9), and the *Portrait of Baroness Betty de Rothschild* by Ingres. All of them had been returned to their owners undamaged. The exhibition also contained Chardin's *The Bottles of Soap* and Fragonard's *Woman Reading*. And then there were Cézanne's *The Bathers*, Van Gogh's *The Pont de Langlois at Arles*, and Pissarro's *The Port of Le Havre*—these last works having been chosen by Goering at the Jeu de Paume to use as exchange pieces.

Following the end of the war, announcements in the press alerted the rightful owners of pillaged art. As life returned to normal, a number of French citizens exercised their right to recover their property.

Still, not everyone was in a position to claim their lost works.

One obvious reason was that many French families, Jewish or otherwise, had disappeared during the war, and their heirs, if any, often
had more urgent problems to resolve or did not know that the
works belonged to them or had left the country. Others realize today that they were too relieved at having survived the war to worry
about reclaiming material possessions.

Certain works that remained unclaimed, making one wonder if
their owners hadn't voluntarily sold the works to the Nazis and did
not claim them for fear of being accused of collaboration to get
them back. In fact, sold and looted works were given back to France
since. In 1943, from London, the Allies had issued a directive annulling all acts of dispossession in all territories occupied or controlled by the Germans. The directive annulled not only
confiscations and sales under duress, but also all kinds of sales and
"seemingly legal" transactions undertaken with or by Nazi Germany throughout Occupied Europe.

□

Whatever the case, some 15,000 works recovered by the French
government were not claimed.

Thus, when the Commission de Récupération Artistique (CRA)
was dissolved in 1949, nearly 2,000 of the most important works,
from these 15,000 were selected for safekeeping by national museums, which gave the best examples—the Bouchers, Chardins,
Cézannes, and Courbets—to the Louvre and a few other museums.
The other 13,000 were deemed to be of less aesthetic value and put
up for auction without much public announcement.

The museums' curators had to place these MNR works among
their large public collections, even though it was decreed by law
that they belonged neither to the Louvre nor to these other museums and, hence, couldn't be fully integrated into their inventories
or collections. A government decree dated September 30, 1949,
clearly specifies that the Louvre and other museums would be dé-

tenteurs précaires ("precarious holders"), but still responsible for preserving the works. What's more, the museums were under certain other obligations: They had to exhibit these works soon after receiving them and establish a provisional inventory. These are obligations that have not been met to this day. Moreover, these museums should also have made themselves accessible to despoiled collectors hoping to obtain information. But the museums' directors have never undertaken serious property research.

Indeed, obtaining information about these works from the Administration of French national museums is not easy. For four years I contacted them to ask whether they could provide a general inventory of MNRs. The replies were always either evasive or absurd. The director of communication first declared that such an inventory had not been completed—but that it was in progress. Then, reacting to my surprise at the slowness with which they were preparing this inventory fifty years after the end of the war, the same official explained that putting together such an inventory was a very delicate and very complex undertaking, given that the curators wanted the job done right. He added that it would not be possible for him to tell me either the date when the inventory would be finished or the names of the curators compiling it. Meanwhile, at the same time, I was denied access to the archives on Nazi art confiscation kept at the French Ministry of Foreign Affairs because of the very strict French privacy laws. These precious archives had been stored away by the Administration of French national museums until 1991, when they were handed over to the Ministry of Foreign Affairs.

Several months after this interview with the Administration of national museums, and after many requests, I managed to obtain an interview with their legal department. They repeated the same responses and handed me an internal memo concerning the MNRs, signed by a former administration director. But they continued to deny me access to even a partial inventory of unclaimed works.

To get more information about them, I was told to consult the enormous general catalogs of the Louvre, Orsay, and large French

museums, each one containing thousands of entries and dozens of different internal codes. There, among all the numbered pieces, I was supposed to find, one by one, all the works individually marked "MNR" or its equivalent, and then to obtain, however I could, information about each one. In the years that followed, I renewed my attempts to get a complete MNR inventory, right up to the publication of this book, but was met with the same stonewalling.

The long and tedious work of research and investigation of MNRs in the general museum catalogs has been complicated and difficult, but not impossible. What was required was methodical determination. Naturally, I made use of the other documents in my possession, documents I had gotten overseas, principally at the National Archives in Washington, D.C. This second investigation, following the one started for the rest of this book, led to the results presented in this chapter.

□

To return to Léger's *Woman in Red and Green* (*see* insert C13), let's look more closely at its itinerary to see whether it is possible, with a little determination, to establish the history of an "MNR" painting during the war years and to trace it back to its original owner. Occasionally I was able to locate the missing owner, or to provide an important clue to their history, in the course of a single afternoon.

In the catalogue raisonné of Léger's work and in exhibition catalogs we find that Daniel-Henry Kahnweiler, the great Cubist dealer, bought *Woman in Red and Green* from the painter's studio before he left on vacation in July 1914 and Léger enrolled in the French army.

The outbreak of World War I took Kahnweiler, a German citizen, by surprise while he was traveling between Switzerland and Italy, and he was unable to return to France. The painting was one of a hundred or so works found in his tiny gallery on Rue Vignon, behind the Madeleine. *Woman in Red and Green* would therefore be

among those works owned by German citizens living in France and subsequently sequestered by the French government in 1914.

The government-run public sales of this legendary stock, which included hundreds of works by Picasso, Braque, Gris, Vlaminck, and Léger, would take place several years later. *Woman in Red and Green* was sold as lot number 155 on November 17–18, 1921, at the Hôtel Drouot. Léonce Rosenberg, Paul Rosenberg's brother, bought the work for the ridiculously small sum of 235 francs.

Here a small digression in the story is necessary to provide an example of the Nazi-plundering absurdity. The Léger and the hundreds of other examples of "degenerate art" confiscated by the French in World War I from Kahnweiler—a German Jewish dealer of modern art residing in Paris—will be claimed in World War II by the Nazis as German assets in the Kümmel Report. At the same time, Kahnweiler was being persecuted in France as a Jew by the very Nazis who were claiming that his possessions were part of the Germany patrimony.

To return to that part of the Léger story that occupies us here: In 1932, Léonce Rosenberg loaned the painting to an exhibition in Amsterdam. In 1935, it appeared as number 93 at the exhibition called *The Creators of Cubism* in Paris.

Then came the Second World War. All traces of the painting disappeared. According to the collection's curator at the MNAM, the available files and the exhibition catalogs, there are no further clues to the painting's history until 1949, when the Léger was given on a provisional basis to the museum.

With a closer look at the Léger catalogs, which can be found in any good art library, one can find in the bibliography a succinct entry for the work that will allow us to understand what actually happened to the work during these missing years.

The reference is to an illustration that appears in the appendix to Rose Valland's memoirs, *The Art Front*, which contains one of the many official photographs taken by ERR photographers at the Jeu de Paume. The photograph shows one of the backrooms where the

Nazis had stored all the "degenerate art." Partitioned off from the rest of the museum by a curtain, this small room became the storage area for modern plundered art, and Valland ironically termed it the "Room of Martyrs," because of all that these paintings would have to endure under the ERR (*see* insert C12). The modern paintings scattered around the walls were "second choices"; the Nazis intended to swap them.

We would keep ourselves busy by trying to recognize in this photo the very works the ERR Nazis so disdained. On the left, on the back wall, you can clearly make out a Picasso. Below it is a work by Yves Tanguy, the French Surrealist. On the photo's far right is Léger's *Odalisques*, painted in 1920 and looted from the collection of Alphonse Kann—to whom, after the war, the work was returned.

If you look at the upper-right quadrant of the photo, you will see the work that interests us: *Woman in Red and Green*. This photographic proof, provided by the Nazis themselves, confirms our suspicions: The painting was confiscated from a private owner living in the Occupied Zone. The ERR probably used it afterwords in an exchange or sold it in Paris. This means someone had owned it—and did not claim it after the war.

Then a logical conclusion presents itself: If this painting appears in the Nazi photo it must also appear, with the name of its owner, in the inventories of looted art compiled by the ERR's art experts. These inventories and files, collection by collection, provide concrete information and evidence on the confiscated artworks. But as we have seen, these documents are jealously guarded by the Administration of French national museums and the Ministry of Foreign Affairs, and inaccessible to the public in France. There are, however, duplicates and partial lists in the National Archives in Washington, D.C.

Among the National Archives documents is a copy of a German inventory dated March 10, 1942. The Nazis had compiled a list of modern paintings stored at the Jeu de Paume, most of which by this point had been shipped to Germany. Listed on this inventory are

mostly modern paintings looted from fifteen collections, destined to be exchanged or sold and of no particular interest to Hitler, Goering, or other Nazi leaders. The lists indicate the name of each painting, its title, and the dimensions of these works stolen from the collections of Alexandrine de Rothschild, Lévy de Benzion, Paul Rosenberg, Alphonse Kann, and the British Peter Watson, among others.

Under the words "Rosenberg, Paris" are the descriptions of five paintings—the ones taken from the home and gallery of Léonce Rosenberg. The third painting on the list is none other than Léger's *Woman in Red and Green*, along with its dimensions (100 x 81 centimeters, about 39 x 33 inches), which match those of the painting now to be found at the Pompidou Center. What I had suspected turned out to be the case. The photos and the Nazi lists both led straight to the work's original owner, Léonce Rosenberg.

To follow the full journey of this painting, we need to add that quite possibly *Woman in Red and Green* is the same "degenerate" painting clumsily designated in other Nazi lists as *Knight in Armor* (105 x 82 centimeters) by Fernand Léger, a painting that also came from the Rosenberg collection. In chapter 9, I recounted how the work had been acquired in February 1942 by the dealer Gustav Rochlitz in an exchange. The date of the Jeu de Paume inventory is a month later than the dates of the transaction, probably reflecting the time it took the understaffed ERR to get around to this piece of art.

More to the point, two renowned experts on Léger's work have confirmed that, first of all, none of the painter's works was ever given the title of *Knight in Armor*, and that moreover Léger never painted anything resembling a knight in armor.[1] Finally, they added that the dimensions of *Knight* were not those used by Léger. As was the case with *Woman in Red and Green*, a Léger canvas of that size would have had standard dimensions—100 by 81 centimeters. In my opinion, the difference in size can be explained simply: Some of the ERR's technical personnel at the Jeu de Paume were soldiers dragooned into doing the work, and often in their hurry they included the frame, or part of it, in their measurement.

The question remains: Why didn't Léonce Rosenberg acknowledge and reclaim his painting after the war? The reason is probably simpler than we suppose. Léonce died in 1947. The painting was placed in the care of the national museums in 1949. His wife and three daughters never managed to get his affairs in order and therefore were never aware of the missing works. That is probably why *Woman in Red and Green* was never reclaimed.

Whatever the case, how could the curators of France's museums not have ascertained these facts themselves after all these years? The only reason can be the lack of any will to learn who the owner was, or why he never reclaimed the work.

I have said that some of these unclaimed works were put on loan to museums outside Paris, and this makes locating and researching them more difficult. One, *Head of a Woman* (*see* insert C11) by Picasso, an oil on canvas signed and dated 1921 (listed as "R16P" at the MNAM and Zervos IV, 341), was loaned to the Musée des Beaux-Arts in the city of Rennes, in Brittany. The museum's files indicate that the date and signature on the painting, which has been in its possession since 1950, were covered over with a light coat of paint. The back of the painting bears a label indicating "Simon Gallery no. 1782 1924."

Naturally, my first reaction was to verify what this label meant, since doing so would probably provide new leads.

It seemed highly surprising that the museum's curators felt no curiosity about the work. It is well known in the Paris art world that the Simon Gallery was created in the 1920s by the determined dealer Kahnweiler, following the sequestration of his goods, as was discussed earlier.

Through my research, I learned first of all that the actual inventory number on the label was 7782, not 1782. But, most important, I also learned that the Simon Gallery had sold the Picasso in December 1924 to Alphonse Kann. It was therefore very possible that this painting was among the thirty-five Picassos confiscated from the Kann collection—unless, of course, Kann had sold the painting

to someone else before his works were confiscated. Moreover, by studying the ERR lists, I learned that this Picasso had been confiscated by Goering for use as an exchange piece. I also learned that the Nazis had lost or misplaced the name of the original owner and simply listed its owner as *unbekannte*, or "unknown." These facts should have been enough to merit a thorough investigation by the museum. To this day one has not been undertaken.

As we already know, the Anglo-French collector Kann lost a significant number of paintings and artwork after Nazi confiscation. We found one of those works, *Landscape* (R1P) by the Cubist painter Albert Gleizes (*see* insert C15). This landscape of the village of Meudon is still an MNR, and can be found at MNAM in Paris.

Gleizes was one of the young painters who, along with Robert Delaunay and Jean Metzinger, went into Cubism after Picasso and Braque. This Cubist "salon" had been given the name of Section d'Or, referring to the ratio between the side of a square and its diagonal). In verifying the ERR documents, I discovered that it was without a doubt this oil—measuring 146 by 115 centimeters, or about 57 by 45 inches, painted in 1911 and seized from Kann's home on Saint-Germain-en-Laye—that bore the Nazi confiscation number KA 1149.

To confirm the conclusions of my investigation, I asked the Gleizes specialist who is producing the catalogue raisonné of his work. He confirmed that in that year, 1911, the painter had painted only one landscape with those dimensions. This painting was indeed entitled *Landscape*, or *Landscape of Meudon*. Why, I wonder, did it take until my investigation, fifty years later, to make these facts known?

Other examples of well-known and unclaimed paintings abound. Each has its own story. There is *Pink Wall* by Matisse, a small painting done in 1898, at the MNAM under the code "R5P." Its history and provenance is interesting. The pink wall in question is that of the Hospital in Ajaccio, on Corsica. Matisse had just gotten married and was experiencing Mediterranean light for the first

time. *Pink Wall* was one of the 145 paintings sold in 1914 during the famous auction of modern art at the Hôtel Drouot called the "Peau de l'Ours." All trace of the painting disappears between the time of this sale and its reappearance in 1949, when it was placed into the care of the MNAM.

There are 2,000 artworks, of which 1,000 are paintings, in this absurd and awkward situation. Up to this point, I have provided new leads only for modern paintings.

Let's look more closely at the MNR paintings by some of the great masters of the eighteenth and nineteenth centuries, paintings today found in the Louvre and the Musée d'Orsay. They find themselves in the same limbo as their modern confederates. No ownership research, until now, has seemingly been undertaken.

☐

Boucher's *The Forest*, or *Forest Scene with Two Roman Soldiers* (*see* insert C14), shows a landscape bordered on the left by two pine trees and on the right by tall evergreens. In the middle, the green and red leaves and the dense underbrush of a dark forest are illuminated here and there by the light of the setting sun. In the foreground is a clearing, a stream with a bank on which sit two Roman soldiers deep in conversation. The bright red of the helmet and cape of one of them provides a vivid contrast to the dominant dark green and blue of the setting. Further back, two silhouettes can be made out against the clearing, one seated, one standing. A dog is nearby.

The authenticity of this Boucher has never been questioned. Its history has been proven, and it has been closely studied and widely commented upon. The large canvas (131 x 163 centimeters, about 49 x 64 inches) was presented by its author at the Salon of 1740, and was one of a number of landscapes that he had started at the time. It is signed and dated, "F. Boucher 1740," on the rock in the lower right of the picture. It went with another painting shown at the same Salon, *Landscape with Mill*, also called *View of Mill with a Temple in the Dis-*

tance, which today can be found at the Nelson Atkins Museum in Kansas City. Both have a long history, carefully documented, which is not surprising, given their importance. *The Forest* bears the number 1750 in Soullié and Masson's catalogue raisonné, and the number 176 in Anatoff and Wildenstein's. The first reference to the work goes back to 1778, when it was sold among other goods belonging to Madame de la Haye, a widow of a former general. As the catalog notes, "These two paintings . . . are rich and interesting in their composition, with clear colors and a seasoned hand, but pleasant and good. François Boucher did them in leisurely fashion in 1740."[2]

During the second half of the nineteenth century, the two works went their own ways. *The Forest* ended up as part of an eighteenth-century collection belonging to Jacques de Chefdebien, and in February 1941, when the Dubois-Chefdebien estate sale took place at Drouot's auction house, the painting, lot number 17, was valued at 260,000 francs by the well-known Paris auctioneer Étienne Ader.[3]

At that exact moment, however, the history of this work, duly registered, studied, and recorded by eminent specialists, comes to a rude stop—having been traced for two centuries. And the Boucher catalog for the exhibition at the Grand Palais in 1986, prepared by curators from the Louvre, also ends there. The painting's history, however, does not.

French privacy law prevents us from knowing who bought *The Forest* at Drouot's in 1941. Ader's files doubtless contain the answer. Was the buyer French or German? Was the painting stolen from the new owner by the Nazis? Did the Germans buy it legally? I tried, on my own, to search for Ader's auction files, which I learned he had donated to French public archives. I managed to find the files for the de Chefdebien estate auction sale, but the specific file concerning the auction sale of this Boucher was missing. Who took it? We might wonder what happened in the final years of the war and what the Administration of French national museums plans to do to find out.

This painting cannot be found in the catalog of plundered goods the French government published after the war. Despite the num-

ber of clues and the information at their disposal, the curators, as well as historians and Boucher specialists, have not done any research to locate the painting's true owner. Because no one has lain claim to this work of art, it was remanded "temporarily" in 1951 to the Louvre, which has been housing it since then.

□

The same was the case for *Cauldron with Ladle*, one of Jean-Baptiste-Siméon Chardin's still lifes, presented as number 45 at the 1975 Chardin exhibit at the Grand Palais in Paris: "A cauldron with ladle, a jug, a slice of salmon placed on an upside-down earthen plate, a knife, a small stoneware pot with stopper, and three mushrooms." This painting, of modest proportions (32.5 by 40 centimeters, about 13 by 16 inches), which is signed in the lower left, was painted between 1750 and 1760.

In his catalogue raisonné of Chardin's work, Pierre Rosenberg, the director of the museum, confirmed that painting number 142 was painted between 1750 and 1760 and belonged to the second period of the painter's still lifes, the period during which "what is most striking is the great variety of the objects painted," and in which Chardin's compositions become more rigorous. In his 1983 book, Rosenberg tells us that this painting "went to the Louvre after the war," perhaps without being aware that this phrase is normally applied to works that actually belong to the Louvre.[4]

As was not the case with the Boucher, this time the Grand Palais exhibition catalog gives a few details about what happened to the painting, but they are terribly succinct. Having belonged to the collection of an L. Paraf, and then to Georges Renand, the painting was "sold"—the original text employs quotation marks—to the Dusseldorf Museum, and was returned by the Germans after the war and placed in the care of the Louvre in 1951.

This raises even more questions: Why the quotation marks around "sold"? Could they mean that this work was involved in yet

another of those countless wartime transactions on the Paris market that were declared null and void by the Allies? If such were the case, why didn't the Louvre's curators attempt to resolve the matter?

Georges Renand, the painting's last apparent French owner before it was bought by the Dusseldorf Museum, was one of the wealthy owners of La Samaritaine department store in Paris. He was a partner of the art collector and bibliophile Gabriel Cognacq who, under the Occupation, was appointed by Vichy to succeed David David-Weill as president of the national museums' advisory board.

When the Chardin was sold, Renand had already become an important collector. In his memoirs, Louvre curator Germain Bazin recalls the "splendid" collection of Corot's work Renand had assembled just after the war. It contained no fewer than forty works by the painter and had been begun in the 1920s and 1930s. During an interview, the art dealer Henri Bénézit told me that Renand was one of the lucky collectors who had bought works at rock-bottom prices during the years of crisis: "Once each week, and every week, Renand went with a friend to buy art, and he chose what he wanted from the various galleries." If *Cauldron* belonged to Renand during the war, did he willingly sell it to the Dusseldorf Museum? If this were true, it would explain why he didn't attempt to claim it after the war. Or did the Dusseldorf Museum buy it through an intermediary?

There are several possible answers. The Chardin is probably the same one that appears in the Schenker Papers—though there it was described simply as a Chardin "still life"—and it is mentioned in my chapter on the Paris art market. It was sold in 1941 for 400,000 francs by an unidentified Parisian dealer to the Dusseldorf Museum, part of a group of sixty-eight paintings, each identifiable, bought by the museum on the French market.

☐

This leads us to the story of yet another of these MNRs: *Portrait of the Artist*, which Cézanne painted between 1877 and 1880, and

which today hangs in the Musée d'Orsay. This small, three-quarter profile was one of thirty self-portraits Cézanne did. Here he portrays himself as taciturn and sullen.

Like the other MNRs we have seen, this well-known painting has been carefully studied and appears as number 371 in Venturi's catalogue raisonné, as number 507 in Orienti's catalogue. It should not be confused with another Cézanne self-portrait, Venturi 372, in the respective catalogue raisonné, which was painted on wood in 1880 and whose history is very similar.

The MNR self-portrait had an official existence and prestigious provenance that began with the dealer Ambroise Vollard. It then went into the private collection of Pissarro, one of Cézanne's oldest friends, and from there into the collection of the writer Octave Mirbeau. In 1919, the French businessman Charles Comiot bought the painting at Mirabeau's estate auction sale. Then in the 1920s, the dealer Jean Diéterlé bought it. But there the story ends abruptly. The next owner was an unidentified private collector, and after an historical gap during the war and postwar years, the painting was "provisionally" placed as an MNR in the Louvre's care in 1950 and then went to the Musée d'Orsay. Though it was very soon exhibited, beginning with the *Homage to Cézanne* show at the Orangerie in 1954, no one came forward to claim ownership of it.[5]

The same questions need asking: To whom did Jean Diéterlé sell the painting? Did the Germans confiscate it or was it sold on the market during the war? Given how easy it would be to find the owners (or heirs) of a painting such as this, why has no curator at Orsay ever tried?

The MNR matter is a recurring problem, continually encumbering the museum curators and administrators involved. Like the Loch Ness monster, the MNR question resurfaces from time to time. Several years ago, a discreet message was addressed by the head of

the Administration of French national museums to the minister of justice, asking him to decide what the legal status of the MNRs was, and to inquire whether there was any statute of limitations for claims. This note was later unwittingly handed over to me by the Aministration's legal department.

The minister's reply would affect the status of the MNRs as well as their future. The curators, of course, would have welcomed a positive reply. Were the time limits to have run out, then the Louvre, the Musée d'Orsay, and other French museums would be able legally to integrate the works into their permanent collections once and for all. A positive reply would have also given the museums the possibility of going, painlessly, from de facto to de jure ownership without having to undergo an undoubtedly controversial public debate. Better still, it would have quietly resolved the problem, absolving the museum's curators from any moral reproach for not having searched for the actual owners of the works for so many years.

In 1992, however, Jacques Sallois, the head of the Administration, sent an internal memo relating the minister's reply. This note that was unwittingly handed over to me repeats—in the event that some curators might have forgotten—that there can be no expiration date of claims, and the national museums are only temporary guardians of these works. Because ownership in France is inprescriptible, no statute of limitation is applicable. The memo ends definitively: "This provisional guardianship on behalf of others will always prevent [the museums] from becoming themselves owners of these assets through statute of limitation." Since the reply from the minister of justice on this point of law, the MNR problem has remained unresolved. It continues to put the national museums in an awkward position.[6]

The high quality of the works in question only aggravates the situation. Each carries its burden of questions about why it has not been returned to its owner.

The Musée d'Orsay contains MNR number 561, Courbet's *The Cliffs of Étretat, after a Storm* (*see* insert C14). This luminous work was painted during the summer of 1869 and exhibited at the Salon of 1870, signed and dated by Courbet in the lower left-hand corner. Courbet had used a large canvas to depict a seascape bathed in light, devoid of any living being. Like the MNR works mentioned earlier, the work's history ends abruptly. According to the centenary exhibition of Courbet's work at the Grand Palais in 1977–78, *The Cliffs* was part of a well-known Carlin estate sale in 1872. In 1933, it passed into the collection of an André Candamo and there the story seems to end. As with the majority of the MNRs in French museums, the curators have been unable to fill in the blanks, or even to identify the painting's owner. After the war, the first news we have about the painting is that it went to the Louvre in 1950, and from there to the Musée d'Orsay, where it can be found today.

But we found some new elements concerning this painting. As we saw in the chapter on the Paris art market, *The Cliffs of Étretat, after a Storm* figures in the Schenker Papers, where it was found by Douglas Cooper. The Folkwang Museum in Essen bought it and had it shipped to Germany. The seller, according to Schenker, was the dealer André Schoeller, and the price tag was 350,000 francs, though the date of the transaction is not indicated. Schoeller had also sold Corot's *The Horsemen in a Village Street* to the Folkwang in January 1941; perhaps he sold the Courbet painting at the same time. Could it have been confiscated or stolen from a private French citizen and then sold to the Germans? Or was it part of a legal wartime transaction between a French dealer and a Reich museum? Schoeller had, after all, sold other works to the Folkwang, including a Daumier and a Rodin watercolor. Why couldn't the national museums examine Schoeller's sales book and identify the owner of the painting?[7] This is not beyond their power.

The case of another MNR Courbet at the Musée d'Orsay also raises doubts about the determination of custodians of such works to discover their ownership. The painting in question is *Rocky*

Landscape, near Ornans, painted in 1854. In the 1977–78 exhibition catalog, the historical background given about the work is succinct about its provenance, telling us that it was part of von Ribbentrop's collection and that following the usual gap in the story during the war years, it went to the Louvre in 1951. The catalog contains no additional details about the painting's history, from the date of its execution in 1854 to when it was integrated into the Reich's foreign minister's private collection. How did the painting get from Courbet's studio into von Ribbentrop's hands, seventy or eighty years later? Was it bought by the Nazi leader or was it stolen by his henchmen? Did the German embassy in Paris buy it or steal it? Who owned it at the start of the war? Where was it found?[8]

One last MNR Courbet located at the Musée d'Orsay requires our attention, and that is *Bathing Women*, also known as *Two Nudes* (MNR 876, Fernier 229), which underwent a change in format. We learn from volume 3 of the *Illustrated Catalogue of the Louvre* that at first the painting measured 200 by 200 centimeters, about 78 by 78 inches. Sometime between 1930 and 1950, the painting shrank by 65 centimeters taken from the upper part and by some 20 centimenters from the lower. This mysterious operation reduced the painting to 115 by 155 centimeters, which is how it looks today. The painting is signed at the bottom, but before its transformation one could also read beneath the signature "H. Hanoteau, 1858." According to the catalog, the figures were painted by Courbet and the landscape by Hector Hanoteau. The reduction, which might have happened before, during, or after the war, was probably done to do away with Hanoteau's signature, making the painting appear to be a pure Courbet and therefore more valuable. It might also have been done because reducing the format would make it easier to sell. Another reason for its transformation could have been that, if the painting had been uncovered during the war, its reduction could make it more difficult for its rightful owners to identify. Was it confiscated by the Nazis or sold to them? The curators of the Orsay with access to the rele-

vant files are probably in the best position of anyone to answer this question.

This book was published in France in November 1995. It was well received by the art world and the cultural media. The book's disturbing findings on the Paris art market, looted art, and the MNRs have astonished readers and provoked much debate.

Ever since the book's publication, and concerning the MNRs, the Administration of French national museums has been moving sluggishly and replying cautiously to an ever widening circle of people interested in the subject. Soon, several families, learning that their paintings were hanging on national museums for all these years, started laying claims on their artwork.

In April 1996 I published a subsequent article on the MNRs in *Beaux Arts* magazine and gave an interview to the French daily *Le Monde*. In it, I insisted that no important ownership research had been carried out by the Administration of French national museums, nor by the Ministry of Foreign Affairs in more than forty years. The head of the museum Administration, Françoise Cachin, replied in *Le Monde*.

Without acknowledging the obvious absence of ownership research that I demonstrate in this book, Cachin wrote that her Administration had never considered the MNR's as a part of the public collections. She added what I had been told earlier by the Administration's legal department: Any owner or researcher interested in finding out about MNR paintings should look into the general catalogs of French museums. We now know what little information can be obtained from these brief catalogs where the MNRs are scattered throughout.

Finally, Cachin promised to publish a basic illustrated MNR catalog at an unspecified date and that an Internet site would be set up to help facilitate claims. In the fall, an international symposium on Nazi looting would also be organized.

Work on this illustrated MNR catalog has started, but the curators in charge are not carrying out any true ownership research; it is

as though the Administration of French national museums feels this most urgent of duties does not apply to them. Judging from past experience it is hard to believe a succcint catalog with scarce information will be useful in finding any owners.

The museums' MNR Internet site is already a grand disappointment, except for public relations purposes. Without taking into consideration the fact that comparatively few French households are linked to the Internet, the information provided about the paintings it features is hopelessly incomplete and useless.

Users do not have access to a full list of the unclaimed MNR paintings and their history. Then, once a user types the name of a painter or a painting he will obtain little information about his search; this may be good enough for browsing but not for any kind of careful ownership research.

An example will suffice. If a search is attempted for *The Forest*, or *Forest Scene with Two Roman Soldiers* (*see* insert C14) by Boucher, a painting we already know has more than two centuries worth of history, only two dates in the museums' MNR site are displayed. The first involves the date of *The Forest*'s first sale at auction in 1778, and the second is the date of its "temporary" arrival as an MNR at the Louvre in 1951. There is, according to this site, no more history concerning this artwork in between these two points in time. All the important dates and information we saw earlier—which could help lead back to its owner during the war—have been omitted.

The Administration's implicit and steady line of argumentation has been that these MNR artworks were sold voluntarily, and, hence, this is why they have not been claimed and why they do not need or deserve any ownership research.

I have proven in this chapter this is not the case. Active ownership research is the only way to elucidate whether a painting was looted, sold under duress, or sold voluntarily. Waiting passively, as the museum administration has done, for years on end, for owners to show up or for ownership claims to be filed is not an acceptable solution.

It is true, as one Administration official admits off the record, that

many of these unclaimed MNR artworks were voluntarily sold to the Germans by collectors and dealers who became important museum donors after the war. Opening up these "collaborationists" files could be extremely embarassing for them as well as for the museums. Moreover, facing these facts about the shamedly active Paris art market—as we unveiled them in previous chapters—where many were willing to collaborate with the Nazis, would touch a raw nerve in French society.

The museum Administration now claims also that they have not been able to solve this problem because most of the records concerning the MNRs are held in confidential files at the Ministry of Foreign Affairs and elsewhere. But they forget to add that not only have they had almost fifty years to ask for access to these files but also that most of these records now held by the French Foreign Office were in the Administration's hands until 1991. The Administration had put them away haphazardly in a depot on the outskirts of Paris since the death of curator Rose Valland in the early 1980s.

The announced symposium took place at the Louvre School in November 17, 1996. I participated and insisted on my findings. Cachin qualified them publicly during the day as "contrary to the truth." But, as we know art looting is a puzzle subject to sudden developments that often take unpredictable and unsuspected shapes. In late January 1997, this inconclusive matter surged up forcefully again. Except this time the information on the MNRs did not remain within the restricted circle of the European art world. It spread out to the larger circles of international public opinion.

In the midst of the disclosures on Nazi gold and Jewish assets in Switzerland, French Prime Minister Alain Juppé publicly promised the creation of an independent commission to search for and to evaluate Jewish assets held by the French government since the war.

Coincidentally, that same week, a confidential inquiry on the MNRs by the Cour des Comptes (the French respected equivalent of the United States General Accounting Office) was leaked to the press and published almost simultaneously by *Le Monde* and *Le Figaro*, another French daily.

The strongly worded report, dated January 1996, highly criticizes the Administration of French museums for not making any efforts to return the works to their owners. It also proved that several ministries in the government had known for years the existence of assets looted by the Nazis in French museums. This official document was a vindication of my investigation.

The eleven-page report—addressed to the Ministry of Justice—describes how difficult it proved even for a governmental investigative agency like the Cour des Comptes to obtain from museum curators all the necessary information on MNRs. It insisted on the fact that most museum curators—except those at the Orsay—tried minimizing the importance and the value of the MNRs they were holding. The writer of the report realized this clearly when the Orsay curator wrote to him: "[S]ome of them are masterpieces that had we not obtained them this way, we would have been forced to buy them at very high prices," sooner or later. The report concludes, finally, by warning the Ministry of Justice that, if claims to MNRs had no statute of limitations, then the museums could be held publicly liable for not having accomplished their duty to make this matter known.

An official at the Administration of French national museums quickly reacted to the publication by claiming the report "false," adding it was based on preliminary information that had been disputed by the museums. But the spokeswoman at the Cour des Comptes said *Le Monde* was "well-informed" and that the information published was accurate.

A few weeks later, the Minister of Culture himself admitted that the museums had to clear up the MNR matter and face up to the war years. Soon after, the Centre Pompidou and, then, the Louvre, Orsay, Versailles, and the Sèvres museums announced the organization of public exhibitions of the MNRs in their possession. They would be held for two weeks in April. These have been the first exhibitions of their kind since the 1950s.

But, unfortunately, these two-week exhibitions are not enough.

They have partially satisfied public opinion, but cannot replace the necessary ownership research that museum curators or, better still, an independent mixed commission should undertake. We will add that, if this research is to take place, the opening of the documents, records, and archives of the period is an absolute necessity.

This book's inquiry into Nazi plunder confirms the constructive, and sometimes heroic, role curators at French national museums played during the war. Between 1939 and 1944, most of them—especially Jacques Jaujard and Rose Valland—proved tenacious in their resistance to German pressure. They were a bastion of support against looting—by protecting private collections in the national museums' provincial depots, by exercizing preemptive rights to choose confiscated art at the very moment of its confiscation and, lastly, by the exceptional work performed by the Commission de Récupération Artistique (CRA) after the war. Yet today, paradoxically, it would appear as though some museum curators in France are helping to prolong one of the final mysteries of this troubled period in European history. This must change.

In this book readers have seen how the consequences of those four years of looting, massive transfer, and destruction of art in France are still being felt today; how paintings confiscated in Paris during the war reappear elsewhere in museums or private collections, after years of absence, having innocently changed hands in the international art market; how, in Switzerland, looted paintings have tenaciously been held onto and how their real history has been conjured away; how they surface up unexpectedly in Eastern Europe and Russia; and, finally, how some are still hanging in neglect in French museums.

These looted artworks are the revenants of a lost museum destroyed and scattered about the world by Hitler's murderous attempt at changing history and his nationalistic covetousness for art. By tracking these works down and bringing their stories back to life the shadows created by all these years of oblivion will, hopefully, dissipate at last.

APPENDIX A

The Schenker Papers

REPRODUCED AT THE NATIONAL ARCHIVES

SECRET

Tel : VIC 3858 Central Control Commission for Germany,
Ext : 50 (British Component),
 Monuments, Fine Arts & Archives Branch,
 Flat 101, Block No. 8,
 Ashley Gardens, London. S.W.1.

Ref. : INTR/62875/1/MFA 5th April, 194 .

 Copies
To : SHAEF 30 (including Missions)
 U.S. Gp. CC 4
 O.S.S. 2
 Macmillan Commission 4
 Roberts Commission 4
 C.A. 20 B. 2
 Austrian Commission 2
 Interior Div. 2
 J.I. Co-ord. 2
 Legal Div. 1
 Prop: C: (Finance) 1

 Subject :- Accessions to German Museums, and Galleries
 during the Occupation of France (The Schenker
 Papers, Part I).

 Herewith The Schenker Papers, Part I, compiled
by M.F.A. & A. Branch, distribution as above.

 Cecil Gould
 F/Lt

 Douglas Cooper,
 Squadron-Leader,
CG/DP. for Director, M.F.A. & A. Branch.

DECLASSIFIED
Authority NND760238
By _____ NARA. Date 3/31/9

REPRODUCED AT THE NATIONAL ARCHIVES

aug 246
②

-6-

Identifiable Pictures (Cont'd)

Artist	Subject	Medium	Dimensions etc.	Dealer etc.	Price Paid	Date of Trans- action
(Attributed to) POUSSIN	Country Road with monument					
PUGET, P.	Design for monument to Louis XIV	Pen & Wash		Maurice Gobin (ex collection Vivant-Denon)	10,000 fr:	
RENOIR	2 Girls				25,000 mks (Sic)	
PICCI	Fertility	(Canvas)		Leegenhoeck	45,000 fr:	17/7/4?
(Attributed to) RIZOIS	Romantic Landscape about 1820.				40,000 fr:	13/4/43
ROBERT Hubert	Broken Pitcher	(Canvas)	63 x 79 signed & dated 1758.	Jacques Mathey	225,000 fr:	
"	"Les Gorges d'Ollioules"	Oil	Signed & dated	Cailleux	300,00 fr:	10/7/41
ROSLIN	2 Girls				25,000 Mks. (Sic)	
SISLEY	Landscape				50,000 Mks. (Sic)	
SOLIMENA (Attributed to)	Project for Ceiling			Schmit	10,100 fr:	30/6/
TILBERG	Girl at Toilet in a Garden		Signed & dated 166-		60,000 fr:	
TIEPOLO J.B.	Adoration of Magi	Pen & Wash drawing	Signed (Monogram)	Maurice Gobin	28,500 fr:	
"	Caprices (de Vesme Nos. 3-12)			" "	7,000 fr:	
TIEPOLD, D.	Marys at Tomb	Pen & Wash drawing.	Signed	" "	13,500 fr:	
UTRILLO	Country Road					
VAN GOYEN	Country Road					
VINCENT	Allegory					
WATTEAU (Attributed to)	Nymphs : (Original carved wood gilt frame).	Paint on Paper.	31 x 38	Schmit	500,000 fr:	9/5/41.

 REPRODUCED AT THE NATIONAL ARCHIVES

aug 24 6
27

-7-

<u>Dusseldorf</u> (Cont'd)

(b) <u>Other Pictures</u>

Further paintings or sketches (of which no subjects or details were specified) were purchased, bearing labels of the following artists (one of each) :-

CAMPHAUSEN, OTTMAR ELLIGER, the Younger, FYT, GUARDI, KRÜGER, LENAIN, LINGELBACH, MURILLO, PELLEGRINI, RUBENS, TOCQUE, VERVEER, WOUWERMANN.

(c) <u>Miscellaneous Objects of Art etc.</u>

An enormous quantity of knick-knacks was also bought for the Düsseldorf collections, consisting of tables, chairs, desks, commodes, bas-reliefs, faience vases and plates, caskets, medallions, Dresden figures, tapestries, mediaeval ivories, clocks, pieces of metal-work, miscellaneous sculptures, enamels, mantelpieces and between 300 and 400 art-historical books.

8. Essen : Folkwang Museum

(a) <u>Identifiable Pictures</u>

Artist	Subject	Medium	Dimensions etc	Dealer etc	Price Paid	Date of Transaction
BAUGE	Tiger rolling			Schoeller	50,000 fr:	
BOUDIN	Sailing boats in Deauville Harbour			Gerard	150,000 fr:	
COROT	Old Harbour at Rouen			Bignou	450,000 fr:	28/2/41.
"	Horseman on Village Street	(Canvas)	26 x 38	Schoeller	160,000 fr:	15/1/41.
"	Landscape			Fabiani	1,500,000 fr:	
COURBET	Etretat cliffs after the storm			Schoeller	350,000 fr:	
COUTURE (Thomas)	White cock, attacked by one leg.			Heim	20,000 fr:	5/5/41.
DAUBIGNY	Storks			Gerard	125,000 fr:	
DAUMIER	"Hercules of the market-place"	Drawing		Schoeller	50,000 fr:	
DELACROIX	Cromwell by the Coffin of Charles I.	Drawing		Gerard	175,000 fr:	
"	Horseman			"	120,000 fr:	
"	Albanian Dancers			Schoeller	150,000 fr:	

REPRODUCED AT THE NATIONAL ARCHIVES

-8-

Aug 24 6
(23)

(a) Identifiable Pictures (Cont'd)

Artist	Subject	Medium	Dimensions etc.	Dealer etc.	Price Paid	Date Transaction
DELACROIX	Hamlet & Ophelia	Etching or Engraving	(1st State)	Gobin	4,500 fr:	5/6/41.
"	Wild Horse attacked by Tiger.					
"	Faust					
DUFFE (Jules)	Farm in the Woods	(Canvas)	50 x 69	Schoeller (ex coll:Gallice Epernay)	65,000 fr:	14/1/41.
GAVARNI	5 Water-colours				95,000 fr:	
GERICAULT	Horseman	Drawing		Sabatery	3,050 fr:	27/2/41.
"	"Body of Fualdes thrown into the river"	(Painting)				
"	"Horses going to a fair".	"				
"	"The Flemish Farrier"	"				
"	Entrance to Adelphie Wharf.	".				
INGRES	Portrait of Madame Gabriac			Gerard	85,000 fr:	15/1/41.
JONGKIND	Nevers, 1872			Gerard	55,000 fr:	
LANCRET	Family Group					
MAILLOL	Woman with Sash.	Terracotta		Balay	250,000 fr:	
ROBERT (Hubert)	Tivoli		Signed & dated	Schmit	350,000 fr:	16/4/41.
RODIN	Hanako	Water-colour		Schoeller	8,000 fr:	
ROUSSEAU (Th:)	Landscape			Wüster	300,000 fr:	
SISLEY	Landscape			Fabiani	2,000 fr:	

REPRODUCED AT THE NATIONAL ARCHIVES

aug 246
(24)

-9-

(a) Identifiable Pictures (Cont'd)

Artist	Subject	Medium	Dimensions etc.	Dealer etc.	Price Paid	Date of Transaction
TROYON (C.)	The Bird-nest Robbers			Schoeller	130,000 fr:	
VALLAYER-COSTER	Still Life			Manteau	100,000 fr:	
VIGEE LE BRUN	Female Portrait	Pastel		d'Atri	150,000 fr:	

(b) Other Pictures

Other Unspecified pictures by Caresmes and Lemoyne were also purchased (one of each artist).

(c) Drawings

Drawings by the following artists were bought :-

GRAFF, (Anton) (2 drawings), GREUZE, INGRES, MENZEL (3 drawings) PRUD'HON and Hubert ROBERT.

(d) Miscellaneous Objects of Art

Metal-work and porcelain was purchased but not in very large quantities.

9. Frankfurt-am-Main

On 20th November, 1942, one picture was despatched to the Städtisches Kunstinstitut (Durerstr: 2, Frankfurt a/m) and 101 Kgs of books to the Archaeologisches Institut des Deutschen Reiches, (Palmengartenstr: 12, Frankfurt a/m). No other entries related to the Frankfurt public collections.

10. Hamburg : Kunsthalle

A Rubens for this gallery - "Flora and Pomona" - was bought for 2,000,000 fr.

11. Karlsruhe : Kunsthalle

The following pictures were purchased on behalf of the Karlsruhe gallery :-

(a) From Leegenhoeck

Fragonard	:	Head of an old Man.
"		Scene from the Passion
Heda	:	Still Life
v. Beyren	:	Still Life (Fish)
Schwab	:	Death of the Virgin (c.1510)

(b) From Fabiani

Sisley	:	Landscape.

REPRODUCED AT THE NATIONAL ARCHIVES

Aug 246
(25)

-10-

12. Kassel : Hessishes Landesmuseum

 Some eight paintings (including a male portrait by Mignard) were purchased as well as some twelve pieces of furniture, vases etc. No details of these purchases were recorded.

13. Kassel: Wall-paper Museums (Deutsches Tapetenmuseum).

 A Gobelins Tapestry was bought on behalf of the above museum on the 29th July, 1942 for 38,000 fr: from Saigue. Wall-papers were purchased as follows :-

Date	Dealer	Price
19/7/42	Feuve	260,000 fr:
29/7/42	Saigne	10,000 fr:
13/7/42	Roy	18,000 fr:
15/7/42	Carlhian	325,000 fr:

14. Krefeld : Kaiser Wilhelm Museum

 (a) Identifiable Pictures etc.

Artist	Subject	Medium	Dimensions etc.	Dealer etc.	Price Paid	Date of Transaction
AVED	Lady at Dressing-table.			Cailleux	150,000 fr:	
"	Lady in Blue				45,000 fr:	
BACKHUYZEN	Amsterdam Harbour			Landry	80,000 fr:	6/2/42.
BELLE (Alexis Simon)	Portrait of Madame de la Mariniere			Cailleux	250,000 fr:	28/3/41.
BERNARD	Girl with white satin cloak over her shoulders.	Pastel (signed & dated)		Cailleux	35,000 fr:	3/3/41.
BOILLY	Still Life			Aubry	25,000 fr:	
"	Young Woman			Cailleux	300,000 fr:	
BOUDIN	Rotterdam Harbour				190,000 fr:	
"	Trouville Beach			Bignou	400,000 fr:	
CARPEAUX	Faun at the grape-vine.	Marble		Schoeller	175,000 fr:	
CLAEUW (attributed to).	Still Life	(Canvas)	94 x 86	Manteau	45,000 fr:	
COELLO (Attributed to).	Female portrait	(Canvas)	68 x 54	Manteau	30,000 fr:	

 REPRODUCED AT THE NATIONAL ARCHIVES

-11-

Aug 2+6
(26)

Identifiable Pictures etc. (Cont'd)

Artist	Subject	Medium	Dimensions etc.	Dealer	Price Paid	Date of Trans-Action
COURBET	"Painting"			Fabiani	1,500,000 fr:	
COYPEL	Young Woman	Pastel		Cailleux	250,000 fr:	
DELACROIX	Flowers			Fabiani	2,200,000 fr:	
DE TROY	Portrait of M. de Vandieres, later Marquis of Marigny	(Signed)		Cailleux	200,000 fr:	3/3/41.
DULZ (Jacob)	Jovial Company				100,000 fr:	
DUPLESSIS	Male portrait			Trotti	150,000 fr:	
GAUGUIN	Vase of Flowers			Bignou	300,000 fr:	28/2/41.
GERARD (M)	Family picture and an engraving after it.			Cailleux	120,000 fr:	
"	The Letter			Fabiani	150,000 fr:	
Gobelins Tapestries	4 pieces "Children Gardening".				850,000 fr:	
GROS Baron	Portrait of General Joubert.			Gerard	93,000 fr:	
HEINSIUS	Female Portrait			Wüster	90,000 fr:	
"	Male Portrait			Cailleux	60,000 fr:	
JONGKIND	Evening Landscape			Schoeller	150,000 fr:	
"	Antwerp Harbour			"	700,000 fr:	
MAES	Portrait of young man.			Müller	150,000 fr:	
MAILLOL	Female nude	Clay		Fabiani	25,000 fr:	
"	" "	Terracotta		"	30,000 fr:	
MONET	Hunting trophies			Gerard	250,000 fr:	
MOREAU le jeune	Landscape			Fabiani	100,000 fr:	
MOSNIER (J-L)	Woman suckling a child		(Signed & dated)	Cailleux	60,000 fr:	3/3/41.
NATTIER	Madame Adelaide de France as Diana			Schmit		20/1/42.
ONGKEGANK, D.	A flock			Trotti	100,000 fr:	

REPRODUCED AT THE NATIONAL ARCHIVES

Aug 24 6
(29)

-14-

<u>Würzburg: Martin von Wagner Museum</u> (Cont'd)

fishermen by Vernet (which of that tribe unspecified). Also a few drawings
and books. No prices were quoted for any of these articles.

<u>Index of Paris Art Dealers and Individuals who sold Works of Art to
German Museums</u>

Name	Address
d'ATRI	23, Rue la Boetie
AUDRY	2, Rue des Beaux-Arts
BALAY, R.	58, Rue de Vaugirard
IERNATOV	31, Rue Campagne - Premiere
BIGNOU	8, Rue la Boetie
BRIMMER, E.	126, Rue du Faubourg St.Honore
CAILLEUX	136, Faubourg St. Honore
CAMOIN, A.	9, Quai Voltaire
CARLHIAN	22, Place Vendome
DOMATH, Etienne	14, Rue Milton
ENGEL, Hugo	22, Boulevard Malesherbes
FABIANI, M.	26, Avenue Matignan
FEUVE, R.	20, Rue de la Chaise
GERARD, Raphäel	4, Avenue de Messne
GOBIN, Ro Maurice	1, Rue Laffite
CROSVALLET (GROVALET)	126, Boulevard Haussmann
HEIM, Madame Georges	3, Rue Dugnay - Trouin
	(also spelt Dugay-Trouin)
HOLZAPFEL, R.	45, Avenue des Peupliers
INDJOUDJIAN, H.A.M.	26, Rue Lafayette
JORET	30, Rue des Sants-Peres
KALERDJIAN, Freres	52 bis Avenue d'Iena
KELLERMANN	13, Square de Port-Royal
KNOEDLER	22, Rue des Capucines
LANDRY, Pierre	1, Rue Chardin
	(12, Place Vendome)
LEEGENHOECK, J.O.	230, Boulevard Raspail
MANTEAU, Alice	14, Rue de l'Abbaye
MATHEY, Jacques	50, Avenue Duquesue
MATIS	5, Avenue Montaigne
MELLER, Dr.	3, Rue du General-Appert
MÜLLER, R.	11, Rue Jean-Ferandi
POPOFF, Alexandre	86, Faubourg St. Honore
POUMAY	27, Boulevard de Clichy
RATTON, Charles	14, Rue de Mariguan
RECHER, Madame A.	7, Quai Voltaire & 1, Rue
	Bourdaloue
RENAND	30, Quai de Bethune
ROCHLITZ, Gustav	222, Rue de Rivoli
ROY L & C Soeurs	69, Rue des Mathurius
SABATERY, Mlle. S.	35, Rue Boissy d'Anglas
SAIGNE, Marcel	44, Rue des Mathurius
SAMBON, A.	7, Rue du Docteur- Lancereaux
SCHMIT & Cie	18 - 24 Rue de Charonne
SCHOELLER, A.	13, Rue de Mehávan
STORA, M. & R.	32 bis Boulevard Haussmann
TROTTI, Avogli	88, Rue de Grenelle
TOUZAIN, E. Aine	27, Quai Voltaire
VANDERMEERSCH	23, Quai Voltaire
WANNIECK	29, Rue de Monceau

APPENDIX B

An Interview with Alain Vernay

Journalist Alain Vernay is the grandson of French collector Adolphe Schloss. Vernay, born in 1918, served in the French Army when war broke out in 1939. In 1940, he drove the Nabi painter Edouard Vuillard, a family friend, across France to the art dealer Alfred Daber's country house, where the painter would die weeks later—an anecdote that shows the tight interrelation and small size of the Paris art world of collectors, painters, and dealers. After the French army was routed, Vernay joined the Resistance and kept fighting the Germans in central France. After the war, he became a foreign correspondent and a managing editor at the Paris daily *Le Figaro*.

—*Why have you never spoken out about the Schloss collection?*

—French families of noble descent can dedicate their entire lives to a castle's preservation, and to how it ought to be handed down to the next generation, forgoing or at least limiting career and marriage choices for its sake. It's an honor, a burden, and a full-time job. So much so that certain members of the family flee and become disinherited. So too the heir of a large collection has to make a radical choice: to devote his life to getting it back, and to seek justice from the vultures that profited from its theft, or else to take a step back and let justice run its course. My choice was the latter, because I am certain that justice will prevail. Anything is possible or at least probable—the revelations contained in the documents from the time contain as many surprises as the STASI documents do in German politics.

—*Can you be more precise?*

—Well, for example, I possess a number of documents, such as the correspondence between an expert from the Louvre and the German confiscator of the Schloss collection, in which he offers to state that the paintings are rarely by the famous painters to whom they are attributed, and suggests that he attribute the works to the great painters' disciples, or that he say they are fakes, or that he evaluate them at ridiculously low prices, because the interest for Dutch painting would eventually go down. He was paid 10,620 francs.

—*Why have you not talked about this before?*

—Because he was a close relative of a high-ranking member of the Resistance, and my mother, father, and my uncle Lucien decided it was better to let it go. There are other examples that are even more shocking.

—*Could you give us some of them?*

—I'm afraid I can't answer that question. In general, when you delve too deeply into those war years of double agents and cowardice, which were also years of heroes and courage, many things can give you a nasty surprise. The war period was so confusing that

some people have even tried doubting Rose Valland's courage—which, to me, is beyond question.

But everything is possible in the realm of the great art collections when, long after his death, it was discovered that the venerable art critic and art historian Bernard Berenson was paid by British art dealer Duveen to evaluate paintings—at the latter's requests—as fakes or originals.

—Do you believe that any of the great Jewish dealers worked with the Germans? I'm thinking of Georges Wildenstein, who, it is well known, conducted all his business from overseas. I have the letters he sent to Roger Dequoy's father-in-law in the South, and I've found passages in them to that effect.

—I have no idea. I do know that Georges Wildenstein came to visit my father in the Free Zone, in Nice, at the Hotel Royal, very soon after France collapsed, and just before he left for New York. According to my father—I wasn't there—he offered to buy the entire Schloss collection, which had not yet been discovered, for a very considerable sum that would be remitted in Switzerland in dollars, along with the status of honorary Aryan citizenship for himself, my mother, and her brothers. My father wisely answered that he'd think about it, and then swore that he'd never have anything to do with Georges Wildenstein again.

—Have you heard it said that officers of the United States army helped themselves now and again to paintings stolen by the Germans?

—There's a bad apple in every barrel. Two Americans came to see my father in Paris a few years after the Liberation, introduced themselves as officers, and told him that they had in their possession some important paintings from the Schloss collection. They offered to return four of them, in exchange for some forty thousand dollars, which was cheap. My father told me the story of how he kicked them out, telling them they should be ashamed to be wearing U.S. army uniforms. This always seemed strange to me. At the time, it seemed unbelievable. It doesn't anymore.

—Do you think there are any paintings from the Schloss collection hidden away somewhere in the Louvre?

—I really have no idea. I understand why you ask, since to this date no representative of the State has ever been allowed to conduct an official survey of the Louvre's holdings. That's left to the Ministry of Justice or to Foreign Affairs.

—Do you trust anyone at this point?

—I have full confidence in the research and restitution department of the Musée d'Orsay, where some amazing people are working around the clock, indefatigably, despite the many obstacles in their path.

—Do you hope that more information will come out about all this?

—Yes, certainly, and soon the people who have discovered paintings from the Schloss collection in museums in the U.S. or in Europe will be able to trace their journey there. Is there not after all some moral accountability on the part of the dealers who auctioned off works marked "stolen by the Nazis"? Have not lots of paintings been discovered because of inheritance disputes in Germany? And in these cases, were they not restored to their rightful owners through the intervention of the German Ministry of Justice, whether or not the rightful owners were making claims, but simply as German war reparations?

—Can you talk a bit about Adolphe Schloss?

—He was a genius whose passion was art. He was born in Austria and came to France in 1873, taking on French citizenship. He was the biggest broker of goods and commodities in Paris, working simultaneously for the Russian czar and the Austrian emperor as well as for Woolworth and Nieman Marcus. He was their buyer. His ambitions . . . well, I never knew him myself; I only knew my grandmother, and she worshiped him. She was killed by a tram in front of her house in the late 1930s. My grandfather kept track of all the great paintings in every city of Europe and the United States. He had purchased many of his paintings from the son of Countess

Hanska, Balzac's lover. If he had died just a few years later, he might never have owned all three hundred and thirty-three paintings, because although no one knew it except perhaps his eldest son Lucien, my mother, and his wife, he planned to sell around fifty of them to buy a Vermeer. His death prevented this transaction from taking place. It would have been the crowning moment in life as a collector.

NOTES

Introduction

1. See Albert Speer, *Inside the Third Reich: Memoirs* (New York: Collier Books, 1981), p. 179.
2. See Raoul Hilberg, *The Destruction of the European Jews* (New York: Harper & Row, 1961), pp. 419–20.
3. In the United States, Janet Flanner, European war correspondent for *The New Yorker* magazine is, to my knowledge, the first writer to have attempted to give an overview of Nazi art-looting in her "Annals of Paris: The Beautiful Spoils." Her series of articles on the subject were published soon after the war in *The New Yorker,* in the Feb. 22, March 1, and March 8 issues of 1947. Surprisingly, very few people remember this, even *The New Yorker* itself.

 Also, see James J. Rorimer, in collaboration with Gilbert Rabin, *Survival: The Salvage and Protection of Art in War* (New York: Abelard Press, Inc., 1950) and Craig Hugh Smyth, *Repatriation of Art from the Collecting Point in Munich After World War II* (The Hague: SDU Publishers, 1988).

In France, the anthology of official documents on looting, *Le Pillage par les Allemands des oeuvres d'art et des bibliothèques appartenant à des Juifs en France* (Paris: Editions du Centre, 1947), edited by Jean Cassou, is an essential book because of its presentation of a great variety of internal correspondence between German leaders and offices and internal Vichy French memorandums and Nazi confiscation.

Curator Rose Valland's memoirs, *Le Front de l'Art* (Paris: Plon, 1961), is a classic on the subject. Valland describes her experience at the Jeu de Paume Museum and reveals many facts.

Lynn Nicholas's recent book, *The Rape of Europa* (New York: Knopf, 1994), treats the subject of Nazi looting policy and the retrieval of art after the war in all of Europe, using many documents.

Hopefully, readers are less aware, I believe, of the very precise stories to be found in *The Lost Museum*.

On French W. W. II history, the basic books used here are: Robert O. Paxton, *Vichy France: Old Guard and New Order, 1940–1944* (New York: Columbia University Press, 1972) and Michael R. Marrus and Robert O. Paxton, *Vichy France and the Jews* (New York: Basic Books, 1981).

Chapter 1. Vermeer's *Astronomer*

1. J. Cassou, op. cit., p. 85.
2. Speer, op. cit., pp. 171–73.
3. Adolf Hitler, *Mein Kampf* (Boston: Houghton Mifflin, 1971 edition), pp. 262, 258–59.
4. Ernst Hanfstaengl, *Hitler: The Missing Years* (New York: Arcade Publishing, 1994), pp. 59–61.
5. For more on the close bonds between the Jewish world and seventeenth-century Dutch painters, see "Rembrandt's Holland," catalog prepared by Martin Weyl for the Israel Museum, Jerusalem, 1993, and Simon Schama, *The Embassment of Riches: An Interpretation of Dutch Culture in the Golden Age* (New York: Knopf, 1987).
6. Hitler, *Mein Kampf.*
7. "Consolidated Interrogation Report, Linz Museum," National Archives (NA), Roberts Commission. The document was part of the investigations undertaken in Germany by the U.S. army following the war.

8. "Records Group (RG) 260," boxes 387, 388, 438, National Archives (NA), Washington, D.C.
9. See "Hitler's Last Will" in Louis L. Snyder, *Encyclopedia of the Third Reich* (New York: Paragon House, 1989).

Chapter 2. The Kümmel Report

1. Few copies of the Kümmel Report remain. One photocopy, easily accessible to the public, can be found at the Watson Library of the Metropolitan Museum of Art in New York. Also, see Rose Valland, op cit., pp. 19–26.
2. Peter Watson, *Wisdom and Strength* (New York: Doubleday, 1989), pp. 254–66.
3. Marie-Louise Blumer, *The Commission for the Research of Science and Art Objects in Italy (1796–1797), The French Revolution,* January–June 1934, and *Catalog of Paintings Transported to France from Italy Between 1789 to 1814.* Bulletin de la Société Française d'Histoire de l'Art, 1936.
4. See Pierre Assouline, *L'Homme de l'art, Daniel-Henry Kahnweiler* (Paris: Gallimard, 1992).

Chapter 3. Hermann Goering, "Friend of the Arts"

1. Consolidated Interrogation Report No. 1 (CIR 1), "Activity of the Einsatzstab Rosenberg in France," by James S. Plaut. National Archives (NA), Washington, D.C.
2. Cassou, op. cit., p. 40; Consolidated Interrogation Report 1, especially "Accusations in the Otto Abetz Case, Tribunal Militaire de Paris," 1948; also information obtained in an interview with Colonel Paillole.
3. Cassou, ibid., p. 84; and CIR 1.
4. See Jacques Beltrand's appraisals of Hermann Goering's looted artworks, 1941 and 1942, RG 239, box 74, National Archives (NA), Washington, D.C.
5. Cassou, op. cit., pp. 105–7.
6. Ibid., pp. 189–229.
7. Ibid., pp. 92–98; and CIR 1.

Chapter 4. The Exemplary Looting
of the Rothschild Collections

1. The information in this chapter comes from interviews with and archives provided by Baroness Liliane, Baron Élie, and Baron Guy de Rothschild, from Madame Kolesnikoff, and from Herbert Lottman's *The French Rothschilds: The Great Banking Dynasties Through Two Turbulent Centuries* (New York: Crown Publishers, 1995). Other details are from documents in the National Archives, RG 331, box 327, which contains Peyrastre's deposition concerning the possessions of Maurice de Rothschild, the transport lists of the Rothschilds' art drawn up by the ERR, as well as the inventories compiled by the Rothschild family as part of their reclamation files at the end of the war.
2. Interview with Liliane de Rothschild.
3. Deposition of M. Peyrastre, National Archives, RG 331, box 327, folder 246.
4. ERR inventory, National Archives, RG 331, box 325, "Looting; Einsatzstab Rosenberg."

Chapter 5. The Paul Rosenberg Gallery

1. John Richardson pointed out to me André Salmon's commentary, which follows.
2. André Salmon, *Revue de France*, no. 11 (1921).
3. E. Tériade, "Interview with Paul Rosenberg," supplement to *Cahier d'Art*, no. 9 (1927): 23–30.
4. John Richardson, *Picasso*, vol. 1 (New York: Random House, 1991), pp. 263, 266.
5. Interview with Georges Halphen.
6. Maurice Sachs, *The Decade of Illusion, Paris 1918-1928* (New York: Knopf, 1933), p. 37.
7. Recounted in *L'Art vivant*, no. 3 (February 1925).
8. Confidential interview with Alfred Daber, February 1995.
9. Ambroise Vollard, *Souvenirs d'un marchand de tableaux* (Paris: Albin Michel, 1937), p. 72.

10. Interview with Alfred Daber.
11. Vollard, *Souvenirs*, p. 95.
12. René Gimpel, *Journal d'un collectionneur* (Paris: Calmann-Lévy, 1963), pp. 199–200.
13. Interviews with the Rosenberg family; also see Michael Fitzgerald, *Making Modernism* (New York: Farrar, Straus and Giroux, 1995), p. 85.
14. Jacques Helft, *Vive la chine!* (Monaco: Éditions de Rocher, 1955), p. 201.
15. Raul Hilberg, *The Destruction of the European Jews* (New York: Harper & Row, 1961), pp. 419–20 and footnotes; and Cassou, op. cit., pp. 132–38.
16. Archives of Paul Rosenberg correspondence, New York.
17. Ibid.

Chapter 6. The Bernheim-Jeune Collection

. Note: The names of the paintings used in this chapter were those used by the Bernheim-Jeune family. For the names of the others, see the catalogues raisonnés for each painter, or the catalog for the Toulouse-Lautrec exhibition in London in 1991, and Paris, RMN, 1992.
1. See the illustrations in Jean Dauberville, *En encadrant le siècle* (Paris: Editions J. and H. Bernheim-Jeune, 1967).
2. See Ernst Junger's *War Journals* (*Journaux de guerre*) (Paris: Juilliard, 1990). Descriptions of his visits to Bérès can be found on pp. 235, 269; the Faubourg Saint-Honoré, p. 260; for the Pâtisserie Ladurée, Rue Royale, see p. 218.
3. Letter from Jacques Lauwick found in the Bernheim-Jeune file of the CRA and the DGER, in Record Group 239, box 74, National Archives, Washington, D.C.

Chapter 7. David David-Weill

1. The information in this chapter came from the David-Weill archives. Reclamation files of the David David-Weill collection: lists from 1946, 1957, ERR inventories, and documents prepared by Marcelle Minet.

Chapter 8. The Schloss Collection

1. The story of the Schloss collection's confiscation was reconstructed from interviews with Schloss's heirs: Alain Vernay, his grandson; and Jean de Martini, the adopted son of Henri Schloss. Also used were the transcripts of the August 3, 1945, trial of Jean-François Lefranc and DGER files. Also helpful was Rose Valland's recollection of the Schloss affair, which is to be found in RG 331, box 326, at the National Archives in Washington, D.C.
2. See Germain Bazin, *L'Exode du Louvre* (Paris: Somogy, 1992), pp. 89–98.

Chapter 9. Visitors to the Jeu de Paume

1. Rose Valland, *Le Front de l'art* (Paris: Plon, 1961).
2. Cassou, op. cit., pp. 108–9; and CIR 1.
3. Valland, *Le Front*, p. 58.
4. Interrogation of Bruno Lohse, investigation into Lefranc, and CIR Bruno. National Archives, Washington, D.C.
5. See the Lohse interrogation.
6. Letter from Hofer located in the Paul Rosenberg archives, New York.
7. CIR Rochlitz, and "Report on Mission to Switzerland," Douglas Cooper, December 10, 1945. RG 239, box 82, "Swiss Report" folder. National Archives, Washington, D.C.
8. DGER report in National Archives.
9. Ibid.

Chapter 10. Business as Usual

1. See Raymonde Moulin, *Le Marché de la peinture en France* (Paris: Editions de Minuit, 1967), p. 42. See also *L'Annuaire général des ventes publiques en France* [Yearbook of public sales in France], vols. 1, 2, 1940–43; and Lynn Nicholas's *The Rape of Europa*.
2. Compare Bertrand Dorléac, pp. 145–51; Moulin, pp. 40–50; see also *The New Pallas*, Geneva.
3. Compare Moulin, p. 41, and the *Annuaire général* cited in note 1 above.

4. See Chapter 4, and compare the OSS report on the ERR's lists, and the ERR's report for 1944; see also the claim lists presented by the Rothschild family.

5. See the abundant official correspondence on the subject in Cassou, op. cit., pp. 187–229.

6. See the Schenker Papers, RG 331, box 326, folder 246, "Looting: France"; also see the interrogation transcript of von Mohnen, and Grote Hasenbalf, RG 239, box 238, and D. Cooper's conversation with Bührle (Swiss Reports), as well as the DGER lists on Cailleux and Jansen, RG 331.

7. See Mohnen and OSS Paris Report, RG 331, box 325, folder 246.

8. To my knowledge, the Schenker Papers and other documents reproduced in Appendix 1 of this book and cited in this chapter, have never been published or commented on in France. I found both original and copies in the National Archives in Washington, D.C.

9. For the names of the three principal curators, see chapter 2.

Chapter 11. Switzerland

1. The Allied investigation in Switzerland was also led by Douglas Cooper, as set forth in his "Report of Mission to Switzerland," RG 239, box 82, "Swiss Reports" folder.

Chapter 12. The Found and the Lost

1. See CIR 1, "The Einsatzstab Reichsleiter Rosenberg."

2. See "Act of Accusation Against Otto Abetz," Tribunal Militaire de Paris, 1948, p. 88; also, a letter from the German Federal Office of External Restitution to Alexandre Rosenberg, June 13, 1960; and the Paul Rosenberg archives, New York.

3. Abetz, "Act of Accusation," p. 92.

4. James J. Rorimer, *Survival* (New York: Abelard Press, 1950), pp. 159–60.

5. DGER Reports, RG 239.

6. Paul Rosenberg archives, and interviews with Elaine Rosenberg and Jorge Helft.

7. Letters between Edmond Rosenberg and Paul Rosenberg, September–December 1944.
8. Interview with Craig H. Smyth.
9. David David-Weill archives.
10. Documents from Jean de Martini and Alain Vernay.
11. Ibid.
12. Interview with Liliane de Rothschild.
13. DGER Bernheim-Jeune file, and interview with Michel Dauberville.
14. David-Weill archives, and ERR inventories compiled in 1943 and 1944.
15. Information furnished by Laure Murat.
16. David-Weill archives, and information provided by the Masson heirs, the galleries involved, Sotheby's, and the Centro Reina Sofia in Madrid.

Chapter 13. A Short Swiss Epilogue

1. This document, dated December 10, 1945, can be found at the US-NAR, section RG 239, box 82, folder "Swiss Reports."

Chapter 14. Something New in the East

1. Interview with Madame Katiana Ossorguine.
2. Letter from the Paul Rosenberg archives.
3. Inventory translated from the Russian in the Paul Rosenberg archives.

Chapter 15. The Purgatory of the MNRs

1. Irus Hansma, author of the catalogue raisonné of Fernand Léger's work, and Quentin Laurens of the Louise Leiris Gallery in Paris.
2. I would like to thank Jeanne Bouniort for her help in researching this chapter. This is taken from the catalog of the exhibition, *François Boucher 1703–1770*, at the Metropolitan Museum of Art, January–May 1986; the Detroit Institute of Arts, May–August 1986; and the Galeries Nationales du Grand Palais, September 1986–January 1987.

3. Pierre Rosenberg, *Chardin's Painted Work* (Paris: Flammarion, 1982).
4. Exhibition catalog, *Chardin*, Galeries Nationales du Grand Palais, January–April 1979.
5. This Cézanne painting was not in the Cézanne exhibition of 1995.
6. Note of October 26, 1992, from Jacques Sallois to the department heads.
7. Catalog of the Courbet exhibition, Galeries Nationales du Grand Palais, September 1977–January 1978.
8. Schenker Papers, National Archives, Washington, D.C.

INDEX

CPSIA information can be obtained
at www.ICGtesting.com
Printed in the USA
LVHW081448071221
705514LV00022B/277